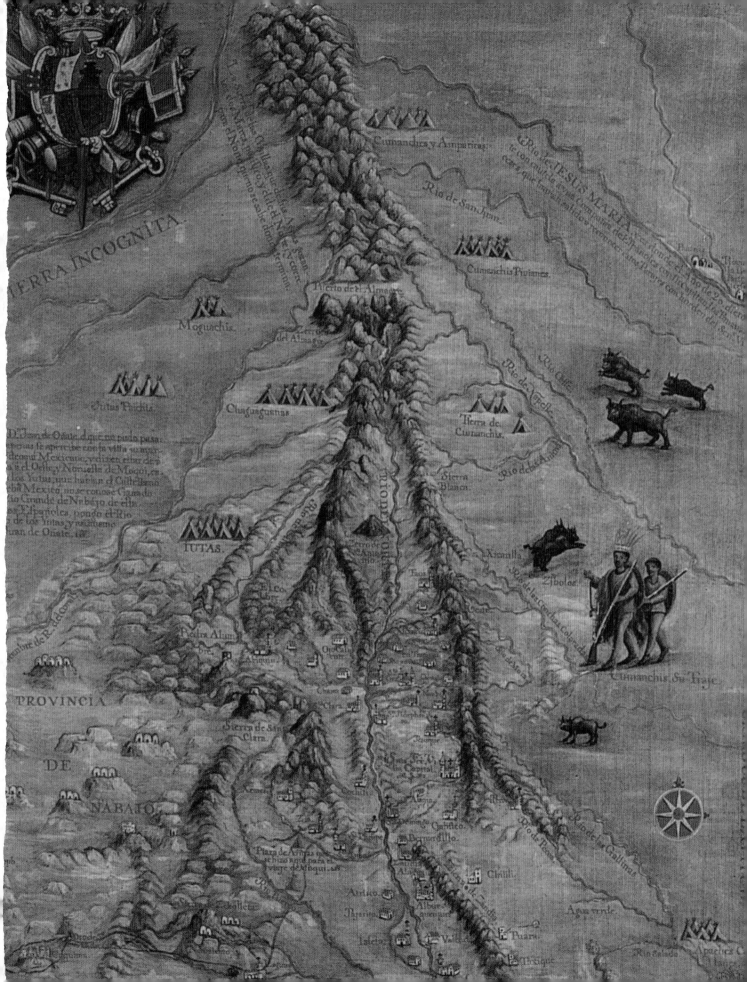

TIERRA INCOGNITA.

Cunanchas y Amparicas.

Rio de San Juan.

Cunanchis Tiuianes.

Moguachis.

Puerto de El Almag.

Ytutas Puchia.

Chaguaguanas.

Tierra de
Cunanchis.

Rio de IESUS MARIA.

Rio del Tizon.

Rio de los Anim.

Sierra
Blanca.

YTUTAS.

Xinulla.

Zibolas.

Cunanchis Su Traje.

PROVINCIA

DE

NABAIO

Rio de la Gallina.

Chilili.

Agua verde.

Atisco.

Apaches.

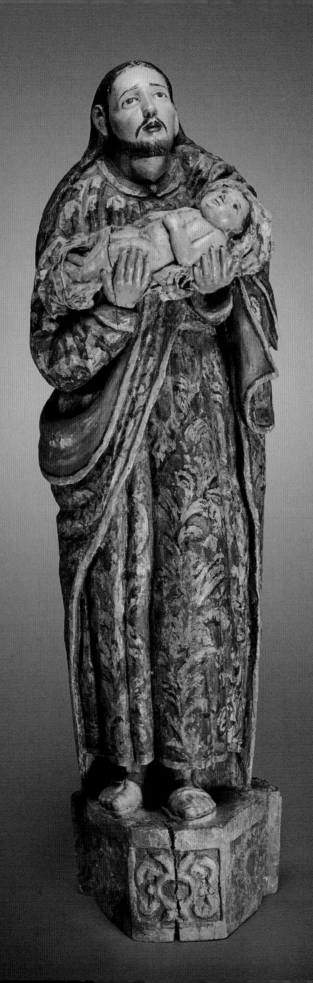

THE ART &
LEGACY OF

Bernardo
Miera y Pacheco

*New Spain's Explorer,
Cartographer, and Artist*

Edited by Josef Díaz

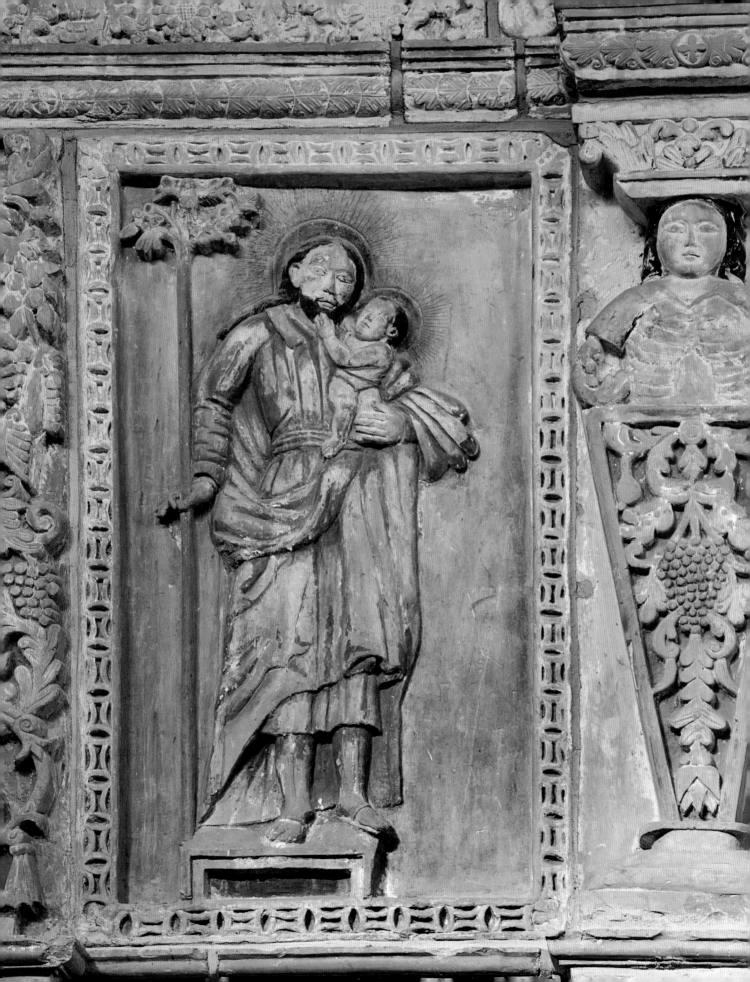

Contents

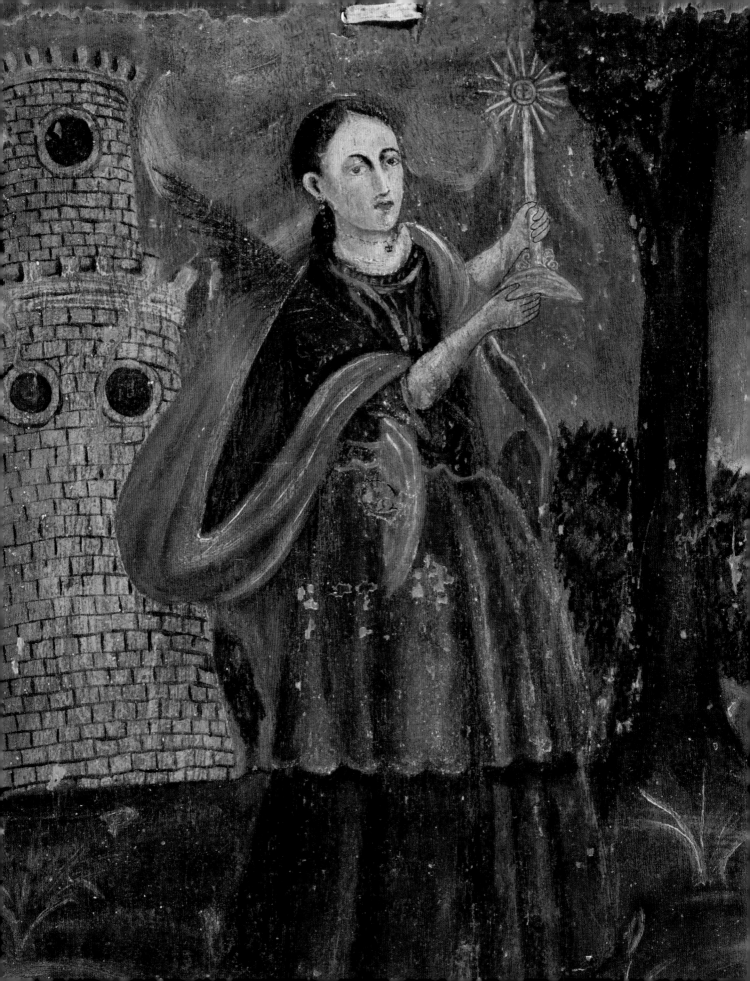

Preface

Josef Díaz

hough small in physical stature—just five feet tall—
Don Bernardo Miera y Pacheco cast a considerable
shadow across the eighteenth-century frontier of the
Spanish Empire, now the American Southwest. Sol-
dier, cartographer, explorer, artist, he was a classic
stranger in a strange land—a land he made distinctly
his own even as change roiled throughout the Spanish Empire, from Europe to
Mexico to a northern colony centered on Santa Fe. Miera's maps and commen-
taries have appeared in nearly every book and article about New Mexico's colo-
nial history, but the full extent of his art, life, and works only recently became the
focus of scholarly interest. This book offers the first complete record of his art,
one long anticipated by art historians and *aficionados* of Spanish colonial history.

Miera would have been remembered just for his exquisite paintings and
religious sculptures, but he also had a multifaceted intellectual curiosity. He
enthusiastically explored a diverse range of endeavors—a distinguished soldier,
a captain of engineers of the Spanish Royal Corp of Engineers, painter, *alcalde*
(town mayor), and an intrepid explorer of Spain's vast northern colony. He
was additionally one of the foremost early cartographers of the region's vast
uncharted lands, producing maps between 1743 and 1779 that were famous for
accuracy, artistry, and attention to geography, geology, and ethnography. His
many maps of Spanish borderlands were key for the strategic military cam-
paigns in defense of New Mexico against French and Comanche advancement.

His scientific knowledge allowed him to successfully explore northern New
Spain and make discoveries for his descriptive maps, such as the one produced
after his famous expedition with Franciscan friars Francisco Atanasio Domín-

(previous spread)
Miera y Pacheco, Saint Joseph,
*1761, volcanic stone, paint. Cristo Rey
Church, Santa Fe, New Mexico.*

(opposite)
Miera y Pacheco, Santa Barbara,
*ca. 1760, oil on wood, 22 x 16 in. New
Mexico History Museum, Santa Fe.*

guez and Silvestre Vélez de Escalante in 1776, one of the most important European expeditions in the American Southwest. Miera's explorations and maps predated the Lewis and Clark expeditions of 1804–1805. Pioneers exploring the Southwest used his maps well into the nineteenth century.

He applied his artistic talents to the sacred as well as the secular. Many art historians consider Miera one of the founders of the New Mexico *santero* tradition, specifically alluding to his prototype development of *retablos* (icons of saints painted on wooden panels) and *bultos* (sacred figures carved in the round). He became a well-known and sought-after source for religious images due to these diverse artistic talents, skillfulness in making sacred images, and his understanding of religious iconography. He received commissions to create altar pieces, such as the one for the *Capilla Castrense,* a stone altar screen that today adorns the Cristo Rey Church on Canyon Road in Santa Fe. While he undoubtedly would have described himself as Spanish, his art sparked a fusion of aesthetics, materials, and styles that helped to create the culturally unique santero tradition that began in the late eighteenth century, flowered into the mid-nineteenth century, and continues to thrive today.

Sadly, only a few of his works are known to have survived. This anthology documents those pieces and explores Miera's life and times. Each chapter addresses a single aspect of his life and asks readers to see his experiences through his eyes. Though each essay stands alone, the sum of the authors' insights creates a portrait of a complex and talented individual who lived in a remote place that invited him to innovate and diversify his interests. Miera lived between two worlds, as a Spanish colonist in a place of indigenous peoples. He saw what many others of his time did not: a crossroads blending and creating a new culture we now know as New Mexican. With this background in mind, readers will gain an understanding of what Miera contributed to creating a culture separate from the more homogeneous Mexican world.

The physical and intellectual setting in which Miera lived is brought vividly to life in the opening essay by Thomas E. Chávez, whose work as a historian has focused on the often forgotten dynamic character of colonial New Mexico in the eighteenth and nineteenth centuries. He places Miera within the brilliant era known as the Enlightenment. Spain, ruled by Carlos III, was an intellectual hub in a period valued for its utopian vision for humankind as illustrated by the Declaration of Independence, the intellectual pursuits of Benjamin Franklin, and, importantly, a revolutionary spirit of change. Dr. Chávez discusses how the placement of Miera on the frontier allowed him to develop into a true Renaissance individual in the same sense as Franklin or even Leonardo da Vinci.

Miera arrived in New Mexico as a trained engineer and cartographer within the Spanish army. His vocation was serving this Royal Corp of Engineers, and the subsequent chapter, by Dennis Reinhartz, analyzes the masterful maps he created for it. Reinhartz's essay sets the stage for the late eighteenth-century impetus to design scientific maps for the military, ones with more preci-

sion and information. Miera created maps that lasted far beyond his lifetime, well into the nineteenth century, guiding future American explorers, pioneers, and settlers. One hundred and fifty years later, Dr. Charles Carrillo gleans different information from those same maps. To him, they show Miera as a keen observer of the people around him, specifically the individual identities of Native peoples experiencing their own era of turbulent change. Miera took note of the environment in which they lived and expressed that geography masterfully in his maps, becoming an adept ethnographer before that discipline was established.

Two consummate curators of Spanish colonial art, Robin Farwell Gavin and Donna Pierce, put into context this artist's innovative growth, inspiration, and development—from his exposure to the artistic traditions he grew up with in Northern Spain and his exposure to academic art in Mexico City to the stimulating development of his personal artistic style on the frontier of the Spanish Empire. By showing how specific examples of altars in cathedrals of Spain and Mexico that were already old when Miera was a youth and a young soldier are reflected in works he created later in New Mexico, these authors vividly illuminate the juxtaposition of the Old World with Miera's New-World creations.

Finally, in William Wroth's chapter, the reader is challenged to consider what Miera's specific contribution was to the development of the New Mexican santero tradition. His essay is an intellectually rigorous review of Miera's stylistic influence on the santero tradition in eighteenth- and nineteenth-century New Mexico. He provides detailed comparisons of Miera's style with that of later artists, emphasizing many stylistic differences between them and exploring whether these variations can be explained by knowing for whom and why each artist created their works.

The essays here included not only illuminate the various facets of Miera's life but pose tantalizing questions about the assessment of his legacy. Did this Renaissance frontiersman spark the development of what we know as the New Mexico santero tradition or is he better thought of as a talented artist who was challenged to excel in many endeavors by the need for resourcefulness in a remote frontier? Such questions will further the next stage of scholarly inquiry into the life and works of Don Bernardo Miera y Pacheco.

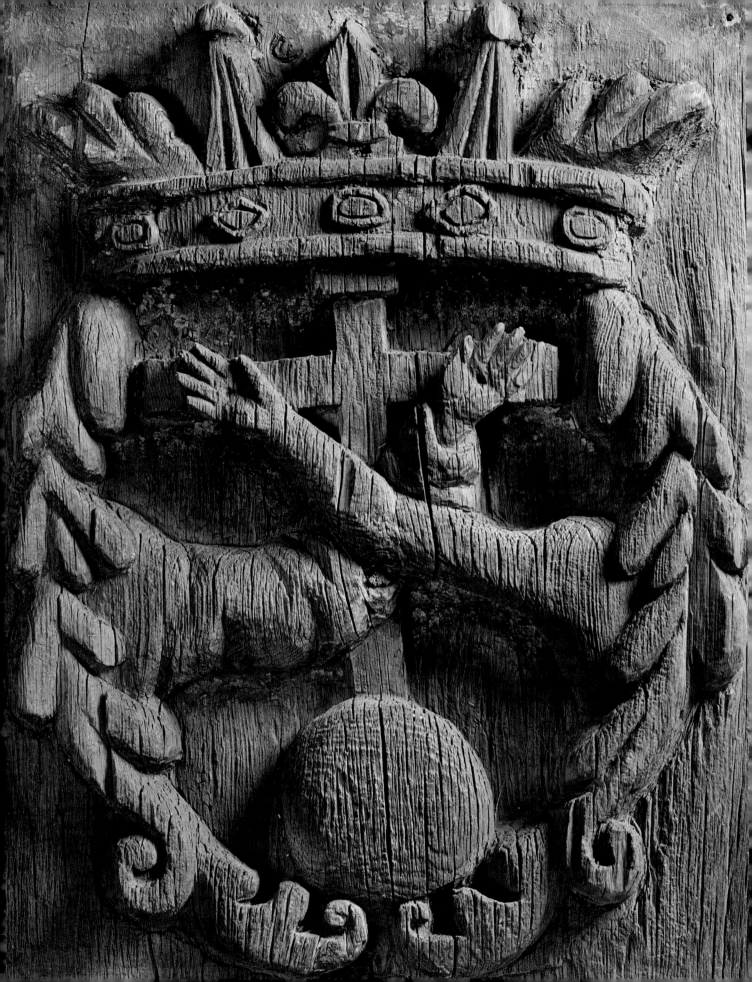

"Because Within Me There Burns a Desire": Bernardo Miera y Pacheco A Life and Times

By Thomas E. Chávez

In 1950, Herbert E. Bolton, the father of Spanish borderland studies, wrote: "As a result of his long service and of his many reports and maps, the archives are replete with the writings and cartography of Miera y Pacheco, which would furnish data for a well-documented and significant biography of Don Bernardo."[1] Despite the wealth of materials, however, until now no book or biography has been devoted to him. That Miera deserves a biography is beyond doubt. He left many manuscript maps as well as works of art that in recent years have become the subject of numerous articles, and now we have John L. Kessell's new *Miera y Pacheco: A Renaissance Spaniard in Eighteenth-Century New Mexico* that has seen the light of publication, fulfilling Bolton's forecast.

A contemporary of Benjamin Franklin, Miera lived through many significant events of the eighteenth century with Spain undergoing the struggle for Bourbon succession that brought about upheavals in European geopolitics.

The northern edge of Spain's viceroyalty of New Spain where Miera relocated by 1741 was considered by Bourbon monarchs to be a defensive bastion. Initially, the area was a buffer against Spain's European rivals, with the French in the east and the English, Dutch, and Russians in the west, a situation that resulted in Spanish expansion into Texas at the beginning of the century and into California at the end of the 1760s. Up until they were eliminated from North America and the end of the Seven Years War (the French and Indian War), the French were suspected of arming and assisting marauding Indians at a time when they had acquired horses from the Spanish. This combination of horses and firearms made them much more dangerous and ellusive.

11

In 1765, King Carlos III initiated a number of actions, the most important of which, for our purposes, dealt with northern New Spain, including New Mexico. He appointed the aggressive and capable José de Gálvez inspector general with instructions to initiate reforms in New Spain and appointed Cayetano María Pignatelli Rubí Corbera y San Climent, the Marqués de Rubí, to conduct an inspection of the region.

The results of their assignments would be many-fold. Gálvez oversaw the settlement of California and the expulsion of the Jesuits from New Spain; proposed a realignment of the northern presidios; and the creation of a jurisdiction of the northern provinces separate from the viceroyalty of New Spain, which he called the Internal Provinces. The reorganization of the north required governmental investment in people, and capital; the expansion of mineral exploration; the opening of new, safe routes that connected the provinces; and finding a solution to the problem of raiding Indians—the key to making all the other changes possible.

Meanwhile, in 1766 the Marqués de Rubí embarked on a two-year inspection that included a visit to New Mexico.[2] The report stated that Santa Fe's population was 2,324 inhabitants and described the presidio, a part of which is today's Palace of the Governors, as "incapable of being defended."[3]

In April 1768, Rubí submitted his report and recommendations, which he called his *"Dictamen."* Four years later, after Gálvez had returned to Spain to assume the post of minister of the Indies, the king issued a royal *"Regalmento"* that created the office of inspector to oversee the new regulations for the presidios on the northern frontier. Don Teodoro de Croix became the first commandant-general. A forthright, intelligent man of action, Croix arrived in Mexico City in 1777 then headed north to see the country for which he had responsibility. While touring he held a series of meetings, the most important in Chihuahua, where the governors and leading citizens of the provinces of Sonora, Nueva Vizcaya, Coahuila, and New Mexico attended, including Bernardo Miera y Pacheco.[4]

Until the settlement of California, New Mexico represented Spain's northernmost expansion into North America. Along with San Antonio in Texas, New Mexico had been allowed to remain beyond the new defensive line of presidios that protected Christian Indians and Spanish settlers. New Mexico also was seen as a possible link to California after officials realized that it would need to be supplied by land, for maintaining the place by sailing north against the prevailing currents and winds would not be viable.

Despite the fact that New Mexico was sparsely populated, poorly defended, and surrounded by hostile tribes, its population was experienced in survival. It had been established as a missionary field by the Franciscans more than one hundred fifty years earlier; now, with the viceroyalty's support for the effort inactive, the Archdiocese of Durango, sensing an opportunity to expand

its own influence, began to make overtures to secularize the area, replacing the Franciscan friars with its own secular priests. The Franciscans, of course, would not give up their northern custody without resistance. Thus, within the context of the creation of the Internal Provinces, New Mexico received three visitations from the Bishops of Durango and a special Franciscan inspector of its missions.

This is the context in which transplanted New Mexican Bernardo Miera y Pacheco lived.[5] He was a man whom scholars have described as an Indian fighter, politician, artist, cartographer, engineer, and militia captain. His art would be prized by museums and the interest of art historians, and his maps the basis for Baron von Humboldt's "Map of New Spain" and would warrant a chapter in Carl I. Wheat's monumental, multi-volume *Mapping the Transmississippi West*.[6]

Bernardo Miera y Pacheco was born in the Valle de Corrieda in the mountains of Burgos in northern Spain on August 4, 1713. Nine days later he was baptized in the town of Santibañez in the same valley. While his parents were not nobles they were accomplished. His mother's father had been the governor of Navarra and a colonel in the Tercio of Lombardy regiment in the royal army. He was mortally wounded in the Battle of Mantua. His father had served under the Count of Aguilar in the army of King Felipe V.[7]

Although almost nothing of his youth and upbringing is known, we can assume that his parents, Don Luis de Miera and Doña Isabel Anna Pacheco, made sure that he received some education. Apparently an impressionable and imaginative youth, he not only observed and learned but had the ability to retain information in different contexts. In his formative years he visited, and possibly was educated in, the nearby city of Burgos, where he was exposed to the creation of two altar screens in the cathedral, the last of which was dedicated in 1735 when he was seventeen years old.[8] Many years later, on a new continent, he recalled the forms and designs of the altar screens and applied those ideas to his own work. He left Spain sometime between age seventeen and twenty-seven and is placed in Chihuahua in 1741.

On May 20, 1741, in the church of the presidio of Janos in the Province of Chihuahua, Miera married María Estefánia de los Dolores Domínguez de Mendoza, who was born in Janos in 1723 and eighteen years old at the time. She was descendant of an early New Mexican family that chose not to return to New Mexico after being exiled during the Pueblo Revolt of 1680. In 1742, Estefánia gave birth to their first son, whom they named Anacleto.

The fact that his wife grew up in Janos in Chihuahua and they celebrated their nuptials in the presidio's church indicates that Miera had embarked on a military career. How long he was stationed in Janos before his marriage is unknown, although we can assume that he arrived there at least a little time

before his marriage. However, he did not stay in Janos long after the birth of his son, for within the year he transferred to El Paso del Norte, where he resided in Guadalupe del Paso, one of the four communities near the mission, described by one inspector as villages for Christianized Indians. There, in 1743, Manuel, the couple's second son, was born.[9]

Miera and his family would spend the next twelve years in the El Paso area, where he rose to the rank of captain in the militia and went on a number of expeditions and made his first known maps. In the summer of 1747, he accompanied Fray Juan Miguel Menchero to the Mount Taylor area in northwestern New Mexico. They started up the Camino Real following the Rio del Norte. Just north of Robledo, the last camping spot before embarking on the Jornada del Muerto, they turned west to skirt the southern edge of the western mountains. They turned north into the Mimbres Valley, where they noted that the Apaches grew corn. They continued to the Gila River, which they followed downstream, noting its tributaries. Then they turned north again, where they encountered another mountain stream that they named the San Francisco River. They followed it downstream in a northerly direction, eventually leaving it for a relatively easy overland ride to Zuni Pueblo. From there they explored the area of Mount Taylor and stopped at Acoma Pueblo before returning via Isleta Pueblo on the Rio del Norte. Presumably, Miera, if not Father Menchero, returned to El Paso by taking the Camino Real south. Whether or not Miera lingered in the north is not known. We do know that Menchero arrived at Isleta Pueblo in December 1747, and we can assume that Miera was still with him.[10]

As a captain and mapmaker, Miera played an important role in the expedition to Mount Taylor, and information gained would be included in subsequent maps that he drew. Sadly, the map he made of the journey did not survive, although one credited to Menchero did.[11]

Upon Miera's return to El Paso, Captain Rubén de Solis asked him to join on an excursion down the Rio del Norte, offering to pay Bernardo eight pesos per day, which the cartographer refused to accept, instead agreeing to accompany Solis out of dedication to his king and country.[12] The trip west from El Paso took place in 1748 and, upon its completion, Miera created what would become the first of his identified maps, one that accurately detailed the area from El Paso del Norte downriver to the confluence of the Conchos River.

In 1751 Governor Tomás Vélez Cachupín carried out a mandatory inspection of New Mexico at its southern border. Vélez had been in New Mexico for two years and already had set in place an Indian policy that had brought a tenuous peace to the area. The attrition of warfare, though, would eventually lead to the defeat of the military, so Vélez sought to negotiate a settlement that took into account the underlying reasons for the Indian raiding. His methods included attending the annual trade fairs to assure that the Indians were not

cheated. He even had his own soldiers protect Comanche horses to make sure that they were not stolen.

Vélez also worked to assist Father Menchero in his goal of establishing four missions among the Navajos and, two years later, in 1753, in legalizing trade with the Hopis. Before his expedition with Miera, Menchero had traveled the Navajo country from the San Juan River south to Cebolleta Mountain, where he visited the scattered Native *rancherías* and baptized children. Menchero's work with the Navajos fit perfectly with Vélez's policies.[13] Miera no doubt listened with interest to Menchero's ideas during their expedition. Conversely, Vélez surely heard from the friar that Miera was a man of some skill.

Thus, in 1751 Vélez traveled south to El Paso to begin his tour of inspection at New Mexico's southern presidio. Although there is no record of him meeting Miera, one can imagine that the governor would have sought out the experienced mapmaker and possibly studied his maps. The governor spent the rest of 1751 and into the next year on his tour, completing a report of the journey in 1754 that included population figures and description of the seven *alcaldías* that divided New Mexico. He also recommended something upon which Miera would focus in his later maps—the establishment of settlements between El Paso and the northern settlements.[14]

How Miera attracted the attention of Francisco Antonio Marín del Valle, Vélez's replacement, is unknown. The new and recently married governor was in Mexico City the year of his appointment in 1754.[15] They most likely met as the new governor's entourage progressed north through El Paso. Perhaps the new governor was impressed with a man who came from the same general area of Spain, and he was likely impressed with Miera's mapmaking ability. The governor had instructions from the viceroy to carry out an inspection and have a map created of New Mexico that included the "particulars of mountains, mines, new discoveries, presidios and missions, the tribes that live around them, and the distances between places." No other maps of New Mexico existed, and Miera was the only person in the area who could create one. By 1756, he had completed a map of southern New Mexico dedicated to the governor. It seems that the governor lured the mapmaker north with a promise of an appointment to be the alcalde mayor of the Galisteo and Pecos district.[16]

Marín del Valle went to New Mexico with certain biases. He openly disliked the Franciscans and wanted them replaced either by Jesuits, for whom he had an affinity, or secular priests under the authority of Durango. He apparently also did not understand the Indian policies of his predecessor, as can be seen from Miera's appointment to be the alcalde mayor to the Galisteo and Pecos district. Former Governor Vélez had recommended that the alcalde mayor he had named not be replaced, explaining that this alcalde mayor was trusted and "greatly loved by the Indians."[17] Apparently, Marín del Valle could see nothing

good about being loved by Indians, for he ignored his predecessor's advice and appointed Miera. For the next four years, Miera, now charged with aiding the missionaries and protecting the Christianized Indians of his district, led punitive expeditions against the Comanches,[18] in the process claiming to have made another map, which has been lost.[19]

In addition, in 1757, the governor granted Miera what must have seemed an odd request—permission to recast two antiquated breech-loading cannons, thus creating two new, more usable weapons. The governor probably was not surprised when Miera failed in the effort.[20]

In 1757, the governor selected Miera to accompany him and the Father Custodian Fray Jacabó de Castro, the head of the New Mexico Franciscans on his obligatory inspection. The entourage traveled roughly two hundred and fifty miles down to El Paso to begin the inspection, touring throughout New Mexico over the next five months, with Miera traveling with his quadrant and compass in anticipation of compiling another map of New Mexico. They would not return to Santa Fe until December 1. Outside of his report and the map that Miera compiled, the trip was notable for the governor's hostility toward the Franciscans.[21]

The trip gave Miera an opportunity to visit all of New Mexico. He knew the El Paso area and the region between El Paso north to Santa Fe, as he had traversed the Camino Real from El Paso north four times. He was also familiar with western New Mexico from the Gila country north to Zuni Pueblo and the Plains. With this knowledge he created an elaborate, illuminated map of New Mexico dedicated to Marín del Valle. Miera then made color copies; the differences between them are seen in figure TK. For the first time he mentioned Comanche Indians and possibly made the first illustration of a Comanche (see figure TK).

One curiosity of this map by Miera is that he accurately located and placed the ruined pueblos and missions east of the Manzano Mountains.[22] This would be the last time he did so for, while making his copies to be sent to various important personages, the governor got him involved in another project. For some unknown reason, despite his previous hostile actions toward the Franciscans, Marín del Valle searched for and found the remains of Fray Gerónimo de la Llana.[23] During his research, which may have included Miera, the names for Tajique and Quarcú pueblos were reversed. Miera was close enough to the search to repeat this error on all his subsequent maps.[24]

At least two presentation copies of Miera's map were commissioned in Mexico City around 1760, produced as oil paintings on linen. One was found in Spain and purchased for the Palace of the Governors History Museum in 1977.[25] The dedication reads: *"Mapa de esta parte interna de la Nueba Mexico que yo Dn Bernardo de Miera de Pacheco leineé por Orden de el Sor Dn Franco Antonio Marin de el Valle Gov. y Capt Genl de este Rein."*[26] Miera claimed that the second presentation map of 1760 was sent to Bishop Don Pedro Tamarón. This map, then, was

passed on to Nicolas Lafora, the Marqués de Rubí's engineer. In 1986 that map was lost; however, it was subsequently discovered in the Museo de Virreinato in Topotzotlan, Mexico. This map is an exact copy or vice versa of the map named above.[27]

Governor Marín del Valle devoted the last years of his administration to leaving a legacy. He paid for the land and construction of a new military chapel on the south side of Santa Fe's plaza named Nuestra Señora de la Luz that would replace the old military chapel in the presidio to be completed in 1761.[28] He commissioned Miera to create the church's altar screen that resulted in the cartographer's most significant artistic project.

Construction of the church progressed, and Miera worked on his stone altar screen. In the summer of 1760, by arrangements that are lost to history, Bishop Pedro Tamarón y Romeral visited to dedicate the church.[29]

In the construction of the church Marín del Valle spared no expense. Although it is not known exactly how much was paid for the church and the confraternity's establishment, more than a decade later Fray Atanasio Domínguez gave a hint in his official report, beginning with a capital fund of 530 ewes.[30] corroborated by Bishop Tamarón.[31]

A white stone was quarried eight leagues north of Santa Fe to the left of the old road a couple of miles north of Nambé on land owned by Vicar Roybal's brother, hinting at the probability that the stone was donated.[32] Miera carved the altar screen in sections, block by block. As he finished they were brought together inside the church. The whole work was originally painted and must have been even more impressive than it is now.[33]

Here is where an interesting convergence comes together, for Governor Marín del Valle's search for the remains of two early missionaries was successful. He located and disinterred the remains of Father Asencio de Zarate and the aforementioned Father de la Llana. The former died and was buried in 1632 in the old mission church at the time in ruins at Picurís Pueblo. The latter died and was buried in 1659, in theory, at Quarac. The governor had the remains of both men transported to Santa Fe and kept with deep veneration at the *casas reales*. The remains stayed there for four and five months respectively. Meanwhile, the governor ordered that a double-chambered tomb be made, which was done from the same stone being used for the new church's altar screens. The crypt of twin chambers was carved out of one stone block. The chambers took two lids cut from the same stone that were beveled around the edges to fit the chambers.[34]

Miera y Pacheco probably carved the crypt and its fitted lids while working on the altar screen. His involvement with the two projects is more revealing in that the tomb contains detailed descriptions of its contents both on its outside and on the underside of each lid. The writing gives brief biographies of each priest and that the "Lord don Francisco Antonio Marín del Valle, Governor and

Captain-General of this Kingdom . . . did the kindness of paying for this sepulcher."[35] The handwriting has the telltale characteristics of Miera y Pacheco.[36]

The reburial took place in September of 1759, apparently to celebrate the centennial of Father de la Llana's death. The remains were marched with a military escort to Santa Fe's *parochial,* or parish, church, where after a solemn mass officiated by the leaders of New Mexico's Franciscans, they were reinterred. Miera y Pacheco's involvement with the whole episode is further evidence that he also did the altar screen.

Bishop Tamarón arrived in Santa Fe early summer of 1760. Marín del Valle's church was months from completion. Nonetheless, after consulting with Tamarón, the governor presented the constitution of the Our Lady of Light confraternity to the bishop. Two days later, on June 5, he convened the religious society and, with Tamarón present, was elected the first *hermano mayor,* or president, of the organization. Miera became the organization's first secretary.[37] Each individual paid two pesos to become a member. Sixteen years later the confraternity was described as the richest such organization in the land.[38]

The Our Lady of Light Chapel was finally completed on May 24, 1761. Presumably, Miera attended the dedicatory mass with a great sense of satisfaction. However, mysteriously the upper portion of the altar screen, as well as the altar that contained a relief of Saint Anthony also by Miera, appear incomplete in nineteenth-century photographs. Whether it was intentionally left incomplete or was, in fact, completed and violated later is unclear.

After Marín del Valle left New Mexico, Miera's mapmaking work ceased for at least the next sixteen years. During this hiatus he apparently had contact with the different governors who rotated to New Mexico. In 1762 Governor Vélez, in New Mexico for a second term, appointed him alcalde mayor for the Keres district, a position he held for the duration of Vélez's term from 1762 until 1767. Whether or not his new political appointment necessitated any new punitive expeditions against the Indians is unknown. However, it is apparent that Miera was involved in ranching during this time, as in 1768 he joined with Pedro Padilla to successfully petition Governor Pedro Fermín del Mendinueta for a land grant in the Keres alcaldía, needed to adequately maintain their growing herd of cattle.[39]

Most likely Miera concentrated on cattle raising and art throughout these years. The poor state of New Mexico's missions and churches no doubt gave him an outlet for his art and a way to earn income. At some point, maybe in El Paso or even Janos, Miera began carving religious statues and painting religious figures, some believing that the canvas of San Miguel in Santa Fe's San Miguel Church was completed sometime before 1760. In New Mexico, people with means began commissioning him to create works then donated to spe-

cific churches. For example, Salvador Garcia de Norriega, a captain, alcalde, rancher, and contractor of church construction, hired Miera more than once to create works of art that he donated to churches.[40] If the later criticism from a visiting priest that Miera overcharged for his work is true, then it seems that he also took commissions from the friars.[41] In any case, Miera's art was installed in churches throughout New Mexico, from as far away as Zuni Pueblo to Nambé and San Felipe.

Not until the young, recently ordained Fray Silvestre Vélez de Escalante came to New Mexico with a desire if not explicit instructions to work with the Hopis and study a route to the recently settled Upper California capitol and port of Monterey did Miera become active again as he had been under Marín del Valle's patronage. Father Escalante, first noted at Laguna Pueblo in late 1774, moved to Zuni Pueblo in 1775 at the age of twenty-four.[42] Distant Zuni Pueblo, the last western bastion of Christianity seventy-five miles from Acoma Pueblo and fifty from Isleta Pueblo and a place of exile where priests and citizens alike could be sent for punishment, was under almost constant threat of attack from Gila Apaches and Navajos.[43]

Father Escalante went to his Zuni assignment with an additional purpose. He wanted to contact the Hopi pueblos and study the possibility of a connection between New Mexico and California through Zuni. He also was interested in a route to Sonora through Zuni.[44]

Consequently, on June 22, 1775, six months after his arrival, Father Escalante set out with a small party to undertake the dangerous but relatively short journey to the Hopi pueblos. His party consisted of the alcalde of Zuni, an interpreter, and an escort of seventeen Zunis. [45] Some historians have argued that Miera went on that trip, but Escalante's diary of the trip makes no mention of him. However, it is entirely possible that he may have gone to those distant pueblos on some other undocumented trip.[46]

From Escalante's point of view, the trip was a disaster. The Hopis treated him rudely, and he was offended by a ceremony that he witnessed. He returned to Zuni on July 6 convinced that only war would subdue the Indians. He had been gone only a couple of weeks but had learned much.[47]

Some of Miera's activities during this time were documented by Escalante. On August 18, the friar wrote plans for an exploration beyond the Hopi mesas, recommending that Miera go along on the trip.[48] Then a few months later, on October 28, Escalante wrote to Governor Mendinueta about his conversation with Miera in which Escalante recommended a road connecting Sonora to Zuni,[49] also providing evidence that the mission church at Zuni Pueblo had more than a few pieces of Miera's artwork. Escalante apparently commissioned Miera to carve two wooden images of the archangels Michael and Gabriel. He also carved some pilasters with cherub heads, as well as a small relief plaque of the Sacred Heart. These pieces were in the church in November 1776, which

means that they were completed before July of the year.[50] It seems probable that Miera traveled to Zuni to fulfill his commission and met with Escalante.

On March 22, 1776, Fray Francisco Atanasio Domínguez arrived in New Mexico with instructions to make a detailed report on the status of New Mexico's missions and missionaries and to look into the possibility of new routes to connect the northern provinces. A stern man with definite biases and little sympathy, he wasted little time with either of his mandates and found little in New Mexico that agreed with him, including some of the Franciscans who complained to his superiors.

Within a month after Domínguez's arrival in Santa Fe, he summoned Escalante to the capital to discuss the route to Monterey. Escalante entered Santa Fe on the evening of June 7.[51] The two men conferred with Governor Mendinueta, gathered supplies, found volunteers, horses, and a scout and prepared to travel northwest up the Chama River Valley. Miera, by now a retired militia captain, joined them not as expedition leader, as some might have suggested, but as its mapmaker. On the day of their departure, Father Escalante felt obliged to clarify the expedition's objective in a letter sent to his superiors in Mexico—that they did not expect to get to Upper California for it was too distant and would instead explore beyond the Tizón River as well as the lands of the "Cosnina" Indians, who lived beyond the Hopis. In recommending Miera for the mission, he "[Miera] would be useful to us as one of those who were to go, not to command the expedition, but to make a map of the terrain explained. And I state that only for this do I find him useful."[52] There is some indication in these words that Miera had lost favor with some, such as Mendinueta and Father Domínguez, but he but was the only cartographer in the land.

As Escalante had predicted, the expedition never got close to California. Using his compass and quadrant, Miera took at least fifteen astronomical observations for direction and latitude. On seven occasions he fixed the expedition's position by the sun and eight times by the north star. His readings, as recorded in the expedition's journal, were always a little high.[53] The expedition meandered up through northwest New Mexico and western Colorado before turning west to the Utah lakes around the present site of Provo, Utah, then from there turned southwest. With the onset of winter, and with dwindling supplies, Father Domínguez announced that it was time to turn back by heading south, southeast toward "Cosnina" and then to the Hopi mesas.

Miera, the oldest, and no doubt considering himself the most experienced member of the group, had been exerting himself. Escalante noted that they had changed course many times "at the importunities of Don Bernardo Miera." At one time, as they wondered through Summit Canyon in southwestern Colorado, Miera took off by himself to find a way out. Much to the consternation of the priests, he succeeded without getting himself lost. As a result they named the canyon "El Laberinto de Miera," Miera's Labyrinth,

because of the varied and pleasing scenery of rock cliffs which it has on either side and which, for being so lofty and craggy at the turns, makes the exit seem all the more difficult the farther one advances—and because Don Bernardo Miera was the first to go through it.[54]

Returning by way of the Cosnina (Havasupai) Indians, they tested the trail that Escalante had hoped to explore on his earlier trip to Hopi and that they knew Fray Francisco Garcés had traveled before them in the spring and summer of 1776.[55]

Bad weather and the fact that they would soon have to resort to eating a horse almost every other day was not enough to stop the grumbling by those who thought the expedition should continue to California. The men started traveling separately from the priests, who "came alone very peevishly: everything was extremely onerous, and all unbearably irksome." Finally, Escalante wrote that "we decided to lay aside altogether the great weight of the arguments . . . to search anew God's will by casting lots – putting Monterey on one and Cosnina on the other," agreeing that if Monterey won "there was to be no other leader or guide than Don Bernardo Miera, since he believes it to be so close and everything started from his ideas." The lots were cast, determining that they would go to Cosnina.[56]

The men, including Miera, accepted "God's will," although apparently there were still hard feelings, for the band continued to travel in two separate groups, coming together only at the campsites, water holes, and to care for the sick, such as when Miera had stomach problems. They became delayed in the tangle of the Grand Canyon's side canyons, but finally, with the help of local Indians, one group of which was bearded, they crossed the great chasm and found their way back to the Hopi pueblos and then on to Zuni, where they arrived in late November in a snowstorm.

Domínguez and Escalante stayed at Zuni Pueblo until December 13, refining the journey's diary for a report that would be delivered to the governor and sent to their Franciscan superiors in Mexico. They finally reached Santa Fe on January 2, 1777, having completed an epic journey of 1,700 miles. The next day they signed and presented their report.[57] Apparently, they did not consult with nor allow Miera to review the report. His job was only to compile an accompanying map, which he was in the process of doing.

However, perhaps suspecting that some of their disagreements on the trail had been described in the written record, Miera prepared more than the map. He had an opportunity to make his case personally. He finished his map sometime before May of that year, for Governor Mendinueta sent a dispatch containing the diary, a report, and the map to Teodoro de Croix, the newly named and first commandant-general of the newly created Internal Provinces who was on his way from Spain to Mexico City.

The map received a wide reception, for, although the original has been lost, at least five variations are known to have been made and dispersed, three dated 1778 and two undated. One of the last two is in Miera's own hand.[58] Miera did not limit himself to cartographic information but also included ethnographic as well as political details and comments. One example is a drawing of a bearded Indian in the location where the expedition encountered such Indians.

Meanwhile, word came that the new commandant-general would hold meetings in the north, to which Governor Mendinueta, as well as the governors from the other provinces and leading citizens, would be invited. Croix's proximity to New Mexico was an opportunity that Miera apparently could not overlook. Probably late summer 1777 he headed south to attend the meetings. In anticipation of them he wrote two late letters and a "memorial,"[59] noting that he hoped to deliver one of the letters to the commandant-general personally. In June of the following year the meetings were held. Also attending were Anza of Sonora, Barai of Nueva Vizcaya, Urgarte of Coahuila, most of the presidio captains of Nueva Vizcaya, and a number of prominent citizens.[60]

In context, Miera's seemingly brazen actions in preparation for the meetings make sense. He had tried the northern route to California, been through the Gila barrier, mapped all of New Mexico in detail, laying claim to having been the first person to locate and illustrate Comanche Indians, the subject of which became a focus of the meetings.

His letters summed up his feelings about the plans for the Internal Provinces. He wrote that the king should invest in six presidios with settlements. The first one should be located by the Lake of the Timpanogos, in northern Utah, another between there and the Grand Canyon, and a third at the confluence of the Gila and Colorado rivers. This, he argued, would create a new interior civilization, convert many souls, and strengthen the king's effort in California. He apparently still operated under the misconception that California was closer than it actually was.

He also argued that the Gila Apaches needed to be subdued and that this could be done by establishing three more presidios with mounted companies, located on the Gila River where it emerged from its canyon, the Mimbres Valley, and on the Rio del Norte at the rest area of San Pasqual, just south of Socorro. These settlements, along with the subjugation of the Hopis, would, he stated, bring peace and posterity to the northern frontier.

In regards to the Hopis, he agreed with Escalante that only war would subjugate them, noting that they were a prosperous, resourceful people and that the war would be limited, for all that was necessary would be to lay siege at the base of their mesas by their water holes to cut off their water source. Then, he concluded, some of the Hopis could be moved north to one of the two new settlements (in Utah).[61]

Along with the letters, Miera wrote to the king and Croix, including an undated memorial in which he listed his life's exploits and accomplishments and asking for honors and promotions for himself and his oldest son Anacleto.[62]

However, nothing came of the effort. He returned to Santa Fe to receive yet another governor, Juan Bautista de Anza, who, unlike the previous governors, had grown up in Sonora and negotiated with Native Americans, led expeditions, and had been a politician and a career military officer. He also was very familiar with Upper California, for he had helped settle the area and open a trail there from Sonora.

Anza came to New Mexico as part of the new reforms, with an agenda to shore up New Mexico's defenses and solve the Comanche problem. Miera would be of help in both matters, for Anza wanted information and maps. First, Miera created a detailed map of the Rio del Norte in southern New Mexico with some detail of the Gila area but more importantly detail of the Camino Real and its camping locations roughly a day's travel from each other.

Miera used the opportunity to print on his map his belief that the proper place for a new presidio was not Robledo, a place that had been under consideration for more than a few years and an idea that both Anza and Croix had considered.[63] In a change of mind from his correspondence to the king and Croix, Anza came to believe that the presidio would be better placed further south at "La Mesilla" across the river from "La Ranchería Grande." This map also served as a perfect complement to his 1749 map of the river south and west from El Paso.[64]

Then the governor commissioned Miera to draw a new, more detailed map of New Mexico that showed abandoned towns and pueblos, enemy habitats, population figures, and trails. Apparently Miera worked closely with Anza for the new map, echoing the governor's observations that none of New Mexico's towns much less Santa Fe were built for defense. On the map Miera wrote about a Comanche raid that had taken place at San Fernando de Taos in 1760. The people

> . . . were warned that the Comanches were coming to attack them.
> They all took refuge in a great house with large towers belonging to
> Pablo de Villalpando – fourteen men with firearms and much ammuni-
> tion. The enemy attacked . . . they all perished, and sixty-four persons,
> large and small of both sexes, were carried off. Of the enemy more
> than eighty died. I include this story to show the constancy with which
> these enemies fight.[65]

This map became Miera's most famous, for it was the most detailed map of New Mexico in the Spanish Colonial period, copied at least four times. Its information would permeate future maps. Anza sent it to his superiors with a report and, no doubt, followed it for his many campaigns, for it indicated the problems besetting the settlements and illustrated methods necessary to correct the situation.[66]

Anza's most famous New Mexican campaign took place in 1779 when he led an army up the west side of the Rio del Norte before finding a pass through

the eastern ridge of the Rocky Mountains to the Plains, where he surprised and defeated Cuerno Verde, the great Comanche leader and scourge of northern New Mexico. This battle led to a peace that lasted into the next century. A map attributed to Miera was completed that same year, recording Anza's campaign with his campsites identified by tipis and the two battle sites marked by flags. This map was also the first to attempt to accurately place the source of the Rio del Norte.[67]

Little is known of Miera's activities after 1780. He most likely stayed active in the Our Lady of Light confraternity and probably continued with his art. Both his sons married and joined the military. He had at least four grandchildren. On December 13, 1783, Estefánia died. She had been with him for at least forty-one years. She was buried in the Our Lady of Light Chapel, and sixteen months later, on April 11, 1785, Don Bernardo Miera y Pacheco, seventy-four years old, joined his wife in death and was buried before his greatest work of art in the same chapel.[68]

Sadly, in the second half of the nineteenth century the Castrense, as the Our Lady of Light Chapel came to be called, fell into disrepair. The roof collapsed, the floor filled with debris, and human bones became exposed, perhaps including those of Miera. The once proud chapel was sold and eventually replaced with stores. The stone altar screen was transferred to storage in the cathedral and eventually installed at Santa Fe's Cristo Rey Church. The remains of Miera are forever lost, but his legacy lives on.

His work is found in museums and archives, and within the century after his, the following occurred:

• In 1829–30, the Old Spanish Trail opened, following the Domínguez-Escalante route into Utah and continuing to California at about the place where Miera complained about Domínguez's decision to turn back.

• In 1847, Brigham Young saw the same potential in the same land by the "Lake of the Timpanogos," fulfilling Miera's hopes of establishing a colony there. Coincidentally, Young and his associates also had the idea of connecting the area to California.

• In 1850, a group of migrants settled along the Rio Grande at La Mesilla, the location where Miera had recommended a presidio and settlement be established.

• In 1851, the United States established Fort Conrad, which became Fort Craig on the Rio Grande just south of the old camp spot of San Pasqual, where Miera had recommended a presidio be located.

• In 1865, a fort was established at Robledo, although it was not until 1866, with the capture of the Apache leader Gerónimo, that peace finally came to the Gila area.

• In 1866, Fort Bayard was established ten miles east of Silver City in the Gila Wilderness, roughly in the area where Miera had recommended a fort be built.

With these developments, in effect Miera's plan was put in place.

Additionally, Miera correctly placed the Continental Divide as early as the 1750s. Further, on ©1760 map he accurately placed a depiction of a fortified town with a French flag at the confluence of the Platte and Loup rivers and, explaining that this was where the French attacked a New Mexican contingent, he referred to a battle in which Pawnee and Oto Indians, allies to the French, had ambushed and defeated a New Mexican contingent in 1720. That battle took place over two decades before Miera arrived in New Mexico. Then, on a later different map he described the Comanche massacre of the Villalpando Hacienda in San Fernando de Taos. One of the sixty-four captives was a young woman named María Rosa Villalpando, who, many years later, surfaced in St. Louis and lived to old age, with her age and history becoming the subject of a legend that Josiah Gregg wrote about in his famous book *Commerce of the Prairies* in 1844.[69]

Numerous historians have remarked on Miera's many activities and qualities, adding to his legacy. Although disparaged by Father Domínguez,[70] a latter-day historian wrote that Miera was "a talented amateur who possessed a fine eye for detail and enough technical skill to transfer his knowledge clearly and charmingly."[71] Another added that he was "a prominent citizen who was never quite as prominent as he wished".[72] He is a man who is more than meets the eye, and we still have more to learn from and about him.

Notes

1. Herbert E. Bolton, *Pageant in the Wilderness*, 13.

2. Lawrence Kinnaird, *The Frontiers of New Spain: Nicolas Lafora's Description* (New York: The Arnot Press, 1967); and Michael F. Weber, "The Cartography of New Mexico, 1541–1800" (master's thesis, University of New Mexico, 1968), 110.

3. Bannon, *The Spanish Borderlands*, 176.

4. Bannon, *Borderlands*; and Alfred Barnaby Thomas, *Teodoro de Croix and the Northern Frontier of New Spain, 1776–1783* (Norman: University of Oklahoma Press, 1941), 36–37. Miera wrote three famous letters that have survived from the Chihuahua area during this time. One was addressed to the king, one to Croix, and the other a "memorial." The two letters are dated 26 October 1777. The memorial is undated. All the originals are in the Ayer Collection, Newberry Library, Chicago, Illinois.

5. Fray Silvestre Vélez de Escalante to Fray Fernando Antonio Gómez, 18 August 1775 in Eleanor B. Adams and Fray Angélico Chávez, trans. and eds., *The Missions of New Mexico, 1776: A Description of Fray Francisco Atanasio Domínguez*

with Other Contemporary Documents (Santa Fe: The Sunstone Press, 2012 [originally 1956]), 304.

6. John Miller Morris, *El Llano Estacado: Exploration and Imagination on the High Plains of Texas and New Mexico, 1536–1860* (Austin: Texas State Historical Association, 2003), 197; *Atlas of Historic New Mexico Maps (*Albuquerque: New Mexico Humanities Council), on-line publication; and Carl I. Wheat, *Mapping the Transmississippi West*, 96, 122, 124, and 133–34. Chapter 6, 94–116, is devoted to Miera.

7. Fray Angélico Chávez, *Origins of New Mexico Families*; and Richard Flint and Shirley Cushing Flint with Rick Hendricks, "Bernardo Miera y Pacheco," New Mexico Office of the State Historian, on-line.

8. Donna Pierce, "The Life of an Artist: The Case of Captain Bernardo Miera y Pacheco," in *Transforming Images*; 135. Pierce's convincing argument lays out the scenario that Miera y Pacheco was around eleven years old when the first altar screen was dedicated and seventeen years old for the second altar screen. See her and Robin Farwell Gavin's article in this book for further details.

9. Chavez, *Origins*, 230; Flint and Flint, "Miera y Pacheco."

10. Frank D. Reeve, "The Navaho-Spanish Peace; 1700's – 1770's," *NMHR*, Vol. XXXIV, no. 1, (January, 1959), 17–18; and Vélez de Escalante to Governor Pedro Fermín de Mendinueta, 28 October 1775, in Alfred Barnaby Thomas, trans. and ed. *Forgotton Frontiers: A Study of the Spanish Indian Policy of Don Juan Bautista de Anza, Governor of New Mexico, 1777–1787* (Norman: Univ. of Oklahoma Press), 156. Father Vélez de Escalante described in detail all that Miera y Pacheco had told him.

11. Although the consensus is that Menchero did the surviving map, some have credited Miera. See Bolton, *Pageant*, 12. Michael Fredrick Weber, "Tierra Incognita: The Spanish Cartography of the American Southwest, 1540–1803," PhD diss. (University of New Mexico, 1986), 164 cites Miera "memorial" and states that the map has not been found.

12. Bolton, *Pageant*, 12.

13. Reeve, "The Navaho-Spanish Peace," 16–18; Robert Ryal Miller, ed., "New Mexico in the Mid-Eighteenth Century: A Report Based on Governor Vélez Gachupín's Inspection," *Southwestern Historical Quarterly* 79 (1975–1976), 166–81; and Thomas E. Chávez, *Quest for Quivira: Spanish Explorations on the Great Plains, 1540–1821* (Tucson: Southwest Parks and Monuments Association, 1992), 41–45.

14. Miller, "New Mexico in the Mid-Eighteenth Century," 166–81.

15. Rick Hendricks, "Governor Francisco Antonio Marín del Valle," New Mexico Office of the State Historian, on-line.

16. Weber, "Tierra Incognita," 164–65; Kessell, *Kiva, Cross, and Crown*, 50, 385; and Chávez, *Origins*, 230.

17. Vélez Cachupín, Instructions to Francisco Marín del Valle, 12 August 1754, quoted in Kessell, *Kiva, Cross, and Crown*, 385.

18. Paul Kraemer, "Miera y Pacheco and the Gila Apaches," La Crónica de Nuevo Mexico, 76 (July 2008), 1–2; and Kessell, *Kiva, Cross, and Crown*, 386.

19. Weber, "Tierra Incognita," 177.

20. "Petición de Dn Bernardo de Miera y Pacheco en que propone fundir cañones, 1757," original in the Bancroft Library, H. H. Bancroft Collection, New Mexico Originals as quoted in Weber, "Tierra Incognita," 168–70. Also see Chávez, *Origins*, 230.

21. Eleanor B. Adams, ed., *Bishop Tamarón's Visitation of New Mexico, 1760* (Albuquerque: University of New Mexico Press, 1954), 25–26; and Kessell, *Kiva, Cross, and Crown*, 385.

22. Kessell, *Kiva, Cross, and Crown*, 385; and Weber, "Tierra Incognita," 165–68.

23. Fray Angélico Chávez, "The Unique Tomb of Fathers Zarate and de la Llana in Santa Fe," *New Mexico Historical Review*, 40, no. 2 (April 1965), 101. Chávez postulates that Marín del Valle did it out of "Christian piety, and perhaps solicitude for preserving his memory." Maybe he wanted to make amends with the Franciscans for, as will be seen, Fray Jacobó de Castro became involved with the project.

24. Weber, "Tierra Incognita," 168.

25. The museum's director at the time, Michael Weber, located the map and raised the money for the purchase.

26. Original map is framed and hangs permanently in The Fray Angélico Chávez History Library.

27. Dr. Donna Pierce and the author "discovered" the map hanging in a stairwell of the museum. Dr. Julio Davila, a supportor of the Palace of the Governors State of New Mexico History Museum, arranged for a computer execution of an exact copy now in possession of the Palace of the Governors and housed in the Fray Angélico Chávez History Library.

28. Eleanor B. Adams, "The Chapel and Cofradia of Our Lady of Light in Santa Fe," *NMHR* 22, no. 4 (October, 1947), 329–333; and A. von Wuthenau, "The Spanish Military Chapels in Santa Fe and the Reredos of Our Lady of Light," *NMHR* 10, no. 3 (July 1935), 188–89; and Chávez, "Unique Tomb," 101.

29. Adams, ibid., 329.

30. Domínguez, in *Missions of New Mexico*, 246–48. "He established a capital fund of 530 head of ewes" and "out of his own pocket he bought the site where the chapel now stands; he made the altar screens of fine white stone; he sent to Mexico to have the canvas with the sovereign image of Our Lady of Light painted; he has given everything as shown in the inventory. . . . "

31. Adams, "Tamarón's Visitation," 46–47.

32. Adams and Chávez, *Missions of New Mexico*, 60 and 60n 7.

33. Adams and Chávez, *Missions of New Mexico*, vii, xi. The edition used here has a color restoration of the stone altar screen on its front cover. The original edition has the same image on its frontispiece.

34. Chávez, "Unique Tomb," 105, 107–08.

35. Ibid, 102, 106–16, for the original Spanish with English translations.

36. The author verbally confirmed this with Dr. Michael Weber some years ago. In his dissertation, Dr. Weber goes into detail about Miera y Pacheco's writing characteristics, both in his letters and on his maps and art. Most striking in this case is Miera's "fairly regular lettering but at times shows the poor spacing and planning that is characteristic of him." Weber, "Tierra Incognita," 179–181. The stone crypt can be seen in the west wall of the Conquistadora Chapel in Santa Fe's cathedral. The outside writing is exposed for all to see.

37. Adams, "Chapel and Cofradia," 329; Wuthenau, "Military Chapels," 186–88, 186 n 24. The citation has the whole printed constitution and record. Also, see Adams and Chávez, *Missions of New Mexico*, 247n 10.

38. Domínguez in *Missions of New Mexico*, 243–47.

39. Weber, "Tierra Incognita," 178.

40. E. Boyd, *Popular Arts of Spanish New Mexico*, 50.

41. Fray Francisco Atanasio Domínguez, as quoted in *The Missions of New Mexico*, 160. The irony here, of course, is that today people cannot pay enough for his art.

42. Adams and Chávez, *Missions of New Mexico*, xiv.

43. Kessell, *Missions Since*, 206.

44. Ibid., 206–07.

45. Ibid., 104–05.

46. Escalante's diary is translated and published in ibid., 118–38. For an example of a historian who claims that Miera may have been on that trip, see Bolton, *Pageant*, 12.

47. Escalante, "Diary," in Eleanor B. Adams, " Fray Silvestre and the Obstinate Hopi," *NMHR*, 38, no. 2 (April 1963),137.

48. Escalante to Fray Antonio Gómez, 18 August 1775, in Adams and Chávez, *Missions*, 304.

49. Escalante to Governor Mendinueta, 28 October 1775, in Thomas, *Forgotten Frontiers*, 155.

50. Miera was indisposed from the end of July until the end of November while he was on the famous Domínguez-Escalante Expedition. On its return, the expedition arrived at Zuni on November 24 and 25. Father Domínguez, who led the expedition, wrote up an inspection of Zuni on December 9 in which he mentioned the works of art subsequently attributed to Miera. See Domínguez in *Missions of New Mexico*, 198; and Kessell, *Missions Since*, 207–08 and 213–14, n 3.

51. Adams and Chávez, *Missions of New Mexico*, xv.

52. Escalante to Provincial Fray Isidro Murillo, 29 July 1776, in Adams and Chávez, *Missions of New Mexico*, 307.

53. The quadrant was the only instrument mentioned in the journal. It measures angular altitudes and consisted of a sighting mechanism with a plumb line or spirit level. The quadrant superseded the sextant. Ted J. Warner and Fray Angélico Chávez, trans. and eds., *The Domínguez-Escalante Journal: Their Expedition Through Colorado, Utah, Arizona, and New Mexico in 1776* (Provo: Brigham Young University Press, 1976), 44 and n44, 195; Bolton, *Pageant*, 12, 13, mistakenly claims he took an astrolabe.

54. Domínguez and Escalante, "Journal," in Warner and Chávez, *Journal*, 16.

55. Warner and Chávez, *Journal*, 292, n 71 and 111, n 20. Francisco Garcés had traveled from San Xavier Del Bac in southern Arizona into California and back south of the Grand Canyon to the Hopi pueblos. From Oraibi he composed a short report dated July 3, 1776, which he sent to Zuni, where Fray Mariano Rosete forwarded it to Domínguez and Escalante in Santa Fe. The two priests received the letter before they left on their own expedition. The letter is translated in Adams and Chávez, *Missions of New Mexico*, 283.

56. Domínguez and Escalante, "Journal," in Warner and Chávez, 73–74.

57. Domínguez and Escalante, "Journal," in Warner and Chávez, 115–18.

58. Weber, "Tierra Incognita," 179.

59. See note 4.

60. Actually, there is no hard evidence that Miera stayed in Chihuahua for the meetings or ever met Croix. Evidence that he was in Chihuahua comes from the address on his letters.

61. The two letters to the king and to Croix say the same things. As noted earlier, both are dated 27 October 1777. Also see Kraemer, "Miera y Pacheco and the Gila Apaches," 1–2.

62. Chávez, *Origins*, 230. Both of his sons ended up presidio soldiers, although the youngest did not enlist until 1779.

63. Weber, "Tierra Incognita," 184–87.

64. Map of the Rio del Norte from San Elizaro to the Paraje of San Pasqual, n d. reproduced in *Missions of New Mexico*, 268–69.

65. Map of the Interior Province of New Mexico . . . made by Order of Don Juan Bautista de Anza, 1779. Reproduced with translation in ibid., 2–4.

66. Weber, "Tierra Incognita," 187–90; and Wheat, *Mapping the Transmississippi West*, 120–24.

67. "Map of the Country Lt. Col. Don Juan Bautista de Anza governor and proprietary commander of this Province of New Mexico, traversed and discovered during the campaign he made against the Comanches and the victory he won over the enemy," 1779. Reproduced with translation in Kessell, *Kiva, Cross, and Crown*, facing 358; also see Weber, "Tierra Incognita," 190.

68. Chávez, *Origins*, 230 and 231n 8.

69. For the Villasur story, see, Alfred Barnaby Thomas, trans. and ed., *After Coronado: Spanish Exploration Northwest of New Mexico, 1696–1727* (Norman: University of Oklahoma Press, 1935), 26–38; see Thomas E. Chávez, ed. *A Moment in Time: The Odyssey of New Mexico's Sagasser Hide Paintings* (Albuerque: Rio Grande Press, 2012),142. For the María Rosa Villalpando story, see Thomas E. Chávez, *New Mexico: Past and Future* (Albuquerque: University of New Mexico Press, 2006), 90–91.

70. Domínguez in *Missions of New Mexico*, 160.

71. Weber, "Tierra Incognita," 192.

72. Kessell, *Kiva, Cross, and Crown*, 386.

Soldier-Engineer of the Greater Southwest: The Cartography

by Dennis Reinhartz

hen Don Bernardo Miera y Pacheco was summoned north from El Paso to Santa Fe to make maps and to become the *alcalde* (administrative judge) of the pueblos of Pecos and Galisteo by the Governor of New Mexico, Francisco Antonio Marín del Valle, in 1756, he had been an accomplished explorer, military engineer, and skilled cartographer for more than a dozen years. He had already executed several important maps, including those in 1747 of southwestern New Mexico and in 1749 of the Rio Grande Valley from El Paso downriver to where it is entered by the Rio Conchos near La Junta. A good deal of Miera's skill and reputation derived from the training he received in the distinguished Spanish Royal Corps of Military Engineers, in which he held the rank of a captain.

Who were these soldier-engineers that counted Miera among their most prominent members? The new and dynamic Spanish Bourbon Dynasty, whose ascendency in 1700 precipitated the War of the Spanish Succession, almost immediately sought to reform the crumbling empire that it had inherited. One of the most substantial aspects of this attempt at imperial rationalization for northern New Spain was the founding of the Royal Corps of Military Engineers in 1711. With the Seven Years War's end in 1763 the Corps became truly significant on the northern frontier of Spain's American Empire.[1] The first director general of the Corps, a Flemish nobleman, Don Jorge Próspero, Marqués de Verboom, also established the Royal Military Academy of Mathematics

in Barcelona in 1711. Thus, these soldier-engineers were to be well schooled in mathematics, field astronomy, and map making.

Near the end of the Seven Years War France ceded Louisiana to Spain, chiefly to thwart Great Britain, and thereafter Spanish fears of British penetration of New Spain and Spanish Louisiana rose substantially. A defensive reorganization of the northern frontier was deemed necessary, for which the Corps of Engineers undertook tours of inspection and exploration yielding extensive reports with attendant accurate maps that offered valuable data and observations and reaffirmed Spanish claims to the region. The trained engineers established the standards of scientific cartography for the era, surveying geographical details that could be observed directly and mapped precisely. [2]

The Cartography of Bernardo Miera y Pacheco

During the period 1743–1756, Miera was stationed at the presidio of El Paso, during which time he participated in at least five military operations against the Navajos and Comanches to redress the near-constant threats to Spanish settlements. One such mission involved the failed offensive led by Fray Juan Miguel Menchero in 1747 to convert and relocate some Navajos to Cebolleta near present-day Grants and their sacred Mount Taylor. This expedition, which journeyed north from El Paso then westward across the Jornada del Muerto to the headwaters of the Gila River and from there on to Acoma and Cebolleta, was ultimately unsuccessful while yielding a good deal of valuable geographical information for Miera's first two significant maps, of 1747 and 1749.

Not long after Miera arrived in Santa Fe in 1756, he was ordered by Governor Marín to assemble information for a comprehensive map of New Mexico covering in all six provinces of northern New Spain, at the behest of Viceroy Marqués de las Amarillas in Mexico City. Upon returning to Santa Fe in 1757–58, Miera drew the first of his remarkable maps of "the kingdom of New Mexico" (fig. 1). [3] It was approved by Marín and a copy forwarded to Mexico City. It must have impressed the viceroy, for he sent his praises of it to Marín and Miera.[4]

Miera's 1758 map, along with Marín's report that were sent to the viceroy eventually came to rest in the *Archivo General de la Nación* in Mexico City, where it remained until at least 1930, when it was photographed by Lansing Bloom, secretary of the Historical Society of New Mexico. In 1925, an *Archivo*-sanctioned, high-quality tracing of the map was made. But by 1951, the originals had disappeared and only an inferior reproduction of the tracing remained. Their fates remain a mystery.[5]

However, it can be assumed that Miera made copies of his map beyond the one destined for the viceroy. He surely made at least one for use by Marín

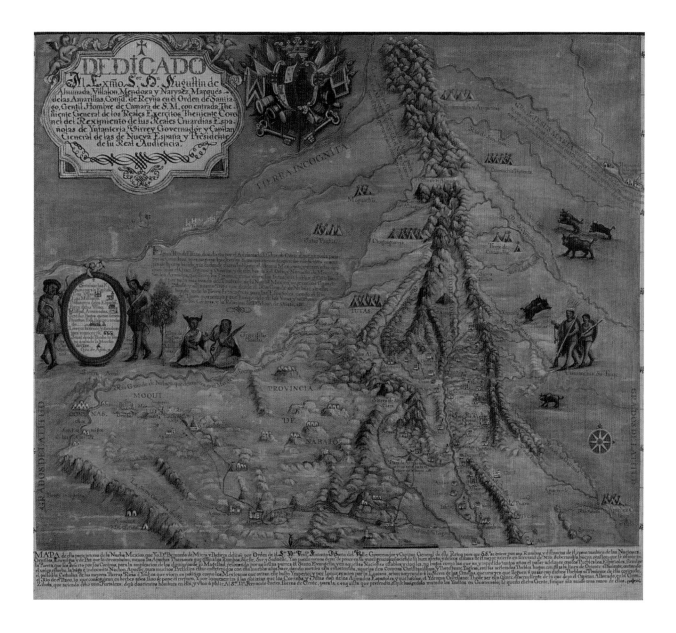

and his successors. There is also a presentation piece, an aged, darkened color oil painting on cotton cloth of the map, probably the work of Miera for Marín and dedicated to him (fig. 2). It was acquired by the Museum of New Mexico in 1977 and received extensive conservation. It currently hangs in the map room of the Fray Angélico Chávez History Library of the New Mexico History Museum in Santa Fe. A two-page reproduction of Miera's 1758 map, created in the late 1970s and based primarily on Bloom's pictures and other sources, has also been published (fig. 3).[6]

Miera's 1758 map shows New Mexico in the south from roughly thirty degrees latitude in northern Chihuahua to north of Taos, and in a somewhat

Figure 1

Miera y Pacheco, Map of Nuevo México, *ca. 1758, oil on canvas, 42 x 38 in. Museo Nacional del Virreinato, Tepotzotlán, Mexico.*

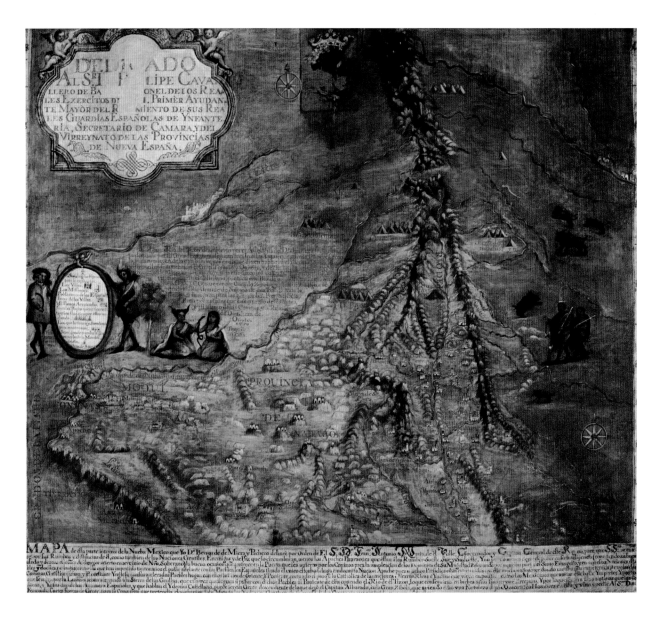

Figure 2

Miera y Pacheco, Map of Nuevo México, *ca. 1758, oil on canvas, 42 ½ x 39 in. New Mexico History Museum, Santa Fe.*

Santa Fe appears in the lower right. Miera made the drawing on which this painting was based.

Figure 3

Miera y Pacheco, Map of the Province of New Mexico, *1758, 32 x 26 in. Center for Southwest Research, University of New Mexico.*

This reproduction by S. Livingston of Miera's 1758 map is a 1977 tracing, slightly restored, based on photos from film of the missing original.

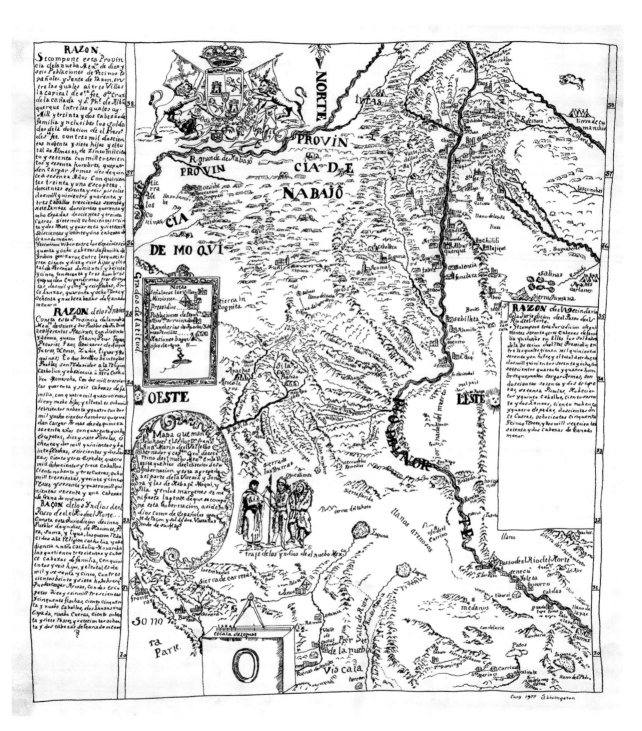

narrowed fashion in the west from the Hopi mesas east to the Pecos River Valley. As is typical of Miera's maps, this one shows latitudes but few longitudes, as at the time there was no fully accurate method of ascertaining them.

The topography—mountains and canyons, mesas, flatlands, and lakes—is rather generally portrayed and labeled. In addition to the Pecos, various other rivers, including the Colorado (*"R. grande de Nabajô"*) in the northwest and another *"R. Colorado"* in the northeast, and the Rio Grande, Puerco, and Chama, among others, are depicted. All the Spanish settlements are indicated, as are the domains of various Indian tribes, natural springs, churches according to actual configurations, and a basic guide to the map's symbols. The Spanish coat-of-arms adorns the upper left corner of the map, a buffalo is in the upper right above a nomadic Indian encampment, and three Indians are conspicuous above the scale.

On either side of the map are written descriptions discussing the Spanish citizenry and Indians of the "province of New Mexico," the "Indians of El Paso del Río del Norte," and the "citizenry of the district of El Paso del Río del Norte," in which, in typical fashion, we are told:

> This district is composed of 563 heads of family, including the soldiers of the garrison of the royal presidio, who among them have 1,561 children. The total of all is 2,568, with 744 men capable of bearing arms. They have 262 muskets, 70 pistols, 915 horses, 162 lances, 194 swords, 211 bluecoats, 855 head of cattle, and 2,772 head of sheep.[7]

These descriptions provide an invaluable written supplement to the graphics of the map and together afford a statistical inventory of human and animal resources and snapshot of life on the New Mexico frontier as gauged by Miera in 1758.

The map also reveals a good deal about the skill of its creator. Miera surveyed and bestowed his 1758 and other maps with the accurateness of an eighteenth-century scientist yet drew them with the aesthetic gift of an artist, as attested to by their design, style, iconography, and beauty. His cartography was a reflection of his complexity.

The painting of the map in the Chávez History Library in Santa Fe is closely derivative of Miera's original and was possibly done by him in about 1760. He was respected as an artist, but because the prototype map today exists only as a copy based on photographic images and tracings, it is not possible to determine positively if the painting is by Miera. It is quite similar in content but differs in style and configuration.

Miera again mapped the Rio Grande Valley in 1773, although little is known about its origins. It proposes presidio sites for protection against Indian raids.[8]

In 1776, Miera's cartographic abilities were again called upon when he was recruited out of his Santa Fe retirement as the senior member of a twelve-person expedition under the leadership of Franciscan friars Francisco Atanasio Domínguez and Silvestre Vélez de Escalante to find an overland route from Santa Fe to Monterey, California.[9] Domínguez had been sent from Mexico City in 1775 by the supervisors of the Franciscan province to inspect thoroughly the missions of New Mexico and to seek out the route. In 1773, the younger Escalante had been sent by the province leadership to minister to the needs of the Catholics at Zuni Pueblo. On one occasion, Escalante had made a journey northwest from Zuni to Moqui (Hopi), in northeastern Arizona, information from which Miera incorporated onto a map of the province that he executed in 1775.[10] Possibly it had come to Domínguez's attention that Escalante would be a valuable expedition partner, based on his knowledge of a region that would figure into their explorations. In the spring of 1776, they joined forces in seeking support for their expedition.

The Domínguez-Escalante Expedition departed on July 29, following water courses to the north/northwest of Santa Fe into Colorado surveying the San Juan Mountains and the San Juan, Dolores, Animas, Uncompahgre, and San Francisco Xavier (Gunnison) river valleys along the way, encountering the Anasazi site later known as the Escalante Ruins, and always sprinkling Spanish place names over the landscape as they went. They passed close to Mesa Verde but did not sight the massive cliff dwellings. Using local Ute guides, they traveled westward into Utah to Laguna de los Timpanogos (Utah Lake) and Laguna Miera (Lake Sevier) in Arizona[11] and then southward into a massive blizzard where, short of food and other supplies, in early October Domínguez and Escalante decided to turn back to Santa Fe. Although ill with stomach problems most of the way, Miera was among the dissenters. At one point in their journey, he had miscalculated that the Pacific Ocean was little more than one hundred miles to the west. But this may have been a knowing mistake, for he hoped to reap substantial personal profits from reaching the Pacific.[12] In the end, the final decision was left to God, with the members of the expedition casting lots with the outcome supporting Domínguez and Escalante.[13]

They journeyed further southward into Arizona for eighteen days to reach the Colorado River near Marble Canyon at what is now Crossing of the Fathers. What was left of the caravan reached Zuni on November 26. There they rested, the friars compiled their journals, and Miera likely refined his sketches for the impressive maps to follow. If only owing to the resulting Miera cartography, their trek deep into the Southwest cannot be deemed a failure. After traveling some 1,800 miles into country that was largely unknown to Europeans,[14] the Domínguez-Escalante Expedition finally reached Santa Fe on January 2, 1777, and, according to expedition journal entries, Miera and its

other participants recounted their many amazing experiences to the governor, Colonel Pedro Fermin de Mendinueta.[15]

In 1777 Miera created a major map, the *"Plano geografico…,"*[16] incorporating the geographical and anthropological data from the Domínguez-Escalante Expedition. The renowned Western historian Oakah Jones has cited it as "arguably one of the most important maps drawn of the American West."[17] It was sent by Governor Mendinueta in May, supplementing Escalante's *Diario Derrotero*, to the viceroy of New Spain, Antonio Maria de Bucareli, to whom Miera had dedicated the map. The receipt of these documents was acknowledged in July in Chihuahua by Teodoro, Caballero de Croix, the new *comandante general* of the *Provincias Internas* that encompassed the northern frontier of New Spain.[18] Miera also prepared a report to the king of Spain dated 26 October 1777, detailing his recommendations for the placement of future presidios to combat the Indian threat to western New Mexico, which probably was transmitted at a later date.[19]

In his *Mapping of the Transmississippi West*, the famed cartographic historian Carl Wheat points to at least six extant distinct manuscript copies of Miera's *"Plano geografico..."* in three variants, dating 1777–79, and located in several international repositories. The topographical information on all them is quite similar, but they do exhibit differences in "title, dedication, notes, and explanations, decorative or illustrated material and orthography of producers of copies. . . ." Furthermore, he suggests that determining exactly which of the copies were actually done by Miera is "problematical."[20]

The original 1777 copy believed to be by Miera (fig.4) and sent to the viceroy is presumed to be the one now in the collection of the British Library in London.[21] How it got there is unknown. It is generally undecorated, as one may expect given that it was prepared so promptly by an experienced soldier-engineer such as Miera, and forms a unique type unto itself. It shows many of the discoveries made by the fathers and Miera, including *"Laguna Miera"* and uses crosses on circles to mark the daily progress of the expedition.[22]

The fact that Miera previously had underestimated the distance from south-central Utah to the Pacific shows that he was not infallible, and so, too, on this map. The portrayal of Laguna de los Timpanogos in its northwest corner is based on a combination of his direct observations of what today is Utah Lake and accounts of the Great Salt Lake farther to the north he must have acquired from the Utes, Paiutes, and other Indians the expedition had encountered. As inserted comments on the map to the west of the lake hint at, he never saw the Great Salt Lake, and he thought it and Utah Lake were one and the same.[23] Despite this flaw, Miera's variant 1777– 79 maps offer the first European depiction of the Upper Colorado River Basin and the lakes and streams of the eastern Great Basin. These features and its topographical and anthropological notations cause Wheat to agree with Jones that the map is of "paramount

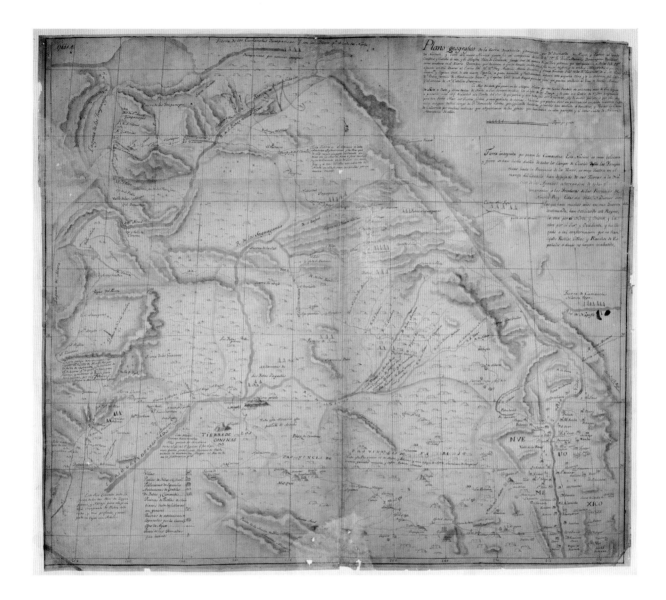

import and occupies a preeminent place among early maps of the American West...."[24]

One copy is known to exist of the "Tree and Serpent type" map that Miera executed during this period, so called for the edenesque rendering of a tree and serpent to the left of the title. It is located in the archives of the Ministry of War in Madrid and, too, is dated 1777. The dedication is to *"Caballero Croix,"* and it doubtless was made by a "professional copyist" for him in Chihuahua.[25]

There are four copies, one possibly done by Miera, of the third variety of the map, called the "Bearded Indian type," dating from 1777–1779. It derives its designation from the four Indians, two of them bearded men, shown to the west of the *"Rio de Zaguana"* (upper Colorado) above the junction with the

Figure 4
Miera y Pacheco, "Plano geográfico..." 1776, 32¼ x 27¾ in. British Museum, London.

"*Nabajo*" (San Juan) and due east of "*Laguna Miera.*" "*Los Barbones travichis*" (the bearded travichis), possibly Utes, is inserted on the northwest shore of the Laguna Miera where they were encountered and as part of the label under their picture. Bearded Indians were rarely come across, and there was a Spanish legend that they were descended from long lost and/or kidnapped Spaniards.[26] A "wholly-irrelevant" papal chariot is located in the upper right-hand corner of the map.[27]

After completing his map at the conclusion of the Domínguez-Escalante Expedition in 1777, Miera probably went back to his well-earned retirement. At this time he may have prepared a now unknown *plano* of Santa Fe.[28] But his respite was again cut short. In 1778, the new governor of New Mexico, Juan Bautista de Anza, initiated a series of campaigns (645 men and 1,500 horses) across northwest New Mexico and Colorado and into Arizona against the Comanches, requesting Miera to accompany him as his force's cartographer. At the close of the expedition, and only a little more than three years before his death in 1783 at the age of seventy, Miera drew the last of his three important New Mexico maps. Although somewhat compressed, it is the most militarily authoritative and least "arty" of the trio.

In the typically lengthy marginal explanatory title of the map,[29] "*Plano de la Provincia interna del Nuebo Mexico…,*" Miera lists himself as a "retired soldier" and the maker of the map in Santa Fe in 1779 under orders from Anza. A dedication to King Carlos III also appears elsewhere. It also has the now-standard Miera scale and symbol guide in the lower left quadrant. Today, it exists in four copies in two differently titled forms with similar contents. The second version is entitled "*Plan der Tierra que se andubo, y descubrio en la Campaña, que hizo Contra los Cumanchis, el Ilrte Colonel Dn Juan Bautista de Anssa, Governador, y Comand.te propietario de esta Provincia del neuvo-Mexico, y la Victoria que consego de los Enemigos.*"[30] Wheat believes the copy in the British Library to be the original by Miera (fig. 5).[31]

Miera's 1779 map had several other functions beyond merely extending a current representation of the province with its eight existing *alcaldías*, or judicial-administrative subdivisions—Santa Fe, Taos, Albuquerque, Sandia, Laguna, Zuni, and Santa Cruz de la Cañada. It of course recorded the route, campsites, and two battles of Anza's campaign against the Comanches and is a "significant map concerning the upper reaches of the Rio Grande above Santa Fe."[32] But perhaps most importantly it made the case graphically and with inserted written admonishments for the defensive measures against the Comanches and other raids that Anza tried to carry out along the northern frontier of New Spain. Kessell ventures correctly that Miera drew the map at Anza's command to demonstrate the "dispersed nature of Hispanic settlement and the Comanche threat."[33]

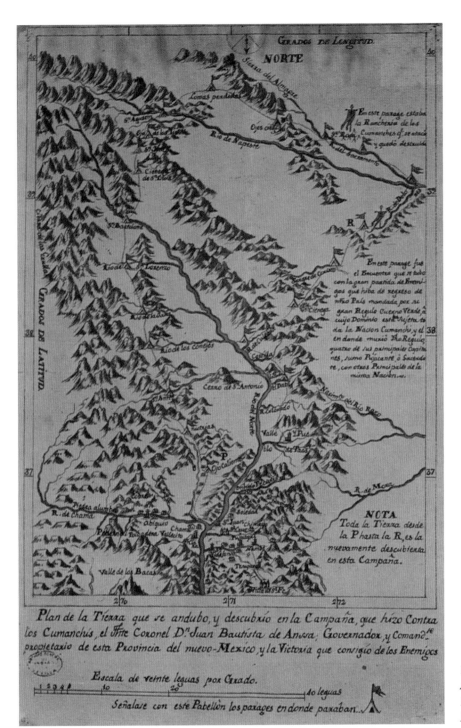

Figure 5
Miera y Pacheco, "Plan der Tierra…"
1779, 25 x 24 ½ in. Archivo General de
La Nación, Mexico City.

In his titular exposition, Miera notes the sorry state of the province's defensive posture "with its towns in their present condition, extremely ill arranged, with houses of their settlers scattered about apart from one another," specifically citing Taos. He goes on to say that as a consequence "there have originated many evils, disasters, and destruction of towns caused by enemy Comanches and Apaches . . . killing and carrying away many families." To begin to remedy this situation, Miera concludes this part of his commentary by saying that Governor Anza's proposed reforms "be placed in effect promptly and precisely," to wit "building their plazas in the forms of forts, each ample for at least twenty families, the small ones with two bulwarks and the larger ones with four, with walls between them because of the short range of the muskets that they use. It is not appropriate to have large towers as in the past, since beneath these the enemy takes cover, breaches them and sets fire to them. . . ." Here he cites the "pueblos of Christian Indians . . . with their two- and three-story houses joined together, forming plazas, and all the houses with portable ladders they pull up in time of invasion, and the roofs and upper and lower terraces with embrasures in the parapets for their defense and for offense against the enemy" as more positive examples from the pre-Spanish past in the area.[34]

The Indian threat was real and ongoing, and in the later eighteenth century it was a drain on Spain's already diminished imperial coffers. Therefore, in an effort to save some of the Crown's treasure and other valuable resources on the northern frontier, Anza proposed to consolidate the colonists, their homesteads, and their settlements more centrally, defensively away from the *acequias* (irrigation ditches) that separated them. Due to old habits and the exaggerated prospects of massive dislocation, there was resistance to Anza's reforms. Albuquerque and other settlements and even Taos were moving toward greater amalgamation, but yet other areas were ignoring the governor's orders outright.[35]

The Cartographic Legacy of Miera y Pacheco

When Miera died he knew more about the geography of the Greater Southwest than anyone before him, and he passed on that invaluable knowledge for others to learn from and build on in his magnificent cartography. He certainly shared copies of his maps with fellow Royal Engineers such as captains Nicolás de Lafora and José de Urrutia, and they with him.[36] Still, their discoveries and cartographic information were not shared extensively beyond government circles. Ever since the voyages of Columbus, Spain usually had the most in-depth and up-to-date knowledge about its parts of the Americas and their surroundings, closely guarded it as a significant "state secret" underpinning its New World Empire, and strictly censored its wider publication. Hence, well into the nineteenth century Tomás López y Vargas Machuca and his sons Juan and

Tómas Mauricio of Madrid, Spain's most successful commercial mapmakers of the era, while given access to government cartographic and other archives, were still forbidden to publish most of the data they found.[37]

A rare exception to the rule of Spanish state-enforced cartographic secrecy was made in the case of the German virtuoso intellectual Alexander von Humboldt. He was a naturalist, explorer, philosopher, diplomat, and author in the vein of Mikhail Lomonosov, Benjamin Franklin, and Thomas Jefferson, among others, who in 1799 was granted permits to access the imperial archives in Madrid, Seville, and Mexico City by the Spanish Crown, in preparation for a five-year visit to the Spanish Americas. Perhaps because of his international standing, these permits also carried no publication restrictions and only the obligation to prepare a summary report for the king upon his return. Some of the findings from this extensive journey were detailed in Humboldt's "Political Essay on the Kingdom of New Spain," published in Paris in 1809 and London, in English, in 1810.

Accompanying Humboldt's essay was his "magnificent cartographic achievement,"[38] the *Carte Generale du Royaume de la Nouvelle Espagne*" ("General Map of the Kingdom of New Spain"), a two-sheet (separating to the north and south at El Paso) masterpiece. In New Mexico, where Humboldt never visited, the debt owed Miera is clear by the watershed, Indian, and other information displayed, and it also is clearly acknowledged. He must have consulted Miera's 1777 *Plano geografico*...and Escalante's *Diario Derrotero* in Seville or Mexico City for in the white spaces of the north of the map there is a written reference, "*Velez y Escalante en 1777.*"[39]

Miera's cartographic impact did not stop with Humboldt. On his way back to Europe in 1804, Humboldt left a manuscript of his *"Carte Generale"* with his friend President Thomas Jefferson in Washington, DC. Among other documents, this copy or a copy of it was made available to Lieutenant Zebulon Montgomery Pike in preparation for his tour of discovery into the reaches of the southern Louisiana Purchase and northern New Spain in 1806–1807. The published account of Pike's expedition included several "master maps" of the American frontier, including "A Map of the Internal Provinces of New Spain" (Philadelphia, 1810).[40] In the far West, it also strongly reflects the work of Miera. Pike may have taken this information directly from Humboldt's sketch map, and/or he may have come upon it during his captivity in Chihuahua.

Pike and his men were apprehended by the Spanish near present-day Pueblo, Colorado, in February 1807 and taken via Santa Fe down the Camino Real to Chihuahua. In detention there, Pike was quartered with the Spanish New Orleans-born Juan Pedro Walker, a Royal Corps of Engineers officer and cartographer. Consequently, Pike, who secretly made notes and sketches during his captivity, may have gotten the Miera data from some of Walker's maps or even one of Miera's originals on display in Chihuahua.[41] Eventually, after some

serious negotiations Pike and his men were escorted from Spanish territory across Texas via San Antonio de Bexar to Natchitoches Louisiana.

Major Stephen Harriman, a soldier-engineer for the United States Topographical Bureau (founded in 1813), led an expedition to explore the Platte, Arkansas, and Red River valleys and the southern Great Plains into the Greater Southwest in 1819–1820. From his surveys and notes and other sources, including Pike, Long produced his large-scale map of the American West in 1820 and published under the title "Country drained by the Mississippi" (Philadelphia: 1823) in ten sheets. In its portrayal of the rivers and lakes of the Southwest and the Great Basin it echoed closely Miera. The future famous Santa Fe Trail is already designated as the "Great Spanish Road." He also labeled the land west of New Mexico as the "Great American Desert."[42]

Through the works of later prominent mapmakers such as Humboldt, Pike, Long, and others, the enduring Greater Southwestern cartographic, geographic, and anthropological legacies of the lesser-known Bernardo Miera y Pacheco reached far into the future. Unquestionably, cartography was one of his most consequential endeavors, and his maps provided some of the earliest and most reliable imagery and commentary on and understanding of the landscape, hydrography, and native inhabitants of the region. He aided in the exploration and mapping of the Great Basin along with key parts of what would become the Old Spanish Trail. This major pack train trade route linked Santa Fe to Los Angeles across the Spanish, Mexican, and American Southwest and helped to sustain Santa Fe and New Mexico from at least 1830 through the Mexican-American War into the late 1850s. With three great maps and numerous lesser ones, Don Bernardo Miera y Pacheco more fully revealed New Mexico than ever before to not only his Spanish contemporaries and king but to generations to come.

Notes

1. Janet K. Fireman, *The Spanish Royal Corps of Engineers in the Western Borderlands*, 27.

2. David Buisseret, "Spanish Military Engineers before 1750," 52–54; Fireman, 27–59; Jack Jackson, *Shooting the Sun: Cartographic Results of Military Activities in Texas, 1689–1829* (Lubbock: Book Club of Texas, 1998), I, 143; José Omar Moncada Maya, *Ingenieros militares en Nueva España: Inventario de su labor científica y especial Siglos XVI a XVIII* (Mexico City: *Universidad Nacional Autónoma de México*, 1993); John Miller Morris, *El Llano Escatado: Exploration and Imagination on the High Plains of Texas and New Mexico, 1536–1860* (Austin: Texas State Historical Association, 1997), 167; and Reinhartz, "Spanish Military Mapping of the Northern Borderlands after 1750," 60–75.

3. "Map which don Francisco Antonio Marín del Valle, Governor and Captain General of this kingdom of New Mexico, ordered drawn in conjunction with a tour of inspection he made of his jurisdiction, to which is added part of Vizcaya and Sonora and the provinces of the Navajo, Hopi, and Gila, and in the margins of which are set forth the people who compose this jurisdiction, Indians as well as Spaniards, non-Indians, and soldiers, all vassals of His Majesty," in John L. Kessell, *Kiva, Cross, and Crown*, 509.

4. Ibid. 385, 507–09.

5. The disappearance of the original of this important map sometime between 1930 and 1951 probably explains why no mention of the 1758 Miera map is made in Carl I. Wheat's monumental multi-volume *Mapping the Transmississippi West*, published in 1957. Wheat also seems to have been unaware of the existence of the painting of the map.

6. Kessell, *Kiva, Cross, and Crown*, 508–12.

7. Full translations of all the descriptions are provided at the end of Kessell's Appendix V; see Ibid. 512.

8. Wheat, *Mapping the Transmississippi West*, 90.

9. Although there is confusion among historians as to the exact number of members, generally ranging from ten to fourteen, in the expedition, in his report to the king of Spain of 26 October 1777 Miera states that "Indeed we were twelve persons in all…"; see Herbert E. Bolton, *Pageant in the Wilderness*, 243.

10. Spanish royal engineers regularly incorporated information from trustworthy Franciscan and Jesuit missionary accounts and maps into their official cartography, and Miera was no exception. See Alfred Barnaby Thomas, ed., *Forgotten Frontiers: A Study of the Spanish Indian Policy of Don Juan Bautista de Anza, Governor of New Mexico, 1777–1778* (Norman: University of Oklahoma Press, 1932), 378, n. 48, and Ralph E. Twitchell, "Colonel Juan Bautista de Anza, Governor of New Mexico: Diary of His Expedition to the Moquis in 1780," *Historical Society of New Mexico Papers*, no. 21 (1918), 12, n. 13.

11. Ted J. Warner and Fray Angélico Chávez, trans. and eds., *The Domínguez-Escalante Journal: Their Expedition Through Colorado, Utah, Arizona, and New Mexico in 1776* (Provo: Brigham Young University Press, 1976), 3–86.

12. Bolton, *Pageant in the Wilderness*, 87–89.

13. *The Domínguez-Escalante Journal*, 87–90.

14. David J. Weber, *The Spanish Frontier in North America*, 254–256.

15. Warner, *The Domínguez-Escalante Journal*, 91–143.

16. "Geographic map of the region discovered and surveyed by Don Bernardo de Miera y Pacheco toward the northwest and west of New Mexico, he having been in the party of the Reverend Fathers, Fray Francisco Atanacio Domín- guez, Visiting Commissary General and Overseer of it, and Fray Silvestre Veléz de Escalante, one of the ten persons who accompanied said Reverend Fathers, as set forth in the Journal they kept, the whole of which has been developed with the sole purpose of serving both Majesties. . . ." See full translation in Wheat, 100–101.

17. Oakah L. Jones Jr., "Spanish Penetrations to the North of New Spain," in *North American Exploration*, vol. 2, *A Continent Defined*, ed. John Logan Allen (Lincoln: University of Nebraska Press, 1997), 50.

18. Wheat, *Mapping*, 100.

19. Bolton, *Pageant*, 243–50.

20. Wheat, *Mapping*, 99–100.

21. British Museum (British Library), Add. Ms.17661c. There also is a fine positive photographic copy of the map in the Karpinski Collection. Louis C. Karpinski (1878–1956) was a professor of mathematics at the University of Michigan and an enthusiastic student of early North American cartography. While on leave, in 1926 he photographed more than 700 American-related maps in European archives, about 180 of them Spanish, including four by Miera. He produced six sets of fine 11 x 17-inch black-and-white prints of these map and donated them to the W.L. Clements Library at the University of Michigan in Ann Arbor, Library of Congress, New York Public Library, Harvard, Huntington Library in San Marino, CA, and Newberry Library in Chicago, respectively to make them available to American map researchers. See Jack Jackson, *Manuscript Maps Concerning the Gulf Coast, Texas, and the Southwest (1519–1836): An Annotated Guide to the Karpinski Series of Photographs at the New- berry Library, Chicago, with Notice of Related Cartographic Materials* (Chicago: The Newberry Library, 1995), 59–60.

22. Wheat, *Mapping*, 101–05.

23. Weber, *Spanish Frontier*, 255.

24. Wheat, *Mapping*, 115.

25. Ibid. 106–07.

26. Warner, *The Domínguuez-Escalante Journal*, 76–80.

27. One copy, dated 1777, is located in the British Library (Add. Ms. 17661d), one, dated 1778, is in the *Archivo General* in Mexico City, and two differing trac- ings from unknown originals, dated 1778 and 1779, with fewer place names

and by different copyists are in the Kohl Collection of the Library of Congress. Orthographic indicators point to the possibility of Miera being the author of the original of one of these Library of Congress duplicates. See Wheat, *Mapping*, 107–14.

28. Thomas, *Forgotten Frontiers*, 378, no. 48.

29. A full translation of the title is provided in Wheat, *Mapping*, 231.

30. Once again, a translation can be found in Wheat, *Mapping*, 232. The copies are in the collections of the British Library in London, Academy of History in Madrid, *Archivo General* in Mexico City, and *Bibliothèque National* in Paris.

31. Ibid, 119–21.

32. Jackson, *Manuscript Maps Concerning the Gulf Coast, Texas, and the Southwest*, 60.

33. John L. Kessell, *Spain in the Southwest: A Narrative History of Colonial New Mexico, Arizona, Texas and California* (Norman: University of Oklahoma Press, 2002), 293.

34. Wheat, *Mapping*, 229–31.

35. Kessell, *Spain in the Southwest*, 293–98.

36. Wheat, *Mapping*, 89, 97.

37. For example, see Tómas Lopéz y Vargas Machuca, *Atlas Geographico del Reyno de España , è Islas adyacetes con unabreve des descripcion de su Provincias* (Madrid: 1757) with its comparatively vague American maps.

38. James C. Martin and Robert Sidney Martin, *Maps of Texas and the Southwest, 1513–1900* (Austin: Texas State Historical Association, 1999), 109.

39. Ben W. Huseman, *Revisualizing Westward Expansion*, 8; Dennis Reinhartz, "Alexander von Humboldt: His Earliest Surviving Map of New Spain," *IMCoS Journal* 111 (Summer 2010), 13–18; and Wheat, *Mapping*, 132.

40. See Zebulon Montgomery Pike, *The Journals of Zebulon Montgomery Pike with Letters and Related Documents*, 2 vols. (Norman: University of Oklahoma Press, 1966 [1810]).

41. Elizabeth A. H. John, "The Riddle of the Mapmaker Juan Pedro Walker," *Essays on the History of North American Discovery and Exploration*, eds. Stanley H. Palmer and Dennis Reinhartz (College Station: Texas A&M University Press, 1988), 102–32.

42. Dennis Reinhartz, "The Arid Lands of the Greater Southwest on the Maps of Zebulon Pike and Stephen Long," *Forum of the Association for Arid Lands Studies* 22 (2006), 12–18.

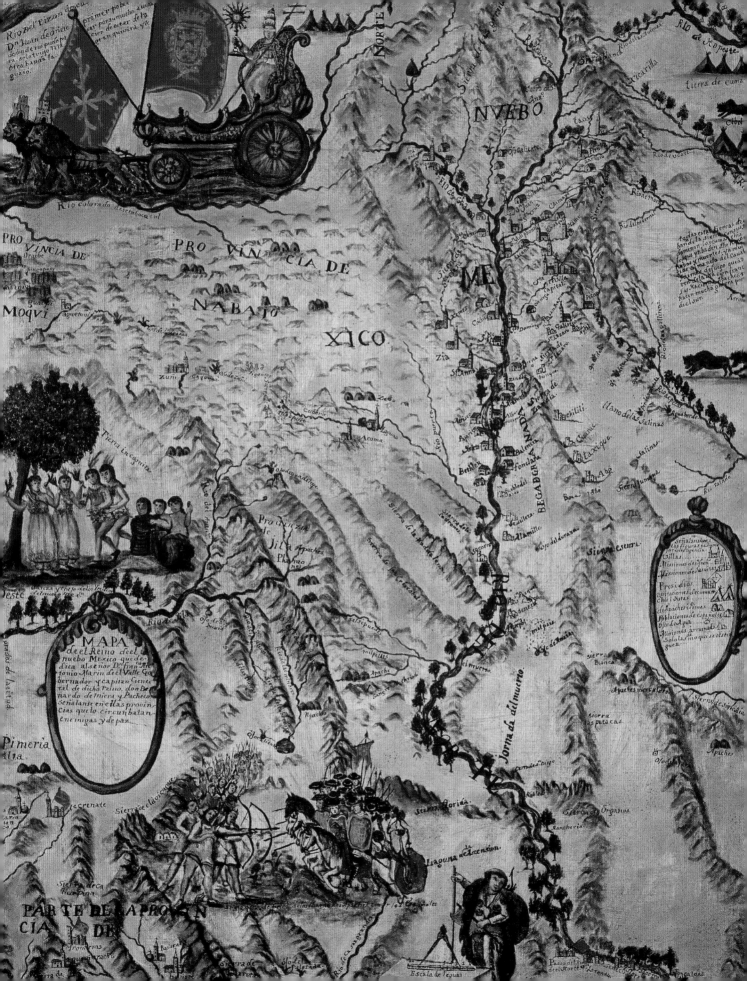

Hogans, Wickiups, Tipis, and Pueblos: The Consummate Ethnographer

by Charles M. Carrillo

In the opening scene of Shakespeare's *The Merchant of Venice*, Solanio says to his friend Antonio: "Believe me, sir, had I such venture forth,/ The better part of my affections would/ Be with my hopes abroad. I should be still/ Plucking the grass, to know where sits the wind;/ Peering in maps for ports, and piers and roads;/ And every object that might make me fear/ Misfortune to my ventures, out of doubt/ Would make me sad."[1] Quite different from the words spoken by Solanio, Bernardo de Miera y Pacheco did venture abroad, to the most northern reaches of the Spanish Empire in the New World. He did peer into maps and also created them through his exploration of vast uncharted areas of the province of New Mexico and beyond. As a result, his encounters with, and depictions of, native peoples of the region were unprecedented. Newly discovered peoples, with their different customs, mores, and traditions, were not feared by Miera but seen as genuine novelties, as evidenced by the fact that he painted them on his maps. This essay examines Miera's depictions of the native peoples of the Southwest, which shows that he possessed a well-rounded knowledge of both the Pueblo and non-Pueblo peoples who inhabited the lands of New Mexico and beyond.

The province of New Mexico had been reoccupied by Hispano settlers in the reconquest of 1692 for less than six decades when Miera began documenting the native peoples he encountered in military campaigns beginning in 1747. In that year Juan Francisco de Güemes y Horcasitas became the new viceroy in Mexico City. To address the instability of the province due to repeated accounts of marauding Navajos and Comanches that threatened the Hispano

Miera y Pacheco, Map of the Kingdom of New Mexico, *ca. 1760. Dirección General de Geografín y Meteorolgía, Mexico City.*

and Pueblo population there, he ordered the militias of Nueva Vizcaya (modern Mexican state of Chihuahua), northern Sonora, and New Mexico to counter the threat to settlement in a campaign for which Miera was present.[2]

Miera had moved his family to the El Paso area from Chihuahua sometime in 1743 where, not long after arriving, he advanced in his military career to the rank of captain. During his time in El Paso he participated in numerous campaigns against the "enemy Apaches and Sumas"[3] and in 1749, accompanied Alonso Rubín de Celis on an expedition covering the Camino Real from Guadalupe del El Paso to San Felipe el Real de Chihuahua, during which Miera gathered valuable geographical material.[4]

Miera and his family were settled in Santa Fe by 1755.[5] The following year Governor Francisco Antonio Marín del Valle appointed him as *alcalde mayor y capitán a guerra* of the district of Pecos. In his 1777 memorial, Miera recalled that during his administration of the Pecos district from 1756 to 1760 he led three campaigns against the enemy Comanche's. He also noted that he recorded the vast landscape and the directions of flow of the rivers within the landscape.[6]

In 1757 the governor ordered a comprehensive map of New Mexico. This map details the terminus of known lands from Sonora and Nueva Vizcaya in the south to Taos in the north and bounded by the Moqui (Hopi) Province in the west and the eastern plains of New Mexico. It is the first map on which Miera depicted native peoples. In a small space devoid of both human inhabitants and geographic features, Miera illustrated the "dress of Indians of New Mexico" (fig. 6), capturing in naturalistic style what the Indians customarily wore during wintertime.

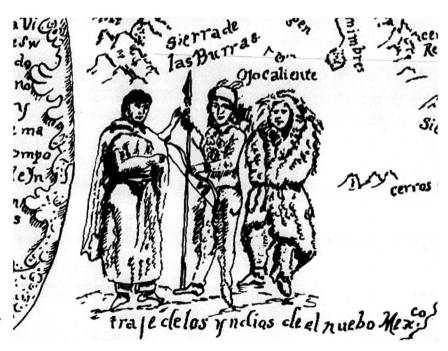

Figure 6
Miera y Pacheco, Map of the Province of New Mexico (detail), *1758. Reproduction by S. Livingston, 1977. 32 x 26 in. Center for Southwest Research, University of New Mexico.*

The drawing shows three figures. One figure is dressed and hooded with buffalo robes, while another appears dressed in fringed leather-buckskin clothing holding a long spear and double-arched bow. He has a parafleche, or quiver, on his back and wears a small headdress. This is likely a Comanche, although he could be a Cosina (Havasupai), as this figure is almost identical to one that Miera paints on a later map discussed below. A third figure is clearly a Pueblo woman, most likely a Keresan Pueblo. She is wearing a waist belt around a manta and is partly covered by what appears to be a blanket because of its squared edges. Her hair is cut with bangs across the front, and she wears long moccasins that wrap around the calf, typical apparel of Keresan Pueblo women.

In addition to these three individuals, Miera recorded on the map all the Pueblo missions and these native groups: *"Apaches Gila," "paches Mescaleros," "Apaches Carlones," "Apaches"* in the Sierra de Sacramiento, *"Sumas, tierra de Coninas, Provincia de Navajo,"* and *"tierra de Cumanchis."* He depicts the traditional dwellings of some nomadic peoples like the *Apaches Carlenes* and *Cumanchis* with tipis and refers to them as *"Naciones bagos,"* or wandering nations (fig. 7). For other native peoples he uses the symbol of a hogan or wickiup referring to these as *"rancherías"* of Apaches and other heathens, habitation sites that refer to temporary encampments of nomadic peoples.

That Miera was aware of ruins or archaeological sites is confirmed by the notation he made on the map regarding Nueba Vizcaya. Immediately south of the colonial town of Casas Grandes he placed the *"ruinas de Gentiles,"* likely the archaeological site of Paquimé.

While Miera may have drawn this map for Ahumada, as directed by Marín, I believe this map on paper likely served as a preliminary draft for Miera as he prepared other fully illustrated maps for the viceroy, his secretary, and even Marín del Valle. The three *"Indios"* he drew on this map were carefully painted on other maps with clear details. Miera painted on canvas two full-color maps. One of these, dedicated to Ahumada and likely completed in late 1758 or early

Figure 7
Miera y Pacheco, Map of the Province of New Mexico (detail), *1758. Reproduction by S. Livingston, 1977. 32 x 26 in. Center for Southwest Research, University of New Mexico.*

Figure 8

Miera y Pacheco, Map of Nuevo México (detail), *ca. 1758, oil on canvas, 42 ½ x 39 in. New Mexico History Museum, Santa Fe.*

Figure 9

Miera y Pacheco, Map of Nuevo México (detail), *ca. 1758, oil on canvas, 42 ½ x 39 in. New Mexico History Museum, Santa Fe.*

1759 , is preserved in Tepotzotlán in the Museo Nacional de Virreinato (see fig. 1) .[7] A second, identical map, dedicated to Felipe Cavallero, secretary to Viceroy Ahumada, is in the collections of the Fray Angélico Chávez Library in Santa Fe (see fig. 2). Both maps were painted on canvas and have exactly the same information, place names, and illustrations.

On the map dedicated to the viceroy, Miera painted six individuals. At center left are two figures flanking the legend. . . . One is wearing *"traje de los Moquinos,"* or clothing of the Hopis, and the other *"traje de Cosinas,"* that of the Cosinas. The Hopi is a young man dressed in a short tunic and short moccasins. His hair is bound by a hair band. His ears appear pierced, as he wears lobe-shaped earrings. Hishi beads are around his neck. He holds a traditional rabbit or throwing stick used by Pueblo hunters, and carries a double-arched bow and quiver on his back. The Cosina man is dressed in a fringed jacket/shirt and leather leggings covered for the most part by thigh-high fringed leather moccasins, and a feathered headdress. He also has a double-arched bow and quiver on his back (fig. 8).

Immediately to the right of the Hopi and Cosina figures Miera paints two Hopi women (fig. 9). One is identified as a *"donzella,"* or unmarried maiden. She wears the typical manta over her left shoulder and what appears to be either a woolen or cotton blanket. Her hairdo is made of butterfly whorls, indicating that she is of marriageable age. A second female also wears a manta, however she wears her hair in two pigtails, indicating that she is married. The unmarried woman holds a snake, while the married woman holds what appears to be

Figure 10
Adam Clark Vroman, Hopi Maidens
Creating Squash Blossom Hairdress IV,
*ca. 1902, Spencer Museum of Art, Lawrence,
Kansas.*

a feather or branch but in fact is a bundled hair comb used by Pueblo peoples
throughout New Mexico. These combs are made by bundling wild straw. The
same scene, minus the serpent, was photographed at a Hopi pueblo at the turn
of the century by Adam Clark Vroman. A bundled straw brush can be seen at
the bottom of the photo between the two females (fig. 10).

 In addition to these figures are two Comanche warriors shown on the
eastern plains of New Mexico (fig. 11). They wear leather leggings, moccasins,
and leather shirts. Both bear oval shields and are carrying flint lock muskets,
probably acquired from French trade. The French had been bringing muskets
similar to those painted on the map to the New World for almost a century
when Miera painted the Comanche warriors. The lead figure has a buffalo robe
draped over his right shoulder. A metal trade hatchet dangles from his arm. He
wears a feathered headdress that has what appears to be a beaded headband.
At Fort Sill, photographer George Addison captured such a young Comanche
warrior in1895, one hundred and thirty six years later (fig. 12).

 In addition to the illustrated figures and details, Miera recorded all the
Pueblo missions and the following native groups: *"Provincia de Nabajo"* (Navajo),
"Xicarilla" (Jicarilla Apaches), *"Apaches Cartanes"* (unknown Apache), *"Apaches
Mescalero ," "Cosinas "* (Havasupai), *"Iutas"* (Utes), *"Iutas Paiches"* (Utes,
unknown group), *"Moguachis"* (Utes, unknown group), *"Chaguaguanas"* (Sabua-
guna band of Utes), *"Cumanchis Piuianes "* (Comanche of unknown group),
"Cumanchis y Amparicus" (Comanche and unknown), *"Pananas"* (Pawnee), and
"Provincia de Moqui" (Hopi Province).

Figure 11
Miera y Pacheco, Map of Nuevo México (detail), *ca. 1758, oil on canvas, 42 ½ x 39 in. New Mexico History Museum, Santa Fe.*

Figure 12
George A. Addison, Winter Dress, Fort Sill, Oklahoma Territory, ca. 1895. Donald C. and Elizabeth M. Dickinson Research Center, Oklahoma City, Oklahoma.

Miera again used tipi and hogan/wickiup symbols, typically clustered in threes (figs. 13, 14). He specified that the tipi symbol represented the "wandering nations who do not have a fixed location and who are always moving." He used the rounded huts, painted white on this map, to symbolize "those who maintain themselves by planting."

Miera utilized the same convention of three huts/wickiups on the Castrense altar screen. The panel containing a carved relief of San Francisco Solano has three wickiups in the background (fig. 15). Traditional eighteenth-century engravings of San Francisco never show such wickiups, suggesting that Miera was depicting Solano's evangelization as if it were occurring among the native peoples of New Mexico.[8]

It is not known if Ahumada ever saw the painted map that Miera prepared for and dedicated to him. The correspondence between Marín del Valle and the viceroy does not indicate that it arrived before Ahumada died in 1760, although the 1758 paper draft version, now lost, did. Not long after he completed the "lost map," Miera finished two identical maps, one dedicated to Viceroy

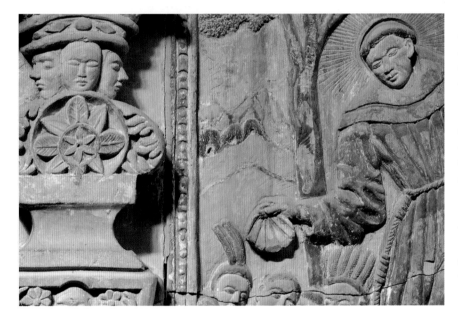

Ahumada and the other dedicated to Felipe Cavallero. He painted on canvas
another map dedicated as a tribute to Governor Marín del Valle sometime in
1759 or 1760.

This map differs from the previous painted maps in that it includes the
entire province of New Mexico from the settlement of Arispe in Sonora in the
southwest corner to Sierra San Antonio north of Taos, bounded on the west by
Hopi and on the east by the plains east of the Rio de Pecos.

The map depicts scores of Pharaones Apaches with their double-arched
bows drawn to face off with mounted Españoles (Spaniards) led by Gover-
nor Marín del Valle (fig. 16). Like his fellow militia men, Valle wears a flat-
brimmed black hat. The edge of his embroidered jacket shows below his red
adarga, or kidney-shaped leather shield bearing a coat of arms. A scabbard

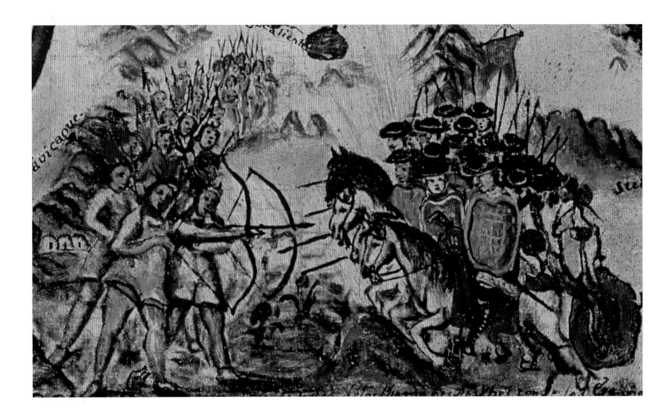

Figure 16
Miera y Pacheco, Map of the
Kingdom of New Mexico (detail),
*ca. 1760. Dirección General de
Geografín y Meteorolgía, Mexico City.*

holds his sword, while the stock of a musket is partially visible outside a leather musket scabbard. The other soldiers are carrying lances, one holding up a red bi-lobed presidio standard. The rumps of two horses behind the mounted governor seem to suggest that the soldiers have formed a circular defensive position. The attacking Apaches are wearing leggings with short fringe, moccasins, and traditional leather shirts. Many also wear headbands with attached red feathers. Some are armed with lances, others with double-arched bows.

The *"Provincia de Moqui,"* (Hopi) is depicted by Miera on the western terminus of the map. The Hopi pueblos of *"Oraibe"* (Oraibi), *"Jungopavi"* (Shongopovi), *"Gualpi"* (Walpi), *"Minsanavi"* (Mishongnovi), and *"Aguatuvi"* (Awatobi) are all shown as tightly clustered multistoried constructions on mesa tops, the only such depictions of Pueblo buildings to appear in any maps by Miera.

Immediately below the designation for Hopi Miera illustrates seven additional natives, which he describes as *"danza y traje de los Yndios de nuebo Mexico,"* or dance and dress of the Indians of New Mexico (fig. 18). Two Pueblo women wearing white mantas, with a design along the lower hem, draped over their left shoulders stand beneath a large cottonwood tree. They are wearing white Keresan-style moccasins. The women have their hands raised in a position seen commonly in Pueblo dances. They appear to be holding branches, such as piñon boughs used in dances, and they have red feathers in their hair. Two male dancers wear their hair in a single *chongo,* or braid, with feathers adorning their

Figure 17
Miera y Pacheco, Map of the
Kingdom of New Mexico (detail),
*ca. 1760. Dirección General de
Geografín y Meteorolgía, Mexico City.*

heads. They both have some type of animal fur around their loins and are wear-
ing typical moccasins used by Pueblo men. Both figures exhibit upper body
paint; the forward figure has some type of upper arm band. Beside the dancers
are three individuals, probably children, who appear to be watching the dances.
One of them is covered in what appears to be a rabbit-skin blanket like those
Pueblo people wove from strips of rabbit fur that have a stripped appearance
(fig. 19). The other two figures are partially covered in a buffalo robe.

Miera records the following on this map: *"Pharones Apaches"* (Faron
Apaches), *"Xicarilla"* (Jicarilla Apaches), *"Provincia de Moqui"* (Hopi Province),
"Provincia de Nabajo" (Navajo Province), *"Pimeria Alta"* (Upper Pima), *"Provin-
cia de Jila Apaches"* (Gila Apache Province), *"tierra de Cumanchis"* (Land of the
Comanches), and *"Apaches Mescaleros."* Curiously, he does not denote any loca-
tion for Utes, although he depicts tipis northwest of Abiquiú.

Finally, at the bottom center of this map, Miera depicts a Comanche male
(fig. 17) and the comment *"traje de los Cumanchis,"* or clothing of the Comanche.

The Comanche warrior is draped with a buffalo robe. He wears tradition
fringed Comanche-style legging. Although he appears tonsured, in reality he is
probably wearing a skull cap. His shirt is covered with circular silver brooches,
and he also wears a silver heart gorget, trade items obtained by Native Ameri-
cans from the early 1700s, especially east of the Mississippi River, until the
opening of the Santa Fe Trail in 1821. High-quality trade pieces were made by

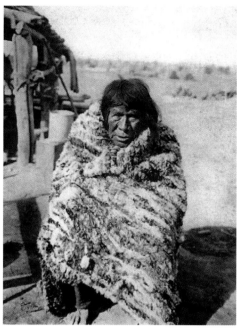

professional silversmiths in large population centers such as Boston, Philadelphia, and St. Louis.

The edge of the figure's double-arched bow and quiver can be seen behind his back. It appears that he is also holding the barrow of a musket in his right hand, as evidenced by the barrel hole at the top. He holds a trade hatchet in his left hand. In 1701, the French ship *L 'Enfamme* delivered to Fort Biloxi in Mississippi a shipment of French trade goods. Among the list were trade muskets and 300 medium and 600 small hatchets.[9] This is the type of hatchet that the Comanche is holding in Miera's illustration.

The painting of the Comanche warrior on this map is the most detailed of all of Miera's depictions of Native Americans. Other illustrations on the maps he created are more like sketches than paintings.

In addition to these maps, Miera is also known to have painted a map for Bishop Tamarón, however this map is missing from the Archives of the Archdiocese of Durango in Mexico. Whether subsequent governors of New Mexico commissioned Miera to make maps is unknown, but sixteen years later, Miera served as cartographer to the celebrated Domínguez-Escalante Expedition of 1776 that attempted to establish a trail from Santa Fe, New Mexico, to Monterey on the coast of California.[10]

If Miera kept journals of the expedition, as did the leaders, they have never been located. The map Miera completed in 1778 is one of the most complete maps ever drafted by him. In a dedicatory cartouche on the northeastern quadrant of the map he penned the phrase *"Plano Geographico de la tierra descubierta*

nuevamente," or Geographic Plan of newly discovered lands. This map somehow ended up in the British Museum in London.

The 1778 map contains more references to native peoples than any of Miera's other maps. He identifies *Las Tabequachis , Yutas Pobres, Barbones Tua-vichis, Itimpachis, Timpanogos, Yutas Payuchis, Yutas Pachuca Yutas Zaguaganas, Aiacantes Yutas Moghis, Cumanchis Yamparicas, Cumanchis Pivianes, Cumanchis Tupis, Cumanchis Cuchun Marica, Provincia de Nabajoo, Provincia de Moqui, Yuvincaris, Coninas, Apaches Jila con nombre de Mescalero, Guacaro, and Paganpachis*; and he names all the Pueblo missions of New Mexico. At the confluence of the *"Rio de las Animas"* and the *"Rio Colorado"* near the present-day towns of Bloomfield and Aztec, New Mexico, Miera indicates the locations of archaeological sites, saying *"Aqui se manifestan las Ruinas de grandes poblaciones de Yndios antiguas"*—"Here are discernible ruins of large settlements of ancient Indians." He was referring to the two large Chacoan outliers, known today as Aztec National Monument and Salmon Ruins,, that were less than twelve miles apart and must have impressed Miera enough to denote them on his map. West of Jemez Pueblo he locates *"Chaca"*—Chaco Canyon. He also notes in the area north of the *"Rio de Nabajoo,"* between the *"Rio de la Piedra Parada"* (present-day Chimney Rock National Monument) and the *"Rio de los Pinos,"* the border of the Ute area. From the diaries kept by the expedition, we learn that there are five bands of Utes.[11] The habitation sites are marked by either a cluster of tipis or a hogan/wickiup symbol. For this map Miera used clusters of three huts, two huts, or a single hut, likely indicating population density.

The most unusual illustration of native people ever made by Miera is of the *"Barbones Tuavichis"* (Paiutes) (fig. 20). In it he illustrates four individuals, two men and two women. The two men are bearded, one carries a dead rabbit, and both carry arrow quivers on their backs. They are dressed in sleeveless leather shirts, leather leggings, and moccasins. They also appear to be wearing some type of head gear. The two female figures are wearing moccasins and short sarongs, carry hooped fishing nets, or more likely conical baskets, and are bare breasted. One man and one woman hold a rabbit net.

Photographs taken almost one hundred years later by John K. Hillers for the Powell Expedition depict virtually the same outfits as those drawn by Miera, including the quivers and bows and the head gear (fig. 21). Additional photographs taken of bearded Paiutes also show a similarity to Miera's sketches. A Paiute woman in one photograph is shown bare breasted with a cone-shaped collection basket and plate (fig. 22).

While near the Sevier Lake area, Escalante commented on their appearance: "In their features they more resemble the Spaniards than they do all other Indians previously known in America, they were so fully bearded that they looked like the Cachupin padres or Bethlemites."[12] The bearded Indians are likely Southern Paiute, or Pahnant Utes. The *"Timpanogos"* referred to on the

Figure 20
Miera y Pacheco, Plano geographico
de la tierra descubierta
nuebamente a los Rumbos Norte
Noroeste y Oeste de Nuebo
Mexico, *1778. Fray Angélico Chávez
Library, New Mexico History Museum,
Santa Fe.*

Figure 21
John K. Hillers, Indians of the
Colorado Valley, *1865. New York
Public Library.*

*Bearded Paiute Indians show similarity
to Miera's sketches.*

Figure 22
John K. Hillers, Moapariat
Paiute Woman Gathering
Seeds, Southern Nevada,
*1873. U.S. National Archives
and Records Administration,
Washington, DC.*

1778 map are likely the Snake band of the Shoshone Indians, who historically occupied the area. Accounts written by Domínguez and Escalante mention a large body of water named *"Laguna de Timpanogos."*

A map that Miera completed in Santa Fe in 1779 titled *"Plano de la Provincia interna de el Nuebo Mexico,"* was made for Governor Juan Bautista de Anza and depicts the New Mexican Province from Taos in the north to the area immediately north of Socorro, New Mexico, bounded on the west by the *"Alcaldia de Zuñi"* and on the east by the abandoned ruins of the Salinas missions. Miera marks on the map the frontier of the Utes, settlements ruined by the enemy Comanches, the frontier and edge of the Comanche enemy, the province of the Navajo, the frontier and principal occupation place of the *"Jila,"*—likely the Gila Apaches, all the Pueblo missions, and, curiously, a location southwest of Jemez Pueblo labeled *"Chacoli,"* possibly a reference to Chaco Wash. This map, completed only six years prior to his death in 1785 is the last known map that Miera created.

In conclusion, Miera's ventures took him to almost every corner of eighteenth-century New Mexico. A keen observer, he was the first to record many of the native inhabitants of the Southwest and Four Corners region. He was also the first European to depict the native dress of Comanches, Havasupais, Hopis,

and Utes/Paiutes. Additionally, he noted archaeological sites as well as settlements either abandoned or in ruins. While his countrymen back in Spain may have had the opportunity to listen to the new music of contemporary composers like Mozart and Beethoven, Miera more likely heard music that was new and strange to him as he was exposed to the native peoples of New Mexico and the vast frontier beyond its inhabited borders. The intrepid Miera has come to symbolize not only courage but, more profoundly, the curious ethnographer. Today, we can only marvel at his simple but descriptive illusrations and imagine what he might have thought as he recorded their attire. We can only deduce from his illustrations that there was a mutual curiosity between him and his subjects.

Notes

1. Jeremy Hylton, *The Complete Works of William Shakespeare*. See shakespeare. mit.edu.

2. Bernardo de Miera y Pacheco to Carlos III, Memorial, Chihuahua, October 26, 1777, Newberry Library, Ayer Manuscript Collection, No. 1165.

3. Miera, Memorial.

4. John L. Kessell, "Campaigning on the Upper Gila, 1756," *New Mexico Historical Review* 44 (1971): 133–60.

5. Felipe R. Mirabal, "Don Bernardo de Miera y Pacheco and the First Twenty-five Years of the Capilla Castrense of Santa Fe," unpublished manuscript, 1997.

6. Miera, Memorial.

7. This map is preserved in Mexico City in the Museo Nacional del Virreinato as catalogno.Pl/0884. See: *Pintura Novohispana, Museo Nacional de Virreinto, Tepotzotlán*, 272.

8. The three wickiups on this stone altar screen were some of the iconographic attributes that Mirabal and Carrillo compared to Miera's maps in 1984 that led to Mirabal's conclusion that Miera had created the stone altar. Felipe R. Mirabal, unpublished manuscript prepared for Mary Grizzard, PhD, 1984.

9. James Hansen, *Museum of the Fur Trade Quarterly*, 44 (2008):22.

10. *The Dominguez-Escalante Journal: The Expedition through Colorado, Utah, Arizona and New Mexico in 1776*, ed. Ted J. Warner; trans. Fray Angélico Chávez (Salt Lake City: University of Utah Press, 1995), 63–66.

11. Ibid., 66.

12. Ibid., 26–38.

The Altar Screens of Bernardo Miera y Pacheco

by Robin Farwell Gavin and Donna Pierce

ew Mexico's altar screens are among its most significant artistic monuments.[1] There are some forty extant Spanish colonial and nineteenth-century examples adorning the churches and chapels of the state. They were originally commissioned and made as devotional pieces—testaments to the lasting and profound impact of the Catholic Church in the region—but are also significant historical and artistic works that yield much valuable information in addition to the stories of the holy personages whom they depict. And they were the harbingers of a new and innovative artistic style—a New Mexico style.

Altar screens as an art form originated in Spain in the fourteenth century.[2] From there the design, construction, and iconography were brought to the Americas and eventually to New Mexico. The Spanish word for altar screen used in all historic documents is *retablo*. The main altar screen in a church was often referred to as the *retablo mayor* (main altar screen); the side or nave altar screens were *retablos colaterales* (collateral altar screens), sometimes shortened to *colaterales*.[3]

Historical church inventories and caravan supply lists indicate that at least a few altar screens were shipped to New Mexico from Mexico in the seventeenth and eighteenth centuries. The inventory for the 1626 supply caravan lists crates containing the base, body, pilasters, and cornice of a retablo.[4] Most likely destined for the parish church in Santa Fe or the recently completed mission church at Guisewa (Jémez), this may have been the first complete retablo

brought to New Mexico.[5] A 1672 inventory of the church at Acoma Pueblo notes three large gilded retablos, one described as "a gilded retablo in three sections with images in the round and paintings, the handiwork of the best artists of Mexico."[6] All three apparently disappeared during the Pueblo Revolt. A document dated 1714 credits a Juan de Medina with the manufacture of an altar screen for the La Conquistadora Chapel in the parish church of Santa Fe that was constructed after the reconquest of New Mexico in 1692–93.[7]

From 1760 on, records indicate that New Mexicans began to produce retablos locally on a regular basis. As they assumed control over the design and construction of these screens, they began to develop a style that by the late eighteenth century was entirely distinctive to the region.[8]

The identity, much less the biography, of most New Mexican artists is unknown. Although artists are mentioned in documents as early as the beginning of the 1600s, no extant works can be associated with them. One notable exception is Captain Bernardo de Miera y Pacheco (1713–1785), the earliest artist working in New Mexico identified by name whose surviving works of art can be connected to him. Miera appears to have created some of New Mexico's first altar screens.

Miera was born August 4, 1713, in the village of Santibáñez in the Valle de Carriedo north of the city of Burgos in the province of Santander in north-central Spain.[9] Nothing is known of his childhood or youth. The time between his baptism in Santíbañez in 1713 and his marriage in 1741 at the late age of twenty-eight to María Estefanía de los Dolores Domínguez de Mendoza in the presidio of San Felipe y Santiago de Janos in the province of Chihuahua in northern Mexico is undocumented, and how and why he journeyed from northern Spain to northern Mexico remains a mystery. But, as we will see, hints of his possible peregrinations may be found in the altar screens he executed in New Mexico.

Sometime after the birth of their first son in 1742 the Mieras moved to El Paso del Norte (present-day Ciudad Juárez), where their second son was born in 1743. By the early 1750s, Miera was conducting business in Santa Fe while still living in El Paso. He moved his family to the colonial capital in 1754, following the newly appointed governor, Francisco Antonio Marín del Valle, a native of Lumbreras in the Rioja region of northern Spain, just east of Burgos and not far from the Valle de Carriedo.[10]

Marín del Valle appointed Miera as *alcalde mayor* (district administrator) of the jurisdiction of Pecos and Galisteo in 1756 and named him as official cartographer in 1757. By 1760 the two were collaborating on the construction of Santa Fe's new military chapel (*Castrense*) dedicated to Our Lady of Light with its magnificent stone altar screen (fig. 23). Whether Miera engaged in artistic endeavors in Janos and El Paso is unknown; in spite of the frequent mention of him in documents from El Paso, no such evidence has come to light. It seems

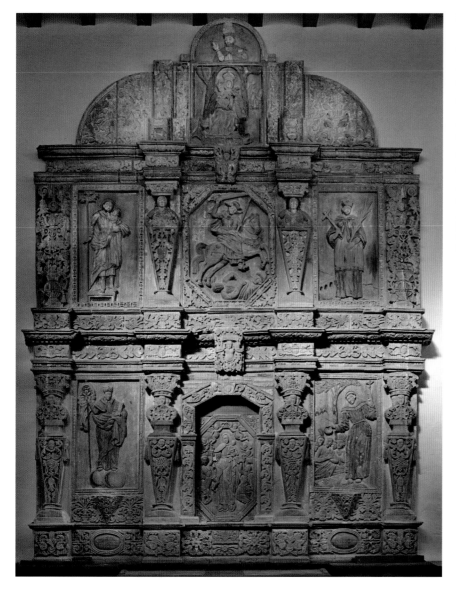

Figure 23

Miera y Pacheco, Altar screen dedicated to Our Lady of Light, *1761 (dated), volcanic stone, paint. Cristo Rey Church, Santa Fe, New Mexico.*

This altar screen was made for La Castrense *(military chapel) on the Santa Fe Plaza. Inscription:* "A devocíon de Señor Dn Fco Anton Marín del Valle, gobernador y Capitán general de este reino y de su esposa Dña María Ignacia Martínez de Ugarte Año Christiano 1761."

that it was in New Mexico, under the patronage of Marín del Valle, that his artistic talents were given an opportunity to fully develop.

Quite the renaissance man, Miera is listed in New Mexico documents of the period as an artist as well as a rancher-farmer, soldier, mathematician, and cartographer.[11] Over the years, he made numerous official maps of New Mexico and the surrounding area under two governors, Marín del Valle and later Juan Bautista de Anza, and, as official cartographer, he accompanied the Domínguez-Escalante Expedition into southern Utah in 1776 as it sought a passage to the Pacific. Fray Francisco Atanasio Domínguez, in his account of the expedition and his official visitation record of New Mexico, mentions Miera as an

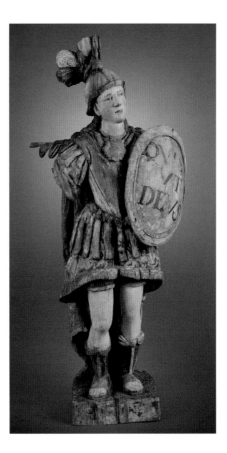

Figure 24

Miera y Pacheco, St. Michael, ca. 1774–1776, wood, gesso, paint, gilding, 40⅞ x 20 in. Zuni Pueblo Visitor's Center, New Mexico.

Made for the church of Our Lady of Guadalupe, Zuni Pueblo. Collected by the Smithsonian Institution in 1880. Repatriated to Zuni Pueblo in 2004.

artist—disparagingly—and credits to him a statue of Saint Phillip in the San Felipe Pueblo church.[12]

Other sculptures and paintings have been attributed to Miera on the basis of stylistic comparisons to the Saint Phillip statue and to the paintings and inscriptions included on his maps.[13] The remaining sculptures and columns of a wooden altar screen from Zuni Pueblo church—described as "new" by Domínguez in 1776—have also been attributed to Miera (figs. 24–26). From this list, it is apparent that he was commissioned to create artwork for churches in numerous Indian pueblos.

If not the first to do so, Miera was certainly one of the immigrant artists to introduce elements of the international Baroque style to New Mexico, where he adapted the style to suit local tastes and materials, as his surviving work shows.[14] His overall goal, like that of European and Mexican academic artists of the period, was realism. His figures have naturalistic poses and are generally well proportioned, if a little stocky, with heavy, voluminous drapery and the dark colors typical of the Baroque style of Spain and Mexico (figs. 27, 28). A distinctive affectation in the human figures carved by Miera is a short, somewhat truncated neck (figs. 25, 27). Some of these figures have their heads inclined back or to the side at awkward angles in what is probably an attempt

Figure 25

Miera y Pacheco, St. Raphael,
*ca. 1774–1776, wood, gesso, paint, gilding,
42 x 20 in.*

*Made for the church of Our Lady of
Guadalupe, Zuni Pueblo. Collected by
the Smithsonian Institution in 1880.
This statue burned while on exhibit at
the Smithsonian Institution in 1965.*

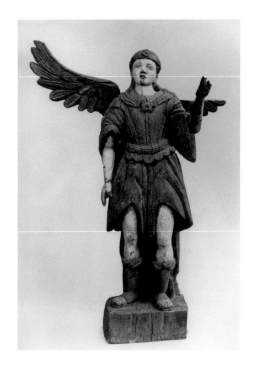

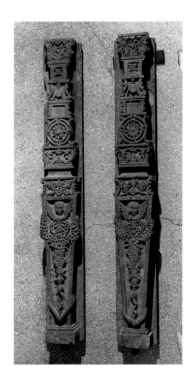

Figure 26

Miera y Pacheco, Estípite columns, *ca.
1774–1776, wood, gesso, pigments, 103 ½
x 14 in. Brooklyn Museum, New York.*

*Made for the church of Our Lady of
Guadalupe, Zuni Pueblo. Collected by the
Brooklyn Museum
in 1904.*

at intentional foreshortening for viewing from below, a standard technique in
the manufacture of statues for inclusion in Baroque altar screens. On occasion,
the saints painted or carved by Miera gaze heavenward in a distinct manifes-
tation of the pose employed by Spanish Baroque sculptors such as Pedro de

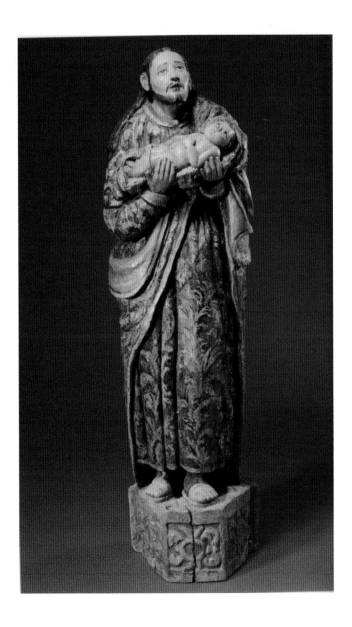

Mena (fig. 29), popularized in paintings by Bartolomé Murillo, and dissemi-
nated throughout the Spanish world by popular imagery and prints. Miera y
Pacheco's familiarity with and use of these Baroque artistic techniques indicate
that he must have had at least some formal training in Spain or Mexico.

In New Mexico, Miera adopted at least one technique from the Pueblo
Indians: he learned from the Zunis of a local mineral, azurite, that could be
made into a blue paint.[15] Miera was so taken with the qualities of this paint,
now known as "Zuni blue," that he advocated its exportation to Mexico for
profit by the government. It is clear from documents that Miera used the
Pueblo-style blue paint along with imported oil paints, as has been identified
through chemical testing on at least one of his pieces.[16] Later santeros often used

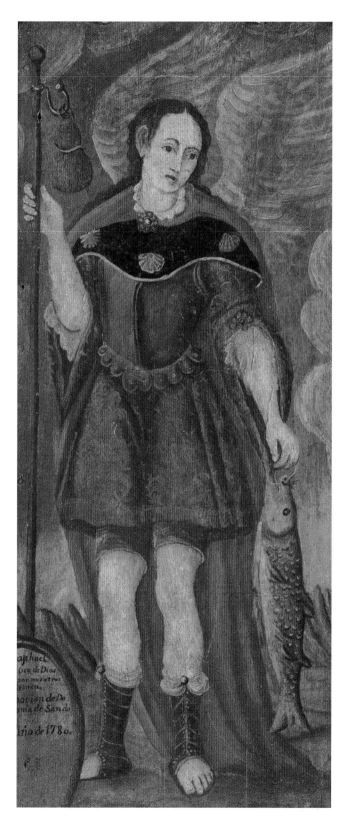

Figure 28
Miera y Pacheco, St. Raphael, *1780 (dated), pine, gesso, oil paint, 49 ¼ x 24 ¼ in. Museum of Spanish Colonial Art, Santa Fe.*

Figure 29

Pedro de Mena, St. Francis Standing
in Ecstacy, *1663, polychromed wood,
glass, cord, and human hair; 38 ³/₁₆ x 13
in. Toledo Cathedral, Toledo, Spain.*

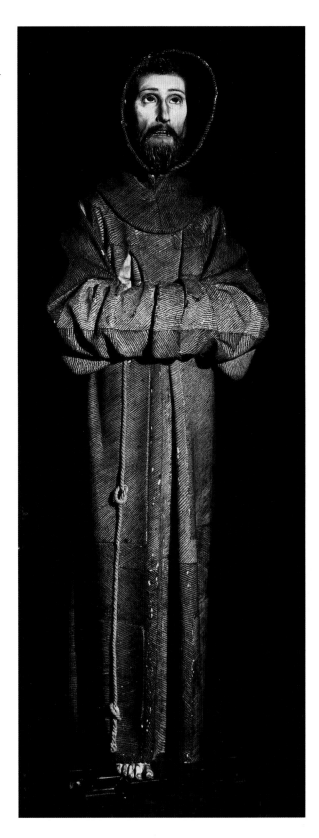

imported pigments, such as cinnabar and indigo, alongside paints made from local vegetal and mineral materials similar to those used by the Pueblo Indians.[17]

<div align="center">

The Castrense Altar Screen
</div>

A large altar screen, matching altar frontal, and façade relief panel were carved from local stone and painted in bright colors for a new military chapel, or *Castrense*, dedicated to Our Lady of Light in 1761 (see fig. 23).[18] Funded by Governor Marín del Valle and his wife, the altar screen for the chapel was previously thought to have been executed by Mexican craftsmen brought to New Mexico from northern Mexico, possibly Zacatecas.[19] Recent research has revealed that it was more likely designed and executed by Miera, who was secretary of the confraternity of Our Lady of Light at the time.[20] A comparison of the Castrense screen to the body of work attributed to Miera reveals strong stylistic similarities. The inclusion of *estípite* columns suggests that Miera may have been the first artist to use the late-Baroque element in New Mexico. Furthermore, the type of columns, decorative details, and structural elements bear some interesting similarities to two major altar screens constructed in the city of Burgos in Miera's youth.

Both of the Burgos projects incorporated estípite columns with their distinctive profile: wide in the middle of the shaft and narrow at the base and capital.[21] This column, previously used in Roman stage sets and as a minor element in the decorative arts, became one of the main leitmotifs of the late Baroque style in Spain and Latin America. Beginning in the early 1700s, this newer version of the Baroque (late or estípite) also incorporated other angular, vertical, and eventually asymmetrical elements into the traditional curvilinear early Baroque repertoire.

When Miera was twelve years old, in 1725, a major altar screen with four large estípites was begun for the main altar of the Jesuit church of La Compañía; when he was eighteen, the altar for the new chapel of Santa Tecla inside the Cathedral of Burgos was initiated, to be completed by 1735 (fig. 30). Both altar screens are similar in structure and design and are attributed to the same architect, José Valdán, who was living in Burgos at the time.

As a teenager and young adult in the Burgos area, Miera was undoubtedly familiar with at least one and probably both of these high-profile commissions. Since Burgos was the only urban center in the region, he probably traveled there with his father to purchase supplies or with his entire family to attend major festivals. Historian John Kessell has speculated that as a youth Miera probably was sent off to school or seminary,[22] in all likelihood to Burgos. If his artistic and mathematical talents and interest had already manifested, it is conceivable that the young Miera may have received artistic training in Burgos and may even have apprenticed on the Santa Tecla screen, which was paid for by the

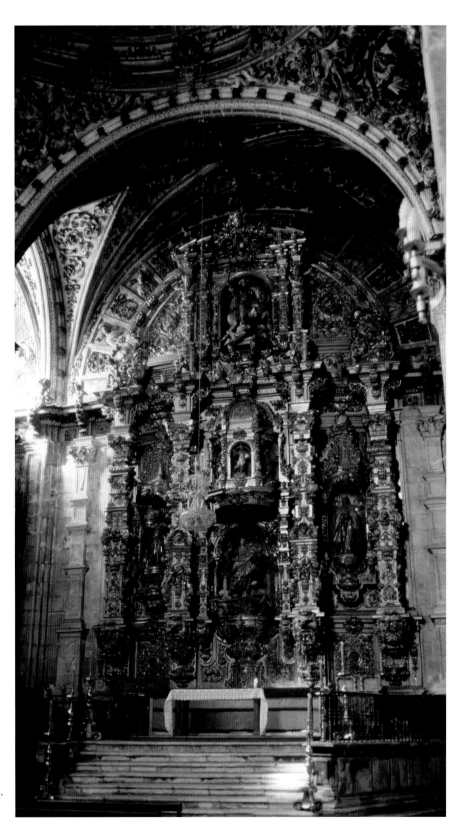

Figure 30
José Valdán, Altar screen in the
Chapel of Santa Tecla, *1731–1735,*
polychromed wood, gesso, gilding, glass,.
Burgos Cathedral, Burgos, Spain.

Archbishop of Burgos, Don Manuel de Samaniego y Jaca. Inaugurated with much pomp and circumstance in 1736 by a week-long series of elaborate processions, festivals, and high masses, it has been referred to as "the richest Baroque altar screen of Burgos" and "one of the best of its type in all of Spain."[23]

Both altar screens in Burgos bear some interesting structural similarities to the Castrense screen in Santa Fe: three horizontal levels and three vertical bays; an arched crown piece with two smaller inset columns; four framing estípite columns; and flat spaces filled with relief-carved floral motifs. Furthermore, the Santa Tecla screen has a prominent upper-central image of St. James (Santiago) on horseback, as does the Castrense screen. As we shall see, the remains of the altar screen at Zuni Pueblo, discussed in detail below, indicate that it also shared these characteristics, with the exception of the image of Santiago and with the additional similarity of having large estípite columns that spanned both lower levels, as do both screens in Burgos.

Presumably Miera left the Burgos area in the 1730s, when he was in his early twenties. Kessell has speculated that he may have come to Mexico in 1734 on the same ship as the newly appointed governor of Cuba (and later viceroy of Mexico) don Juan Francisco de Güemes y Horcasitas, a native of the region just south of the Valle de Carriedo in Santander.[24]

Whenever Miera left Spain, he would have passed through Seville, the administrative checkpoint for all people heading to the Americas. There he likely would have seen the prominent altar screen in the Sagrario Chapel of the Cathedral of Seville. Designed by the artist Jerónimo Balbás, it employed estípite columns on an even grander scale and was installed in 1706 with much fanfare and not a little criticism. It was described as having "four large *estípites*, pilasters, lots of angels prankishly tumbling about and a cornice broken and interrupted in a thousand places with tortuous projections and recesses, the whole topped by a huge arch."[25] Unfortunately, it was destroyed in 1824.

In addition, Miera would have passed through Mexico City on his way to the northern frontier and might even have spent considerable time there. The most prominent large-scale work of art under construction there at that time was the new Altar of the Kings in the cathedral at Mexico City, built between 1718 and 1738. Designed by the same Jerónimo Balbás of Seville, who had left Spain in 1717 for this grand commission, the Altar of the Kings introduced the late-Baroque estípite style to Mexico.[26] Miera most probably saw this new altar piece as he passed through Mexico City on his way to Janos by 1741; he may have even been in Mexico City during the elaborate inauguration festivities in 1738.

Throughout the 1740s and 1750s, altar screens in the new estípite style were being constructed all over central Mexico in imitation of the Altar of the Kings. However, many of these early Mexican estípite screens did not have arched crown pieces seen later in the Castrense altar screen but rather pointed ones, like that of the Altar of the Kings. Use of the arched attic in New Mexico may reflect

Miera's memory of the new screens in his home region of Burgos. Furthermore, the Castrense altar screen has much more in common structurally with the Burgos examples than contemporary Mexican versions, which tended to be more vertical in emphasis and less restricted by the triple bay and level format.

In Mexico the estípite style soon spread from altar screens to the architecture of churches as well. Unlike in Spain, estípite-style carved stone altar screens were applied to the exterior facades of churches after the first use on the prominent Sagrario Chapel attached to the Cathedral of Mexico, designed by Lorenzo Rodríguez and begun in 1749. In northern Mexico, cities such as Durango, Parral, and Chihuahua were being founded throughout the eighteenth century as surrounding silver mining brought wealth to the region. Local clergy and patrons hired the best architects of the day to design and construct parish churches and cathedrals for these burgeoning centers. For the most part, these were executed in the contemporary style of estípite Baroque, embraced throughtout New Spain by architects who eventually transformed it into an expression distinct to the Americas by further emphasizing verticality, incorporating regional motifs into the decoration, and applying carved stone estípite-style retablos to the facades of churches.[27]

Most extant late-Baroque altar screens inside the churches of northern Mexico, at San Luis Potosí, Zacatecas, Chihuahua, and Sonora, appear to date from the late 1760s into the 1770s.[28] The earliest surviving examples that can be securely dated are the altar screens of the Christ of Mapimí in Cuencamé (1765) and those of Santo Domingo church in Zacatecas, dated between 1765 and 1770. Thus, the 1761 Castrense screen in Santa Fe may be the first estípite-style altar screen constructed in northern New Spain and is certainly the earliest to survive to the present.

The Castrense retablo is carved from local stone, quarried in Jacona, some twenty miles north of Santa Fe. In 1803, Don Pedro Pino reported to the Spanish *cortes* (parliament) that there was a common type of gypsum (*jaspe*) from which "the altar screen, pedestals and pulpit of La Castrense were made."[29] The fact that the Castrense altar screen was carved from stone and painted has always been a mystery to historians, given the dominant tradition in Spain and Mexico at that time was to make screens of carved and gilded wood. Yet altar screens of carved stone, although extremely rare, are not unknown.

Not surprisingly, stone altar screens show up in the Burgos and Rioja region of Spain. One example among several is the Chapel of San Andrés, adjacent to the Cathedral of Burgos, where a large late-Gothic-style carved and painted stone screen was installed around 1550. Although it is much older and different in style, the technique of manufacture is virtually identical to that of Castrense. Miera would have been aware of this work of art on the main plaza of Burgos.

A handful of stone altar screens also survive in Mexico, including ones in San Pablo el Viejo in Mexico City (1780–1785) and those in the church of Our Lady of Carmen in San Luis Potosí, installed between 1787 and 1792, including the magnificent side altar screen/façade in the left transept of the church.[30] The latter is not technically an altar screen (there is no altar) but rather an interior façade to the sacristy attached to the left transept of the church. As mentioned, in Mexico the placement of elaborately carved stone altar screens on the exterior facades of churches became exceptionally popular after mid-century. The use of stone altar screens on the interiors of churches, however, remained rare until quite late in the colonial period, when Charles III decreed in 1788, many years after Miera's Castrense altar screen, that they should be made of stone rather than wood to reduce the risk of fire. The decree may have stimulated the construction of the Carmen screens as well as three stone retablos in the Cathedral of Chihuahua completed 1792.[31]

The iconography of saints chosen for the Castrense screen reflects current events of the time. Governor Marín del Valle, who may have had a personal connection to the Jesuit order that was not active in New Mexico, had a well-known personality conflict with the local Franciscans who administered the missions in the area. Historians have noted that only one of the saints in the altar screen is a Franciscan, St. Francis Solano (lower right), and have interpreted this as a calculated insult to the order. However, the choice of iconography was probably more complicated and is decidedly pertinent to the times. Directly above St. Francis Solano is St. John Nepomuk, a Jesuit saint. Both of these saints would have been of recent canonization—in 1726 and 1729, respectively—and in mid-eighteenth-century altar screens throughout Mexico it is common to find them together, regardless of whether the church had ties to either order. Also, St. John Nepomuk was the patron saint of the sanctity of confession, a topic causing controversy between religious and secular officials throughout Europe and the Americas in the period. St. Francis Solano was a Franciscan missionary to Indians in the Americas—again, a topic relevant in New Mexico.

The founder of the Jesuit order, St. Ignatius Loyola, occupies the lower left, perhaps showing bias toward the Jesuits. But it should also be noted that Marín del Valle's wife's name was María Ignacia, making Ignatius her name saint, another reason for choosing him. Above St. Ignatius is St. Joseph, one of the most popular saints in all Christendom from the sixteenth century on and advocated extensively in Spain during the Counter Reformation.[32] Even earlier, his devotion had been used by Franciscan missionaries in Mexico since the 1520s to encourage Native Americans to emulate his family values. In 1555 he was named patron saint of Mexico; in 1629 King Charles II elevated him to patron saint of the Spanish Empire, stimulating a revived interest in St. Joseph in the late seventeenth and early eighteenth centuries. During this second phase of

his popularity, he became associated with good government, making him a popular saint among government officials and politicians, such as Marín del Valle.

The other two images carved on the screen, located in the central bay, include the Virgin of Valvanera (see fig. 45) and St. James the Greater (Santiago) in his guise as warrior against the Muslim invasion of Spain. The original romanesque statue of the Virgin of Valvanera is located in a remote mountain area of Rioja, Spain—just east of Burgos and not far from Marín del Valle's hometown of Lumbreras—where, in fact, she is the patroness,[33] thus explaining her inclusion on the altar screen in Santa Fe.

In Mexico the Virgin of Valvanera had become popularized in the early seventeenth century by Archbishop Francisco Manso de Zúñiga (1627–1636), a native of Rioja, who instigated the construction of a major church dedicated to her, completed in 1673. In addition, a chapel dedicated to the Virgin of Valvanera, attached to the church of San Francisco el Grande, the main Franciscan motherhouse in Mexico City, had been built around 1660. In the mid-eighteenth century, plans were under way for a complete renovation of it, completed in 1765. The interior decoration was designed and executed by the most famous artist in Mexico at that time, Miguel Cabrera.[34] Funding was supplied by an organization of wealthy merchants and Spanish nobles from Rioja.[35] So devotion to the Virgin of Valvanera had been associated with the Franciscans in Mexico since the mid-seventeenth century. Furthermore, the prestigious renovation of her chapel under way in the mid-eighteenth century and funded by wealthy Riojans further strengthened her prestige and her connection to emigrants from northern Spain, such as Miera y Pacheco and the Marín del Valles.

St. James, also occupying the center of the Castrense screen, patron saint of Spain, is frequently seen in upper levels of altar screens in Spain and the Americas. Credited with a miraculous appearance in 731 to aid Christian forces in their first victory against the Muslim invasion of Spain, St. James was subsequently considered to have appeared to Christian forces throughout the Spanish Empire, including in New Mexico. In his role as warrior and defender of Christians against attacks by non-Christians, he would be a logical choice for the chapel built for soldiers of the presidio of Santa Fe, tasked with defending both Spaniards and Pueblo Indians against attacks by pagan Indians, a timely choice given a rash of attacks by Comanches at this time, including a devastating one in Taos on August 4, 1760, that had caused much consternation in the province.

Such fears likely influenced the choice of the titular patron for the chapel, Our Lady of Light. The original image of the Virgin Mary as Our Lady of Light had been made in Sicily (a viceroyalty of Spain at the time) in the early 1700s at the request of a Jesuit and was based on a vision.[36] A painting of her was brought to Mexico in 1732 by another Jesuit and placed in the then-Jesuit church (now the cathedral) in the town of León. This newfound devotion became particularly popular in northern Mexico in the mid-eighteenth cen-

tury after the image was credited with saving settlers near León from an attack by hostile Indians. Although originally associated with the Jesuit order, the Dominican and Franciscan orders championed it, the latter using it in its missionizing efforts in the mid-eighteenth century.

The carved stone panel of Our Lady of Light in the central niche today was originally carved for the facade and placed above the main entrance to the church.

According to Domínguez, the niche in the altar screen originally held an oil-on-canvas painting of Our Lady of Light. This is most likely the painting attributed to Miguel Cabrera that survives today in the convent of the Sisters of Loretto in Littleton, Colorado (fig. 31). The artist is the same Miguel Cabrera,

Figure 31
Miguel Cabrera, Our Lady of Light, *before 1761, oil on canvas, 78 x 58 ½ in. Our Lady of Loretto Convent, Littleton, Colorado.*

Figure 32
Miera y Pacheco, Altar frontal of Saint Anthony with Christ Child, ca. 1760, polychromed stone, 50 x 40 in. Museum of International Folk Art, Santa Fe, New Mexico.

who at the time was planning for the major interior decoration of the new chapel of Valvanera attached to the Church of San Francisco in Mexico City. The stone altar screen must have been almost completed when the painting arrived in New Mexico, since it is too large for the central niche and evidence indicates that it may have been folded down on all sides in order to fit.[37] Years later, when

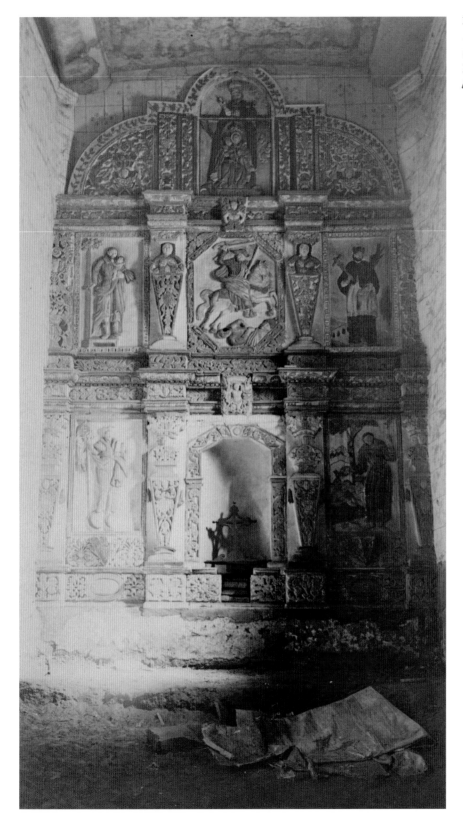

Fig 33
Miera y Pacheco, Altar screen, *1761
(dated), volcanic stone, paint.
This photo shows the original floral
border of the altar screen.*

the Castrense chapel was torn down and the stone screen moved to the Cathedral of Santa Fe, the painting was given to the Sisters of Loretto. When the sisters closed their house in Santa Fe in 1968, the painting was taken with the remaining nuns to the convent in Littleton, where it remains today.

In addition, a panel matching the altar screen was carved for placement in the front of the altar table just below the altar screen. It depicts the Franciscan Saint Anthony with the Christ Child. It survives today in the collection of the Archdiocese of Santa Fe (fig. 32).

Iconographically, the Castrense screen had a more balanced schema than scholars have previously assumed. Including the altar frontal carving of St. Anthony, there were two Jesuit saints (Sts. Ignatius and John Nepomuk) and two Franciscan saints (Sts. Anthony and Francis Solano). There was one image of the Virgin associated with the Franciscans in Mexico, Our Lady of Valvanera; and one associated with the Jesuits, Our Lady of Light. And there were two universal saints: Sts. Joseph and James. The screen's iconography was timely, with newly canonized saints and new, or newly revived, devotions to the Virgin. It also was relevant in referencing current events in New Mexico, such as Indian raids in the area.

The hierarchical plan of the altar screen follows ecclesiastical traditions established during the Counter Reformation in Europe.[38] In ascending order, the lower levels always display images of the "founding fathers" of Christianity, such as the Apostles, Evangelists, Doctors of the Church, founders of religious orders, or preachers. As founder of the Jesuits, St. Ignatius is in his proper location on the bottom row; as preacher to Native Americans, St. Francis Solano is as well. Upper registers of altar screens hold saints of choice, such as St. Joseph and St. John Nepomuk at Castrense. As part of this pattern, the central bay is reserved for the patron saint of the church or altar (Our Lady of Light), the Virgin and/or Christ (here Our Lady of Valvanera with the Christ Child on her lap), and occasionally St. James, with God the Father overseeing the entire ensemble. Miera and the Marín del Valles followed protocol in their plan for the Castrense altar screen. Later artists in New Mexico were less conscientious about adhering to the strictures of hierarchy in altar screens.

The Castrense chapel fell into disrepair and was torn down in 1859, almost one hundred years from its construction. At the time the carved stone screen, the façade carving of Our Lady of Light, and the stone altar frontal carving of St. Anthony were moved to a small adobe room behind the cathedral. In 1939, the altar screen, with the façade carving of Our Lady of Light now in the central niche, was moved to Cristo Rey, the church built by Santa Fe architect John Gaw Meem, where it remains, although the surrounding floral border, seen in a photograph from the late 1800s, was removed during the transfer (fig. 33). Over the years, the original, brightly painted colors have faded almost beyond sight to the naked eye, but even without its original coloration it is a stunning monument to an artist and his patron.

The Zuni Altar Screen

Established in 1629, the mission church of Our Lady of Guadalupe was re-constructed at Zuni Pueblo between 1699 and 1706 under the direction of Fray Juan de Garaicoechea. The Domínguez-Escalante expeditionary team arrived at Zuni in the winter of 1776, when Domínguez noted in his journal:

> It has a small new altar screen, as seemly as this poor land has to offer, which was paid for by Father Vélez [de Escalante] and the Indi-ans of the pueblo. It consists of two sections, as follows: In the center of the whole thing, almost from top to bottom, there is a framework lined with coarse brown linen and very well painted, in which a large oil painting on canvas with an old frame, newly half gilded, of Our Lady of Guadalupe, which the King had given before, hangs. Below this painting is a very old lacquer Child Jesus vested as a priest, the clothing also old.
>
> The lower niches at the sides contain St. Michael on the right and St. Gabriel at the left, new middle-sized images in the round. In the two in the second section above those lower ones mentioned are our fathers St. Dominic on the right and St. Francis on the left, painted half life-size. Above at the top a bust of the Eternal Father in half relief. The gradin is below the little altar screen, serves as a base for it, and has a small tabernacle well placed in the center.[39]

The earliest known record of this carved wooden altar screen is Richard H. Kern's sketches from 1851 (fig. 34), which help to identify one of the sculptures and to date the painting (see below) but which are also missing some elements. The description above does, however, match those elements that can be seen in the earliest known photograph of the screen, taken by Timothy O'Sullivan in 1873 (fig. 35), almost a century after Domínguez's visitation. The painting appears to still be in place, and the image at the bottom center of the painting may be the "lacquer Child Jesus vested as a priest." St. Michael still stands on the right, between the two columns, and on the left is not St. Gabriel, as Domín-guez states, but St. Raphael, identified by the fish he holds in one of the sketches by Kern.[40] The roundels of St. Dominic and St. Francis are just barely discern-ible above the statues. The bust of the Eternal Father in half relief is not shown in O'Sullivan's photo but can be seen in a photo taken by I. W. Tabor (fig. 36). The latter photo is dated 1886 but must be no later than 1880, when Professor James Stevenson and F. G. Galbraith shipped several of the missing objects, including the two statues (see figs. 24, 25), the crowned Sacred Heart *escudo* above the painting, and a decorative scroll from the base of one column to the Smithsonian (fig. 37).[41] The carved and painted columns were later collected in 1904 by Stewart Culin for the Brooklyn Museum (see fig. 26). The location of

Figure 34

Richard Kern, Interior of the Church of Our Lady of Guadalupe, Zuni Pueblo, *1851, watercolor sketch, 4⅜ x 6 in. Amon Carter Museum, Fort Worth, Texas.*

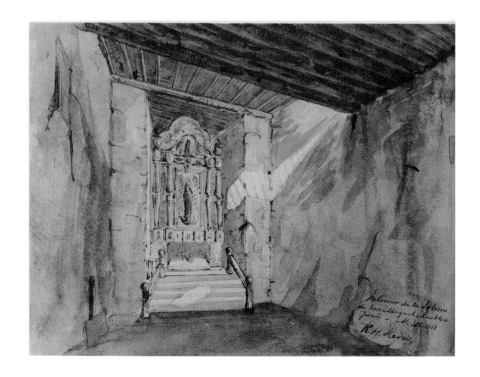

Figure 35

Miera y Pacheco, Altar screen dedicated to Our Lady of Guadalupe, *ca. 1774–1776, wood, gesso, paint, Bancroft Library, University of California, Berkeley.*

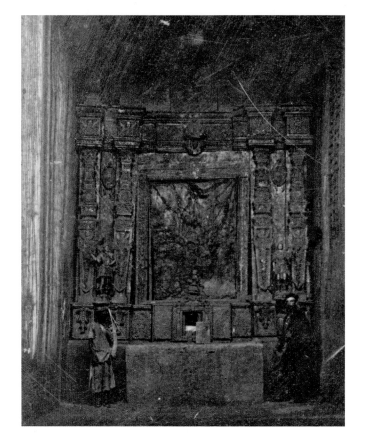

Figure 36
Miera y Pacheco, Altar screen dedicated to Our Lady of Guadalupe, *ca. 1774–1776, wood, gesso, paint, Palace of the Governors Photo Archives, Santa Fe, New Mexico.*

Figure 37
Miera y Pacheco, Shield of Sacred Heart and Decorative Bracket from Zuni altar screen, *ca. 1774–1776, wood, gesso, paint, 14 x 10 in. and 12 x 5 in. National Museum of American History, Smithsonian Institution, Washington, DC. The shield was burned in a 1965 fire.*

the painting and the roundels are unknown, while the image of the Christ Child is said to be the same one that is kept in a private home in Zuni today.[42]

The iconography of the Zuni altar screen merits discussion, as this would appear to be the earliest extant church in modern-day New Mexico dedicated to our Lady of Guadalupe. Although the church is at times referred to as Nuestra Señora de Candelaria, as well as La Purísima Concepción, it is the consensus among scholars of Zuni history that these references are all to the same church, in three rededications.[43] The church was presumably dedicated to Our Lady of Guadalupe at its 1699–1705 restoration, as its titular painting is recorded by Kern and others as dating to 1701.[44] The only earlier extant church dedicated to Our Lady of Guadalupe located in the colonial custody of New Mexico is now in Juárez, Mexico, owing to changes in international boundaries, and was dedicated in 1668.[45]

Our Lady of Guadalupe was the first apparition of the Virgin Mary in the Americas and, importantly, one that appeared to a native Mexican, Juan Diego. Devotion to the Virgin of Guadalupe grew among the native Mexican population throughout the next century. By the mid-seventeenth century the cult had spread to the Creole elite, and la Guadalupana became associated with pride in the Mexican nation, as is true today.[46] The Virgin of Guadalupe was declared patroness of New Spain in 1746,[47] and her cult was spread in northern New Spain particularly by the Franciscan missionaries of El Colegio de Nuestra Señora de Guadalupe, established in Zacatecas, Mexico, in 1707. Certainly this dedication of the church at Zuni was a conscious decision to request the aid of the Virgin as a mediator between the Spanish missionaries and the indigenous Zuni population.

The roundels depicting St. Francis and St. Dominic were also not a random selection. It would seem obvious to have an image of St. Francis, founder of the Franciscan Order that was charged with the conversion of the Indians of New Mexico, in the church. But St. Dominic was patron of the Dominican Order, and at the time there were no Dominican establishments north of the Valley of Mexico.[48] However, there were precedents for presenting the images of St. Francis and St. Dominic together, although the message was sometimes political rather than religious.

St. Francis and St. Dominic, both founders of mendicant orders in the thirteenth century, are said to have met at the Church of the Lateran in 1217, where they became friends. It is this church that St. Francis, and sometimes St. Dominic, are depicted as holding together, both physically and figuratively—an act that was revealed in a dream of Pope Innocent III. After having this dream, the Pope gave sanction to the rule of St. Francis, although there had been some opposition to the establishment of the order.[49]

The Franciscans and Dominicans also famously took opposing sides in a matter of church dogma. For over six centuries, theologians in the Roman

Catholic Church debated the concept of the Immaculate Conception of the Virgin. The Dominicans, who followed the teachings of St. Thomas Aquinas, argued that Mary was conceived in sin, as was all of humankind, while the Franciscans, led by John Duns Scotus, believed that she was conceived without original sin. This debate was perhaps most fervent in Spain and her colonies, where kings and clergy alike supported the doctrine of the Immaculate Conception. The Franciscans of the Province of the Holy Gospel in Mexico (of which New Mexico was a part) showed their support of the doctrine by wearing blue habits, the color of the Virgin Mary. Art came to the service of this debate, with artists such as Peter Paul Rubens, Francisco de Zurburán, and Bartolomé Esteban Murillo creating images of the Virgin of the Immaculate Conception long before the Church formally ruled. It was not until 1854 that the Church finally decreed Mary had indeed been conceived without original sin, and the theology of the Immaculate Conception became dogma.[50]

Thus these two saints or members of their orders, or even their emblems (*escudos*), have been depicted together over the centuries.[51] In New Spain, at the sixteenth-century mission church of San Miguel Huejotzingo, a mural depicts the Virgin Tota Pulchra (surrounded by symbols of her Immaculacy) flanked by St. Thomas Aquinas and Duns Scotus. Two eighteenth-century statues of Saints Dominic and Francis are found opposite one another, flanking the Chair of St. Peter, in the apse of St. Peter's Basilica in Rome. And in New Mexico, on the nineteenth-century altar screen at San José de Gracia in Las Trampas, they again are depicted with the Immaculate Conception, as well as the titular St. Joseph and the archangels Michael and Raphael.[52] At the mission church of Our Lady of Guadalupe at Zuni, there is yet another reason the Saint may have been depicted together—to show their united front against the Bourbon regime that had recently expelled, in 1767, the Jesuit Order from their missions in the Americas.

The two statues of St. Michael and St. Raphael at either side of the altar were also a common pairing in colonial iconography. Of the seven archangels, only three are mentioned by name in the bible: Michael, Raphael, and Gabriel. Raphael, "God's healer," and Michael were the archangels most often depicted in colonial and nineteenth-century New Mexico, reflecting popular devotion to these saints in New Spain. Typically clad in Roman armor with a helmet and sandals with greaves, St. Michael often carries a shield inscribed, as it is here, with the words *Quis ut Deus* ("who is as God;" also see fig. 24). St. Raphael is usually dressed in a traveler's cloak, carrying a staff and gourd, and a fish (see fig. 28), all symbolizing his journey with Tobias to find the gall from a fish to cure the blindness of Tobias's father.

It is curious that Domínguez does not mention the maker of the screen in his journal, for surely it is the work of his expedition's cartographer, Bernardo de Miera y Pacheco. In those pages Miera is mentioned but once as an artist,

in reference to an image of San Felipe Apóstol at San Felipe Pueblo. which Domínguez inspected in the spring of 1776, perhaps before ever meeting Don Bernardo: "A European citizen of this kingdom, called Don Bernardo Miera y Pacheco, … [sold] to the Indians of this pueblo . . . an image of the said Holy Apostle, a large carved statue in the round, which he made himself. And although it is not at all prepossessing, it serves the purpose and stands on the high altar at this mission."[53] However, this absence of mention seems to have been Domínguez's norm—in his letters and diary he also does not credit Miera with the maps that he made of their expedition into Ute territory. As others have noted, there was some discord between them on the trip which might have led to this omission, or perhaps the friar just didn't believe it necessary to name the author of maps and artwork when he was writing for the benefit of his religious superiors.[54]

In any case, the similarity of the Zuni altar screen to that of the Castrense is notable. The estípite columns are identical in both, with flat, low-relief floral and decorative motifs inside thick framing elements, combined with putti that sport the round faces of Miera's figures. The carving of the grapes is also quite similar, as well as the pronounced entablature and overall structure and layout of the screens.

The two statues of archangels are also key pieces in the attribution of the screen to Miera. According to Cushing, the remodeling of the Zuni mission took place under the direction of Fray Silvestre Vélez de Escalante after he was assigned to the mission in 1774.[55] In his biography of Richard H. Kern, David Weber suggests that the statues were made earlier, not specifically for the altar screen at Zuni, which lacks niches.[56] This is an interesting possibility, but the placement of statues on top of pedestals projecting from the screen, rather than in niches, was a distinguishing element of estípite Baroque altar screens, and the relative size of the archangels weighs in favor of them having been made as part of the ensemble.

Art historian E. Boyd was the first to identify these figures as the work of Miera.[57] She stated that they are clearly by the same hand as the San Felipe statue at San Felipe Pueblo and noted their similarity to the figures carved in relief at Castrense. The round heads with short necks, the drape of the garments, the splayed stance, and the realistic proportions of the figures all point to the same artist. And the use of Zuni blue on the statue of San Miguel ties Miera to the work. Additionally, the style, technique, and posturing of the saint indicate that the artist was very familiar with Spanish and Mexican artistic practices, as would have been true of Miera. The application of the gesso and paint on the clothing of St. Michael and particularly the convincingly executed flesh tones all suggest an artist conversant with formal training techniques.

Matilda Cox Stevenson, who along with her husband was responsible for bringing the sculptures to Washington, commented on the execution of the fig-

ures, one of which she illustrated in her 1881 publication *Zuni and the Zunians*: "… an illustration of one of the statues from Zuñi, which is remarkable for the enamel finish on the limbs and face."[58] In 1901, she again mentions this finish in *The Zuni Indians: Their Mythology, Esoteric Fraternities, and Ceremonies*: "the enamel finish on the face and limbs of the figures showing much artistic skill."[59] This enamel finish, which can still be seen on the statue of San Miguel, resembles the technique of *encarnación*, or the creation of flesh tones on sculpture, practiced widely in Spain and Mexico. Rather than simply placing a layer of paint on an image, the *encarnador* placed several layers, painstakingly polishing each in succession until the right sheen and appearance was achieved to make the most realistic flesh tones. It is clear from the conservation report on this figure that this technique was used in the creation of the San Miguel sculpture: "The paint surface, particularly in the flesh tones appears to be multi-layered … [and] there are indications that a surface coating might have been applied to certain areas, particularly in the flesh tones."[60] The use of gilding on the shield also suggests an artist with at least some training in the companion technique to *encarnación* known as *estofado*, in which carved sculpture was polychromed and partially gilded.

Other Altar Screens

SANTA CLARA PUEBLO

The mission church at Santa Clara Pueblo was rebuilt in 1758 under the direction of Fray Mariano Rodríguez de la Torre. In 1808 Fray José Benito Pereyro provided a brief description: "The church has three altars painted in tempera. The main one the Indians of the pueblo paid for, and the two side altars the Rev. Father fray Ramón Antonio González had made at his expense while he was minister of this mission."[61] Bandelier noted in 1888 that there were altar screens in the nave and transept that bore the date 1782.[62]

Although not an estípite screen, the main altar screen at Santa Clara may also be the work of Miera. First, the still-visible figures seen in the 1899 photo by Adam Clark Vroman (fig. 38) are stylistically similar to other images by Miera, particularly those on his maps (see Carrillo, this volume). The subtle curve of the body and the tilt of the head are fairly consistent among these renderings. Second, the image of God the Father bears the same papal tiara as the images on the Castrense altar screen and on Miera's maps. And lastly, the center image of Santiago astride his horse is also rendered in a similar fashion to that in the Castrense altar piece, with the awkward tilt of his head and upraised right arm. The image of San Rafael is very similar in style to the panel painting by Miera in the Museum of Spanish Colonial Art (see fig. 28). In both images, San Rafael wears a dark collar over what appears to be a cuirass along with a long cape and short tunic. The subtle curve in his stance is similar to that of the

Figure 38
Miera y Pacheco, Altar screen, ca. 1780, wood, gesso, paint, Santa Clara Pueblo, New Mexico, Palace of the Governors Photo Archives, Santa Fe, New Mexico.

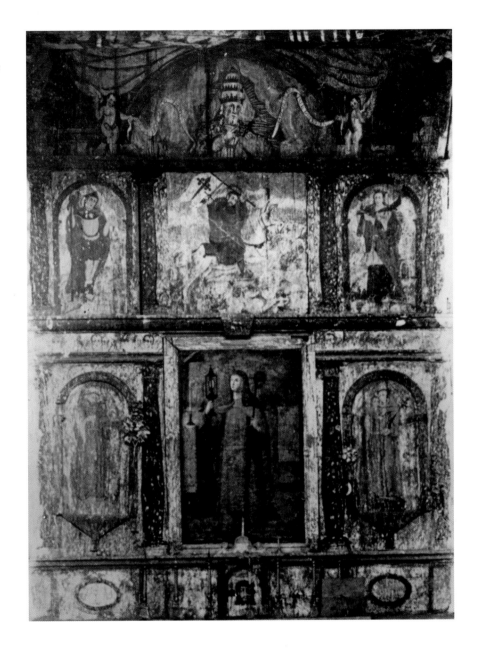

figure of the Comanche drawn on Miera's signed "Map of the Kingdom of New Mexico," ca. 1760 (see fig. 8). Although the columns in the Santa Clara screen appear to be two dimensional and more classical in outline than the estípites of the Castrense and Zuni altar screens, the horizontal emphasis in the layout, the arched attic and strong predella, as well as the overall proportions and rhythm of the screen, are in keeping with the two screens discussed above. Santiago, Santa Barbara, San Francisco, and San Antonio are fairly standard iconography for altar screens in New Mexico, reflecting popular devotion to these particular saints. There are no known extant panels from this altar screen.

In 1915, Gerald and Ina Sizer Cassidy purchased some of the remaining wooden pieces from the church of San Francisco de Nambé. One of these was a panel from the altar screen with an image of the Immaculate Conception, identified by E. Boyd as the work of Miera (fig. 39). This work bears particular resemblance to the above-mentioned panel painting of San Rafael dated 1780 (see fig. 28), especially in its facial features and expression, suggesting that the image of the Immaculate Conception was created about the same time. In addition, the Nambé altar screen is not described by Domínguez in 1776. As Miera died in 1785, the altar screen panels can be dated between 1777 and 1785.[63]

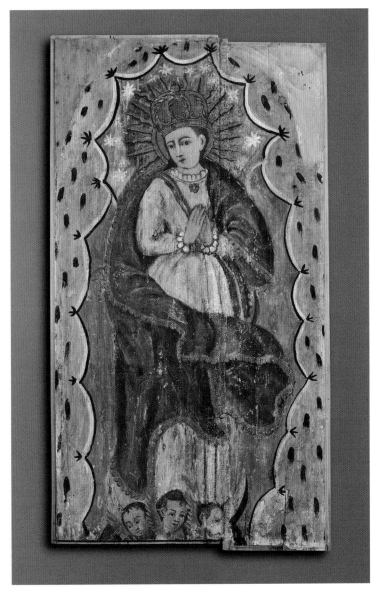

Figure 39
Miera y Pacheco, Virgin of the Immaculate Conception, *ca. 1780, wood, gesso, oil paint, 28 x 11 in. Nambé Pueblo, New Mexico, now at the Museum of International Folk Art, Santa Fe, New Mexico.*

A painted panel attributed to Miera and collected in Manzano, New Mexico, may also have been part of an altar screen at one time, although the church in Manzano was not built until 1830 (fig. 40). This depiction of San Antonio is quite similar to another panel of Santa Bárbara now in the collections of the Museum of Spanish Colonial Art that was acquired from a family in Belén, New Mexico (fig. 41), some twenty miles from Manzano in the central part of the state. The faces in these two pieces are also quite similar—very round, with double chins and rosy cheeks, suggesting that they were painted at the same time and perhaps for a single altar screen.

Several sculptural images by Miera may also have been initially associated with altar screens, as they are about the same size as the archangels from Zuni. One, mentioned above, was commissioned for the church of San Felipe. Another smaller one is still at the church of San José de Gracias in Las Trampas (fig. 42). An almost identical, but larger figure of St. Joseph is now in the

Figure 40
Miera y Pacheco, San Antonio, *ca. 1754–1785, wood, gesso, oil paint, 36 in.. Collected in Manzano, New Mexico.*

Figure 41
Miera y Pacheco, Santa Bárbara, *ca. 1780, wood, gesso, oil paint, 28 x 21 in. Museum of Spanish Colonial Art. Collected in Belén, New Mexico.*

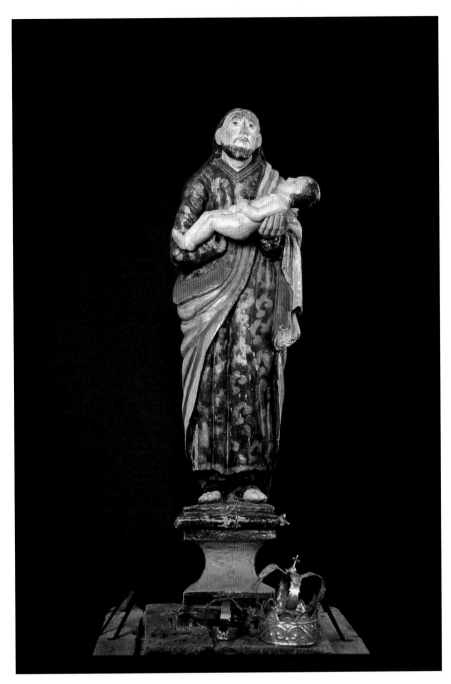

Figure 42
Miera y Pacheco, St. Joseph, ca. 1776, wood, gesso, paint, 34 ¼ x 8 in. Church of San José de Gracia, Las Trampas, New Mexico.

collections of the Archdiocese of Santa Fe with an unknown provenance (see fig. 27), although it may have come from the main parish church of Santa Fe, which had a side altar dedicated to St. Joseph. The foreshortened, slightly awkward poses of these figures suggest that they may have been intended to be

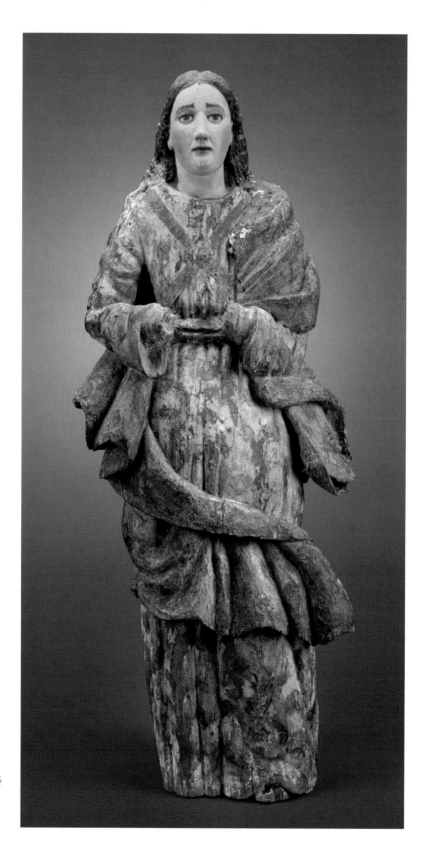

Figure 43
Miera y Pacheco, Virgin of the
Immaculate Conception, *ca. 1754–
1785, wood, gesso, oil paint, 42¼ x 17½
in. Museum of International Folk Art,
Santa Fe, New Mexico.*

placed in an altar screen and viewed from below. There is also a large statue of the Virgin in the Museum of International Folk Art that may have been part of an altar screen ensemble (fig. 43).

<div align="center"><i>Miera's Legacy</i></div>

Miera's life points to the cross-cultural interaction taking place in colonial New Mexico. Although a resident of the Spanish town of Santa Fe, Miera was *alcalde* of the Indian pueblos of Pecos and Galisteo, and he traveled extensively throughout the region as a military engineer and cartographer. His artwork has been identified at the pueblos of San Felipe, Santa Clara, Zuni, and Nambé, as well as in the Spanish towns of Las Trampas, Manzano, Belén, and Santa Fe. At Zuni, Domínguez recorded that the Indians shared in the cost of the altar screen, and Fray Juan Bautista Ladrón del Niño de Guevara made the same observation about the main altar at Santa Clara.[64] This suggests that the residents of the pueblos, as donors to the construction of the altar screens, likely participated in the decision making regarding the style of the screen as well as the choice of the saints depicted, as has been recorded in several instances in Mexico.[65] Commissioned to make art for Pueblo mission churches, Miera would have lived in the pueblos temporarily during construction and would probably have hired and trained assistants from the local native populations, some of whom may have joined the next generation of artists. He also learned from his hosts, as from the Indians of Zuni Pueblo, from whom he learned to make the azurite blue paint that he prized.

During construction of the Castrense and Zuni screens, he introduced the estípite Baroque style to New Mexico. Miera was one of, if not the first, to use this cutting-edge style north of the Valley of Mexico. Rather than being outdated in his work, he was instead in the center of an artistic revolution—artists and architects throughout the northern frontier were in the process of transforming the estípite Baroque into a uniquely American aesthetic. He was also the first to install a carved stone altar screen on the interior of a church.

However, Miera began the process of adaptation by altering the estípite column in New Mexico from the carved and gilded version of Spain and Mexico to a polychromed wood (Zuni) or painted stone (Castrense) variation in New Mexico. Although Miera still executed his columns in a fully three-dimensional manner, the estípite column was altered further by later New Mexican artists, such as Rafael Aragón, to an abstracted, two-dimensional, painted form retaining only the geometric outline of the original, in an example of form being chosen over function (fig. 44). A long-lived example of cultural exchange and the appropriation and alteration of outside forms, the New Mexican variation on the estípite column was used on altar screens for churches in both Spanish villages and Indian pueblos into the mid-nineteenth century.

las tres divinas personas | Nuestro padre Jesus | Son Jose de la tierra gracia

Figure 44

Rafael Aragón, Altar screen, ca. *1838, wood, gesso, organic watercolor pigments, Talpa, New Mexico, now at Taylor Museum of the Colorado Springs Fine Arts Center.*

The stylized estípite *columns can be seen to either side of the Holy Trinity.*

In his work in both Spanish towns and Indian pueblos, he would have worked with assistants and apprentices. In the process, he must have been instrumental in passing on the fundamentals of altar screen construction and layout. He also introduced some of the basic aspects of Baroque sculpture and painting to the region, including the techniques of foreshortening, *encarnación* and *estofado* as well as some iconographic themes that remained popular for decades. As the distinctive New Mexican style evolved, many later artists soon altered these techniques, but the basic foundation as well as the tendency toward appropriating local elements and materials were both established by Miera y Pacheco, paving the way for subsequent generations of local artists.

Notes

1. The authors wish to thank colleagues Tom Chávez, Claire Farago, John Kessell, Nancy Mann, Felipe Mirabal, Cordelia T. Snow, Julie Wilson, William Wroth, and the late Richard Rudisill. Some portions of this essay are adapted from previous publications by the authors (see citations below).

2. Judith Berg Sobré, *Behind the Altar Table.* Also see Jesús M. Palomero Páramo, *El retablo sevillano del renacimiento* (Seville: Diputación Provincial de Sevilla, 1983) and Joseph A. Baird, *Los retablos del siglo XVIII en el sur de España, Portugal y México* (Mexico: Universidad Nacional Autónoma de Mexico, 1987).

3. The term "reredos," which has been used in recent years to refer to these screens, is actually from late Middle English, derived from Old French meaning "behind" or "in back of." This name seems to have been popularized by early twentieth-century Anglo-American writers supplying Anglo-American terminology for the artwork they found in the southwestern U.S. The use of the word *retablo* for smaller paintings on wooden panels also appears to have started at this time; in historic documents these paintings on wood are usually listed as *"imágines de pincel sobre madera"* (painted images on wood) or something similar.

4. This unpublished document is in the Archivo General de las Indias in Seville, Spain, Contaduría, legajo 714, LBB no. 235, ff. 351–52. For a translation see Frederick Webb Hodge, George P. Hammond, and Agapito Rey, *Fray Alonso de Benavides' Revised Memorial of 1634* (Albuquerque, NM: University of New Mexico Press, 1945), Appendix IV, 109–124. Based on descriptions and measurements of the packing crates for this altar screen, Jake Ivey calculated the approximate size and format of the piece, and Pierce analyzed the probable style and iconography. See Ivey, "'El Ultimo Poblado del Mundo' (The Last Place On Earth)," 177–95; and Donna Pierce, "Heaven on Earth: Church Furnishings in Seventeenth-Century New Mexico," 197–208.

5. Portions of altars had been imported earlier, including two large carved and gilded tabernacles in 1612 and a large carved and gilded octagonal baldachin incorporating oil paintings in 1624. See Ivey, "El Ultimo Poblado," and Pierce, "Heaven on Earth."

6. This unpublished document is in the Biblioteca Nacional de Mexico, legajo 1, document 34 and is partially translated in Scholes and Adams, "Inventories of Church Furnishings in Some of the New Mexico Missions, 1672," 27–38. For detailed analyses of these altar screens see Ivey, "El Ultimo Poblado," and Pierce, "Heaven on Earth." The document also inventories three other altar screens made in Mexico in the New Mexico mission churches of Tajique and Chilili; it implies such screens were present in other New Mexico churches including Socorro and Hawikuh. Archeological evidence indicates the presence of some of these screens as well as others at Quarai and Abó.

7. Fray Angélico Chávez, *Origins of New Mexico Families*, 39, 76.

8. For discussion of the distinctive style of New Mexico's colonial art, see Farago and Pierce, eds., *Transforming Images: New Mexican Santos In-Between Worlds;* and William Wroth and Robin Farwell Gavin, *Converging Streams: Art of the Hispanic and Native American Southwest* (Museum of Spanish Colonial Art, 2010).

9. See Kessell, *Miera y Pacheco: A Renaissance Spaniard in Eighteenth-Century New Mexico.* The authors thank Kessell for generously providing them with a copy of his unpublished manuscript. Also see Chávez, *Origins*, 229–30.

10. Although Chávez (*Origins*) and Kessell (*Miera y Pacheco*) state that he moved to Santa Fe in 1756, Miera y Pacheco's own autobiography attached to the Domínguez-Escalante report stated that he came to Santa Fe with his family with Governor Marín del Valle at the beginning of his administration in 1754. For a translation of this document see Herbert S. Auerbach, "Father Escalante's Journal," *Utah Historical Quarterly* 11 (1943); 120–22. Also see Mirabal and Pierce, "The Mystery of the Cristo Rey Altar Screen and Don Bernardo de Miera y Pacheco," 60–67.

11. Chávez, *Origins*.

12. Adams and Chávez, trans. and eds., *The Missions of New Mexico, 1776*, 160–61.

13. E. Boyd did the pioneering work on Miera y Pacheco, as well as most New Mexican colonial artists. See E. Boyd, *Popular Arts of Spanish New Mexico*, 100–02. Also see William Wroth, *Christian Images in Hispanic New Mexico*. At the time, Wroth attributed this body of work to the Provincial Academic I. For a detailed discussion of the maps by Miera y Pacheco, see Michael Frederick Weber, "Tierra Incognita: The Spanish Cartography of the American Southwest, 1540–1803," (PhD diss., University of New Mexico, 1986). Also see Kessell, *Miera y Pacheco*.

14. Portions of this discussion are adapted from Donna Pierce, "Historical Introduction," "Saints in the Hispanic World," and "Saints in New Mexico," in *Spanish New Mexico: The Spanish Colonial Arts Society Collection*, 1–60; from Pierce and Mirabal, "The Mystery"; from Donna Pierce, "The Life of an Artist: The Case of Captain Bernardo Miera y Pacheco," in *Transforming Images*, 134–37; and from Donna Pierce, "From New Spain to New Mexico: Art and Culture on the Northern Frontier," 59–68.

15. H. Bailey Carroll and J. Villasana Haggard, trans. and eds., *Three New Mexico Chronicles: The exposición of don Pedro Bautista Pino, 1812; The Ojeada of Lic. Antonio Barriero, 1832; and the additions by Don José Agustín de Escudero, 1849*, Quivira Society Publications, vol. 2 (Albuquerque, NM: Quivira Society, 1942), 2:99. In his exposition on the natural resources of New Mexico, Pino states: "There are soils of various colors—blue, green, yellow, white, red. In the Zuni pueblo, there is to be found a soil of an azure or Persian blue color which Don Bernardo de Miera, a mathematician and painter has asserted could be made into a useful commercial product because it furnishes a perfect paint of that color," 99.

16. Chemical analysis conducted on the surviving statue of St. Michael revealed azurite blue paint. Jia-sun Tsang, unpublished treatment report, Conservation Analytical Laboratory Examination Report and Treatment Proposal, Paintings Conservation Department, Smithsonian Institution, CAL # 5286, March 26, 1991, and personal communication with Pierce, 1995.

17. Rutherford J. Gettens and Evan H. Turner, "The Materials and Methods of Some Religious Paintings of Early Nineteenth-Century New Mexico," in *El Palacio* 58, no. 1 (Jan. 1951): 1–9.

18. Alexander von Wuthenau, "The Spanish Military Chapel in Santa Fe and the Reredos of Our Lady of Light," 175–94. After the destruction of the Castrense chapel in the nineteenth century, the stone altar screen was stored in a small room behind the apse of the Cathedral of Santa Fe until it was installed in the newly-constructed Church of Cristo Rey in 1940.

19. Pál Kelemen, "The Significance of the Stone Retable of Cristo Rey," 243–72.

20. Mirabal and Pierce, "The Mystery of the Cristo Rey Altar Screen." Also see Pierce, "The Life of an Artist."

21. Juan José Martín González, *El retablo barroco en España* (Madrid: Editorial Alpuerto, 1993), 169–70; Juan José Martín González, *Escultura barroca en España, 1600–1770* (Madrid: Manuales Arte Catedra, 1983), 470–71; Juan José Martín González, *Escultura barroca castellana* (1959; repr. Madrid: Lázaro Galdiano, 1971), 2: 187–88, figs. 272–77; Floriano Ballesteros Caballero, "El retablo mayor del antiguo colegio de la Companía de Jesus de Burgos," *Boletín del Seminario de Estudios de Arte y Arqueologia* (Valladolid: University of Valladolid, Facultad de Filosofia de Letras, 1975), 273–86; and Manuel Ayala López, "La capilla de Santa Tecla en la S.I.C.B.M. de Burgos," *Boletín de la Comisión de Documentos de Burgos* 4 (1934–1937): 388ff.

22. Kessell, *Miera y Pacheco*.

23. Martín González, *Escultura barroca castellana*, 2: 188; Ballesteros Caballero, "El retablo mayor," 285–86.

24. Kessell, *Miera y Pacheco*.

25. J. A. Ceán Bermúdez, *Descripción artística de la Catedral de Sevilla* (Seville, 1804), as quoted in George Kubler and Martin Soria, *Art and Architecture in Spain and Portugal and Their American Dominions, 1500–1800* (Baltimore: Penguin Books, 1959), 159.

26. Rogelio Ruiz Gomar, "Capilla de los reyes," in *Catedral de México: Patrimonio artística y cultural* (Mexico: Instituto Nacional de Antropología e Historia, 1986), 16–43.

27. See Juana Gutiérrez Haces, "The Eighteenth Century: A Changing Kingdom and Artistic Style," in *The Grandeur of Viceregal Mexico: Treasures from the Museo Franz Mayer* (Houston and Mexico City: Museum of Fine Arts and Museo Franz Mayer, 2002), 45–67; Johanna Hecht, "Creole Identity and

the Transmutation of European Forms," in *Mexico: Splendors of Thirty Centuries* (New York: Metropolitan Museum of Art, 1990), 286–314; Victor M. Gonza-léz Esparza, "El estípite o la representación del nacionalismo criollo: hacia una nueva historia cultural." Paper delivered at the annual meeting of the American Society for Eighteenth-Century Studies, March 18–21, 2010, Albuquerque, NM.

28. Baird, *Los retablos,* 128–252; Clara Bargellini, *La arquitectura de la plata: Iglesias monumentales del centro-norte, 1540–1750* (Mexico: Universidad Nacional Autónoma de Mexico, 1991); and, most recently, see the outstanding and much-anticipated publication by Gloria Fraser Giffords, *Sanctuaries of Earth, Stone, and Light: The Churches of Northern New Spain, 1530–1821.*

29. "Piedras canteras. Las hai de jaspe blanco hermoso y de otro mas comun del que se fabricó el colateral, repisas y púlpito de la capilla castrense de Santa Fe...." Don Pedro Baptista Pino, *The Exposition on the Province of New Mexico, 1812,* translated and edited by Adrian Bustamante and Marc Simmons (Santa Fe and Albuquerque: El Rancho de las Golondrinas and University of New Mexico Press, 1995), 12 of transcription. (In the English translation in this volume the word "colateral" is mistranslated as "side pedestal" rather than as "altar screen.") Also see Adams and Chávez, *The Missions of New Mexico,* 60.

30. Clara Bargellini, Elisabeth Fuentes et al., *Los retablos de la ciudad de México,* 242. For San Luis Potosí see Francisco de la Maza, *El Arte Colonial en San Luis Potosí* (Mexico: Universidad Nacional Autónoma de Mexico, 1985), 83–85, and Baird, *Los retablos,* 189–91, 402–3. Baird states that the Carmen screens are not carved stone, but rather made of *argamasa,* a type of stucco made from ground stone. Two altar screens in the state of Puebla are partially, but not entirely, constructed from local alabaster (*tecali*): the main altar screen in the Cathedral of Puebla (installed in 1649 but much reconstructed) and one in the chapel of San José de Chiapa dated after 1769. See Francisco de la Maza, *El alabastro en el arte colonial de México* (Mexico: Instituto Nacional de Antropología e Historia, 1966), 31–34, 47–50, and Maza, *La capilla de San José de Chiapa* (Mexico: Instituto Nacional de Antropología e Historia, 1960).

31. See Clara Bargellini, *La catedral de Chihuahua* (Mexico: Universidad Nacional Autónoma de Mexico, 1984).

32. See the excellent summary of this topic in John McAndrew, *Open-Air Churches of Sixteenth-Century Mexico: Atrios, Posas, Open Chapels, and Other Studies,* 393–97. Also see Charlene Villaseñor-Black, *Creating the Cult of St. Joseph: Art and Gender in the Spanish Empire* (Princeton and Oxford: Princeton University Press, 2006); Joseph F. Chorpenning, O.S.F.S., "The Iconography of Saint Joseph in Mexican Devotional Retablos," in *Mexican Devotional Retablos from the Peters Collection* (Philadelphia: Saint Joseph's University Press, 1994), 39–92;

and Chorpenning, *Patron Saint of the New World: Spanish American Colonial Images of Saint Joseph* (Philadelphia: Saint Joseph's University Press, 1992).

33. Kelemen, "The Significance of the Stone Retable"; Victoria Martínez López, *Valvanera: En el umbral del Tercer Milenio* (Logroño: Editorial Ochoa, 1997); Alejandro Perez Alonso, *Historia de la Real Abadía de Nuestra Señora de Valvanera en la Rioja* (Oviedo: Instituto de Estudios Riojanos y Catedral de Oviedo, 1971). Also see Bernard L. Fontana, "Nuestra Señora de Valvanera in the Southwest," 79–92.

34. Guillermo Tovar de Teresa, *Miguel Cabrera: Drawing Room Painter of the Heavenly Queen* (Mexico: InverMexico, 1995), 121, 187–196, 250; Luis González Obregon, *México viejo* (Mexico: Viuda de Bouret, 1900), 314–25.

35. Emigrants from northern Spain to Mexico in the eighteenth century seem to have had a close association with the Franciscans in Mexico City since three special chapels were funded at San Francisco, including that of Valvanera supported by Riojans; one for the Christ of Burgos supported by natives of Burgos; and one for the Virgin of Aranzazú supported by Basques. Tovar de Teresa, *Miguel Cabrera*, 187.

36. William B. Taylor, *Shrines and Miraculous Images*, 52–56.

37. Personal observation by Pierce when the painting was borrowed for an exhibition she curated at the Palace of the Governors, Santa Fe, in 1994. The painting measures 68½ by 49¾ inches; the niche measures 59 by 35 inches. Before conservation, marks on the canvas indicated it may have been folded by approximately these same dimensions.

38. Guillermo Tovar de Teresa, *Renacimiento en México: artistas y retablos* (Mexico: Instituto Nacional de Antropología e Historia, 1982).

39. Adams and Chávez, *Missions of New Mexico*, 198.

40. David J. Weber, *Richard H. Kern: Expeditionary Artist in the Far Southwest 1848–1853* (Albuquerque: University of New Mexico Press for the Amon Carter Museum, 1985), fig. 80. Several other scholars had also deduced that this was a figure of San Rafael and not San Gabriel. See Boyd, *Popular Arts*, 115; Kessell, *Miera y Pacheco*, 124; E. Richard Hart, *A Brief History of Religious Objects from the Old Zuni Mission* (Seattle: The Institute of the North American West, n.d.), unpublished ms., 24.

41. Galbraith identified the *escudo* as a "font for holy water" in his shipment list, but in 1961 E. Boyd, curator for the Museum of New Mexico and the Spanish Colonial Arts Society in Santa Fe, correctly identified it as an armorial shield (National Museum of American History, Smithsonian Institution, Cat. No. 41913, Acc. No. 9899). We would like to propose here that the shield with its

carved crown was originally located above the painting of Our Lady of Guadalupe as can be seen in the photo by O'Sullivan (1873). In addition, the decorative scroll probably came from the altar screen base (predella) beneath one of the statues, as can also be seen in the photo by O'Sullivan. We are indebted to Steve Velasquez for sharing his files with us. Cushing reported that the objects were removed by the Stevensons in 1879 (Hart, *A Brief History*, 3.)

42. Hart, *A Brief History*, 4. He identifies the home as that of the Kanesta family. The altar screen was reportedly repainted and gilded in 1780; see Kessell, *The Missions of New Mexico Since 1776*, n. 4, 214.

43. George Kubler, *The Religious Architecture of New Mexico in the Colonial Period and Since the American Occupation*, 118; Hart, *A Brief History*, 2; Adams and Chávez, *The Missions of New Mexico*, n. 2, 197–198.

44. The painting of Our Lady of Guadalupe, which "the king had given before," was dated 1701 and signed by an artist with the first name of Miguel. Hart, *A Brief History*, 7 citing Lewis Burt Lesley, *Uncle Sam's Camels: The Journal of May Humphreys Stacey Supplemented by the Report of Edward Fitzgerald Beale, 1857–1858*, (Cambridge: Harvard University Press, 1929), 188–89. See also Kern's sketch of the altar, which has the date 1701 below, in Weber, *Richard H. Kern*, fig. 81.

45. The dedication ceremony of this church is described in France V. Scholes, "Documents for the History of the New Mexico Missions in the Seventeenth Century," *New Mexico Historical Review* 4, no. 2 (1929): 195–201.

46. Johanna Hecht, "Virgin of Guadalupe," in *Mexico: Splendors*, 347.

47. Stafford Poole, *Our Lady of Guadalupe: the Origins and Source of a Mexican National Symbol* (Tucson: University of Arizona Press, 1996, 2nd printing), 3.

48. The northernmost Dominican mission establishment seems to have been in Ecatepec, just outside of Mexico City. See Robert Ricard, *The Spiritual Conquest of Mexico*, translated by Lesley Bird Simpson (Berkeley: University of California Press; 1966, reprint 1974), 62–63.

49. "St. Francis of Assisi," *The Catholic Encyclopedia* on-line. http://newadvent. org/cathen/06221a.htm.

50. See Suzanne L. Stratton, *The Immaculate Conception in Spanish Art* (New York: Cambridge University Press, 1994) and "Immaculate Conception," *The Catholic Encyclopedia* on-line. http://www.newadvent.org/cathen/ 07674d.htm.

51. See for instance: Giffords, *Sanctuaries of Earth*, 387; Bargellini, "Choir Book," in Donna Pierce, Clara Bargellini, and Rogelio Ruiz Gomar, *Painting a New World: Mexican Art and Life, 1521–1821* (Denver: Denver Art Museum, 2004), 251–52; Rosa Dopazo Durán, "Virgin of the Rosary," in *The Grandeur of*

Viceregal Mexico: Treasures from the Museo Franz Mayer, by Héctor Rivero Borrell M. et al. (Houston: Museo Franz Mayer and the Houston Museum of Fine Arts, 2002, 344); Suzanne Stratton-Pruitt, *The Virgin, Saints and Angels*, 158–59; and Marcus Burke, *Treasures of Mexican Colonial Painting*, 62–64.

52. See McAndrew, *Open Air Churches*, 34 and David Wakely, *A Sense of Mission: Historic Churches of the Southwest* (San Francisco: Chronicle Books, 1994), 66, 68. This image, attributed to José de Gracia Gonzales (active in New Mexico 1860–ca. 1875), is thought to cover an identical eighteenth-century image, but as of this date the evidence for this is circumstantial.

53. Adams and Chávez, *Missions of New Mexico*, 160.

54. Greg Mac Gregor and Siegfried Halus, *In Search of Domínguez and Escalante*, 131–35. Fray Silvestre also seems to have had a questionable opinion of Don Bernardo, as he stated in a letter to the Provincial Fray Isidro Murillo in 1776: "With regard to Don Bernardo de Miera, I state that, if I am not mistaken, I merely said in my letter that he would be useful as one of those who were to go, not to command the expedition, but to make a map of the terrain explored. And I state that only for this do I consider him useful." Adams and Chávez, *The Missions of New Mexico*, 307.

55. As cited in Hart, *A Brief History*, 8.

56. Weber, *Richard H. Kern*, 157.

57. E. Boyd, *Popular Arts*, 102. The statue of San Gabriel was destroyed by fire at the Smithsonian in 1965; the statue of San Miguel was recently repatriated to Zuni Pueblo and is on view at the Visitor Center at Zuni Pueblo.

58. Tilly E. Stevenson, *Zuni and the Zunians* (Washington, DC: Government Printing Office 1881), 9–10.

59. Matilda Coxe Stevenson, *Twenty-Third Annual Report of the Bureau of American Ethnology* (Washington, DC: Government Printing Office, 1904), 16–17.

60. Tsang, Conservation Analytical Laboratory Examination Report.

61. As translated in Kessell, *Missions of New Mexico*, 244. Kessell notes that Fray Ramón was minister of the mission from 1782 to 1787.

62. Kessell, *Missions of New Mexico*, 115–16.

63. Although we have no provenance information for the San Rafael panel painting, Felipe Mirabal has noted that the mountains in the background of the panel bear a striking resemblance to the Organ Mountains near La Mesilla and Las Cruces, New Mexico. Felipe Mirabal, personal communication, February 3, 2013.

64. Kessell, *Missions of New Mexico,* 116. Fray Juan Bautista Ladrón del Niño de Guevara, Santa Clara, July 19–30, 1818, Archives of the Archdiocese of Santa Fe, Accounts, Book LXII (Box 5).

65. The best documented example is that of the Indians of Huejotzingo mission, who commissioned a large altar screen for their church in 1584. See Guillermo Tovar de Teresa, *Pintura y escultura del renacimiento en México* (Mexico: Instituto Nacional de Antropología e Historia, 1978), 282–91; for a summary in English see Donna Pierce, "At the Crossroads: Cultural Confluence and Daily Life in Mexico, 1521–1821," in, Pierce, *Painting a New World,* 25–45.

Bernardo Miera y Pacheco and the New Mexico Santeros of the Nineteenth Century

by William Wroth

When recently I reread this conclusion by Toussaint to his chapter "Arte Popular," it was one of those serendipitous moments. I looked up from the text to see the full-page photograph of the eighteenth-century altar screen from the Castrense church in Santa Fe, a work which we now know was created by Bernardo Miera y Pacheco.[2] In 1945 when Toussaint completed his work (it was published in 1948), our field was in its infancy. E. Boyd had yet to publish her first work on New Mexican santos, the only previous book being Mitchell Wilder and Edgar Breitenbach's *Santos: The Religious Folk Art of New Mexico* in 1943. How much we have learned since 1945 and yet how much we still don't know! Toussaint's prescient words are still valid today. We need to apply a discerning eye to our materials and a capacious judgment, and indeed the seas are complicated and stormy. The essay to follow, occasioned by the rediscovery of a lost painting of Santa Bárbara by Miera, is an attempt to shed more light on the still mysterious and fascinating art of the making of religious images in colonial and nineteenth-century New Mexico.

Here I will consider the possible effect Miera's work may have had on the santeros who followed him in the nineteenth century, first dealing with iconographical influences and then with stylistic influences. In both areas a positive, that is cause-and-effect pinning down of influence is difficult to find. In fact, much of the evidence points towards the *absence* of identifiable influence of

Within this category [of popular arts], a multitude of works are available for the scholar, but the eye must be very careful to discern their nuances, and the judgment very capacious neither to minimize their merits nor exaggerate their qualities. We must navigate with a skilled and accurate hand on the rudder through the complicated and often stormy seas of our popular arts. (Manuel Toussaint, Arte Colonial en México) [1]

Miera on the later artists. However, the reasons for this lack of connection are important in themselves and will be explored for the light they shed upon both the art of religious image-making and the complexities and changes in New Mexico society in the period from about 1750 to 1850.

Iconographic Influences

There are few iconographic influences upon later santeros that can be attributed to Miera's work. The most likely are two figures, both of which appear on the Castrense altar screen: Nuestra Señora de Valvanera and Dios Padre (fig. 45). Nuestra Señora de Valvanera is a miraculous advocation of the Virgin Mary from the Rioja region in Spain, said to have been hidden in a hollow oak tree during the Moorish occupation and miraculously rediscovered in the tenth century in a vision by a reformed thief, Nuño Oñez. In the colonial period devotion to Nuestra Señora de Valvanera spread throughout Latin America. A church and convent dedicated to her in Mexico City was founded in 1573, then rebuilt and rededicated in 1671.[3] Another church, Nuestra Señora de Balvanera de la Aduana, was built in Aduana, near Alamos, Sonora, in the first half of

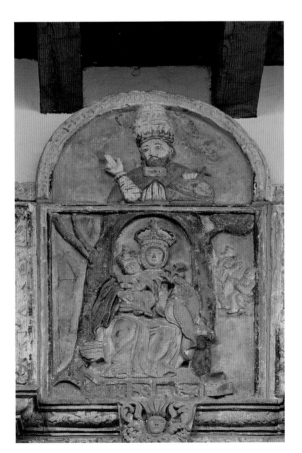

Figure 45.
Miera y Pacheco, Nuestra Señora de Valvanera *and* Dios Padre *at top of altar screen, 1761, volcanic stone, paint. Cristo Rey Church, Santa Fe, New Mexico.*

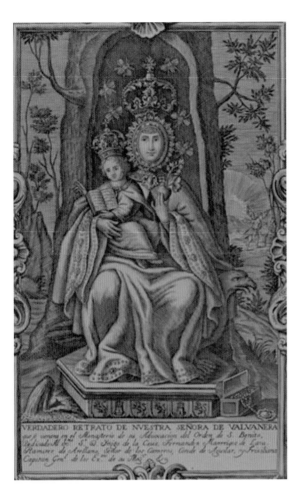

Figure 46
Verdadero Retrato de Nuestra
Señora de Valvanera, *18th century,
engraving on paper, 19½ x 15¾ in.,
Logroño, Spain.*

the eighteenth century.⁴ Her image most likely appears on the Castrense altar
screen because the patron who built the church, New Mexico Governor Don
Francisco Antonio Marín del Valle, was from the Rioja region in Spain.

While Miera may have seen paintings of Nuestra Señora de Valvanera in
Spain or Mexico, he based his rendering for the Castrense altar screen directly
upon an eighteenth-century devotional print, "Verdadero Retrato de Nuestra
Señora de Valvanera" (fig. 46). Miera's stone relief exactly copies all the key
attributes found in the print, such as the crowns of Mary and the Christ Child,
the *rostrillo* surrounding Mary's face, the book in the Christ Child's hand, and
the apple in Mary's hand from which a cross has sprouted. Of particular inter-
est in the print is the bird upon which Mary is seated. This is emblematic of one
of the four eagles of which Nuestra Señora de Valvanera's throne was said to
have been constructed. ⁵ Miera's rendering includes many small details carefully
copied from the print, such as the lion and castle motifs (symbols of Leon and
Castile) carved on the front of the hexagonal base of the chair, the box of pearls
next to the base, and on the right side the angel imparting to Nuño Oñez the

Figure 47
José Rafael Aragón, Nuestra Señora
de Valvanera, *ca. 1830 – 1862, water-
based paint on pine, 16 x 15¼ in Taylor
Museum of the Colorado Springs Fine
Arts Center.*

vision of the oak tree containing the sacred statue. Even all the details of Mary's
robe exactly match those in the print. It is not surprising that Miera depended
upon a print to create his image of Nuestra Señora de Valvanera. Artists in
colonial Mexico and elsewhere in Spanish America, including the most highly
trained academic artists, used prints as sources for both painting and sculpture. [6]

A nineteenth-century retablo of Nuestra Señora de Valvanera by José
Rafael Aragón (working dates 1820–1862) (fig. 47) may have been inspired
by Miera's carved stone relief on the Castrense altar screen. [7] It is a half-length
portrait, no doubt intended for devotional purposes. The narrative elements are
gone, as are some of the other attributes such as the eagle. Mary's crown and
rostrillo are present but much simplified. The oak tree enclosing Mary and the
Christ Child is quite abstracted, and the Child is on the right side instead of the
left. He, not Mary, holds the apple.

On the Castrense altar screen, directly above Nuestra Señora de Val-
vanera, is Miera's carved image of Dios Padre, who typically is placed in the
highest position on an altar screen. This image may have been the inspiration

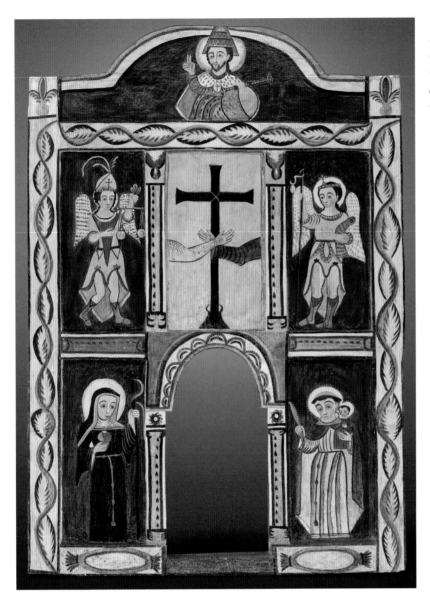

Figure 48
José Rafael Aragón Dios Padre *on altar screen, Vadito, New Mexico, ca. 1830–1862, water-based paint on pine. Museum of International Folk Art, Santa Fe, New Mexico.*

for at least three later pieces by José Rafael Aragón. On the altar screen he painted for the church in Vadito (fig. 48), Aragón has placed a half-length depiction of Dios Padre in an arched crest, as did Miera. Both Miera's and Aragón's images show the bearded Dios Padre wearing the three-tiered papal crown, making the gesture of blessing with two fingers of his right hand. In his left hand, in both images, Dios Padre holds the globe. In Miera's version, the globe is surmounted by the cross, while Aragón has made the cross a pendant at the center and has added the scepter – symbol of authority – to the left hand. Aragón's separate full-length portrayal of Dios Padre in the Taylor Museum follows Miera's in the above attributes, except the left hand holds only the scepter, not the globe.

Aragón had originally placed three lightning bolts—symbols of divine judgment—in the right hand, then replaced them with the blessing gesture. Aragón has also added the triangular halo around the head, symbol of the Holy Trinity and includes at the top a depiction of the Holy Spirit as a descending dove. [8]

Since Aragón lived in Santa Fe as a young man, until the death of his first wife in 1832, it is likely that he spent time in the Castrense church on the Santa Fe Plaza, and one can imagine the young artist sketching some of the images on the altar screen for later use. The images of Dios Padre and Nuestra Señora de Valvanera are attributed to his later working period, beginning in the mid-1830s, which may account for the variations in attributes.

Another artist who may have been inspired by Miera's depiction of Dios Padre is the Truchas Master, whose work has been attributed to Pedro Fresquís. His altar screen in the village of Las Truchas, probably painted by 1818, is surmounted by a rendering of Dios Padre (fig. 49), which bears some elements of Miera's piece. Dios Padre is making the gesture of blessing with his right hand. Like Miera's piece, his face is turned slightly to the right. Of particular interest is the rectangular yellow brooch that fastens his robe, almost identical to that depicted by Miera. However, he lacks the three-tiered crown, having instead the triangular halo, and he holds the scepter in his left hand.

Figure 49
Pedro Fresquís, Dios Padre *on altar screen (detail, top center), ca. 1818, water-based paint on pine, Nuestra Señora del Rosario de Truchas, New Mexico.*

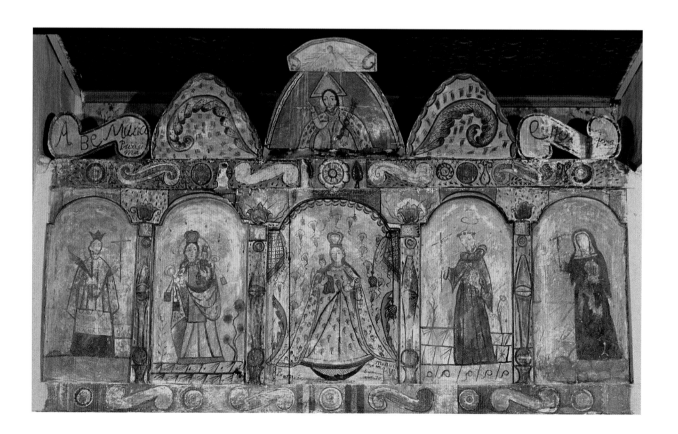

Fresquís may have been directly inspired by Miera's work or may have been working from a print, as he apparently did in many of his smaller retablos.[9]

Most of the other extant works attributed to Miera are of popular saints and holy personages well known throughout the Catholic world in the eighteenth century: San Rafael, San Miguel, San José, San Antonio, Santa Bárbara, Santiago, San Ignacio, San Juan Nepomuceno, Nuestra Señora de la Concepción Inmaculada, and Nuestra Señora de la Luz.[10] All of these popular figures were depicted by the nineteenth-century santeros as well, with certain customary attributes that served both to identify the personage and encapsulate his or her qualities. In addition to the work of Miera, there were several other sources of these popular images available to the santeros.

Printed images were available both as separate devotional prints (*hojas religiosas*) and as illustrations in books. In addition, many churches in larger communities and in Indian pueblos were graced with oil paintings sent from Mexico that would also have inspired the santeros. One example is the retablo of La Sagrada Familia con Ana y Joaquín (also known as Los Cinco Señores) attributed to Pedro Fresquís (fig. 50). Fresquís most likely was inspired by the Mexican oil painting of the same subject on the main altar screen of the Santa Cruz de la Cañada Church (fig. 51). Fresquís's family was from Santa Cruz;

Figure 50
Pedro Fresquís, La Sagrada Familia con Ana y Joaquín (Los Cinco Señores), *ca. 1780 – 1830, water-based paints on pine, 12½ x 11 in. Museum of International Folk Art, Santa Fe.*

Figure 51
La Sagrada Familia con Ana y Joaquín (Los Cinco Señores), ca. 1750 – 1800, oil paints on canvas. On altar screen of Santa Cruz de la Cañada Church, New Mexico.

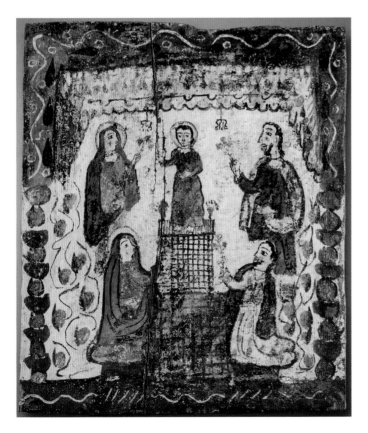

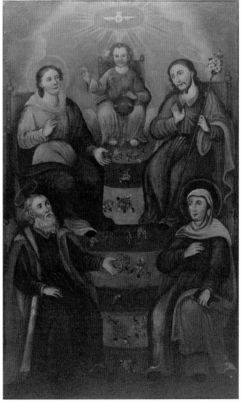

he was baptized in the church in 1749 and later painted images on the altar screen of the south chapel of the Santa Cruz church. In his request in 1831 to be buried at El Santuario de Chimayó, it was noted that he "has worked as an act of devotion on various material projects" of the Santa Cruz church. [11] He certainly would have been familiar with the oil painting of Los Cinco Señores, most likely on the altar screen during his lifetime. Los Cinco Señores is a rare subject for New Mexico santeros—I am not aware of any other examples—and not likely to have been available as a print.

Baroque Influences in Nineteenth-Century Santos

The question now arises of the possible stylistic influence of Miera on the work of later artists. Miera appears to have been a highly skilled but partially trained artist who worked within the baroque conventions of the mid-eighteenth century. He adhered to conventions such as depth of field, elaborate robing, and inclusion of landscape elements but had not the full training and probably not the same quality materials as academic artists in the urban centers of Mexico and Spain. His work is rightfully labeled "Provincial Baroque." As one of the first artists to create works of Catholic religious art in New Mexico, the others being the earlier creators of hide paintings and the painter Fray Andrés García, it would be tempting to be able to show a continuity between his work and that of the later santeros. But there is little stylistic carry-over from Miera to the nineteenth-century artists.

The most likely example of Miera's influence is the work of the painter named by W. S. Stallings Jr. as the "Eighteenth-century Novice." [12] (fig. 52) The paintings of this artist, tree-ring dated by Stallings to the late eighteenth century, are painted almost entirely in oil on pine panels. The Novice attempted to replicate baroque conventions such as flowing garments and modeling and shading to give the effect of volume, but the figures and faces tend to be ill-proportioned and often asymmetrical. The paint is thickly and unevenly applied, often in muddy colors. More than thirty paintings by the Eighteenth-century Novice are known to exist, but in trying to assess this body of the work, we have little to go on beyond the approximate dates and the surviving pieces themselves. We do not know the name of the artist, where he or she lived, or for whom these pieces were made, whether for private patrons or for churches or both. At least six paintings by this artist are of nearly identical size, each with a carved and painted six-petal lunette (*concha*) at the top, which suggests they were made for the altar screen of a church. Two other larger paintings have curved or diagonally cut corners, suggesting that they may have been mounted within the framework of an altar screen.

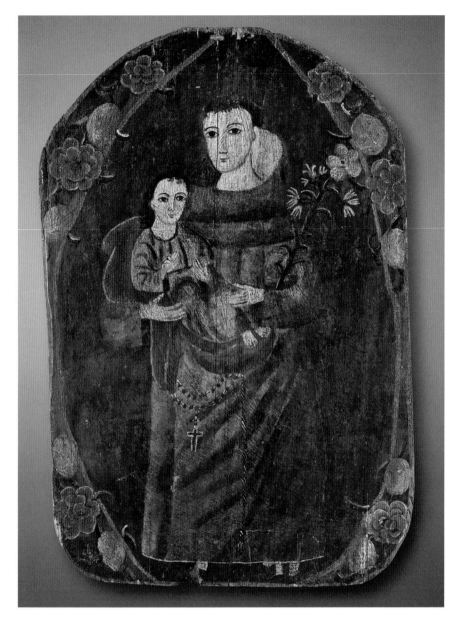

Figure 52
Eighteenth-century Novice, San
Antonio *ca. 1770–1810, oil paints
on pine, 24 x 14 in. Museum of
International Folk Art, Santa Fe,
New Mexico.*

Some of the characteristics of Miera's work are apparent in the work of the
Eighteenth-century Novice but handled with much less skill. Given these simi-
larities and the use of oil paints by both artists, it is possible that the painter was
a member of Miera's family, a not uncommon circumstance in artisan families.
Bernardo's son, Manuel Miera y Pacheco, born in 1743, listed his occupation
in a 1779 document as *"pintor"* (painter).[13] However, at least five of the Nov-

ice's pine panels date by tree-ring dating between 1786 and 1792. By this time a number of Miera's children and grandchildren could possibly have been the Eighteenth-century Novice.

E. Boyd had a negative view of the Eighteenth-century Novice, stating that the "work is totally devoid of any knowledge of painting . . . certainly the novice knew nothing of drawing or composition. . . . " And she quoted approvingly Stallings' evaluation: "Its stylistic influence on succeeding styles was not appreciable." [14] However, the paintings of the Eighteenth-century Novice actually share certain aspects of the work of some later santeros, for examples the strict frontality of the figures and faces, flatness of form, abstracted drapes framing the figure, the use of hand-adzed pine boards, carved lunettes surmounting the rectangular image, and lack of landscape or narrative content, which focuses attention on the central figure. The Novice, like the later santeros, was creating devotional images, and he or she probably worked from prints as often did the later artists. But at least three factors distinguish this body of work from that of the later santeros: the use of oil paints; the generally large size of the works; and the attempt to directly replicate some baroque conventions.

Overlapping with the paintings of the Eighteenth-century Novice but quite distinct from them and from the work of Miera is the work of the anonymous artist known as the Laguna Santero, named for the altar screen he created at Laguna Pueblo. Nothing is known of the Laguna Santero's origins, but it is likely that he arrived in New Mexico from Mexico in the early 1790s and was immediately given a series of commissions to construct, carve, and paint altar screens in Indian pueblos and Hispanic communities. These commissions suggest that he was already a seasoned artisan in the making of altar screens. He was commissioned by Antonio José Ortiz and probably other patrons to create, in less than two decades, altar screens in communities such as Santa Cruz de la Cañada (dated 1795), San Miguel in Santa Fe (dated 1798), Nuestra Señora de Guadalupe de Pojoaque (ca. 1796 – 1800), San José chapel in the parroquía de Santa Fe (ca. 1796), and the Pueblo churches of Zia (ca. 1798), Santa Ana (ca. 1798), Acoma (1802), and Laguna (ca. 1800 – 1808). [15]

The Laguna Santero appears to have been part of a little-documented tradition of popular religious art in Mexico in the late 1700s. His work bears comparison with a number of surviving Mexican pieces, mostly without provenance (fig. 53), and also with some of the large and colorful wall paintings in the church of San Xavier del Bac in Arizona, created by anonymous Mexican artists in the 1790s, the same time period in which the Laguna Santero was working in New Mexico (fig. 54). [16] Both the paintings of San Xavier del Bac and those of the Laguna Santero come out of the academic baroque tradition but dispense with its naturalism and complexity. Forms are flattened; robes, while often flowing, have a weightless quality, their folds demarked simply

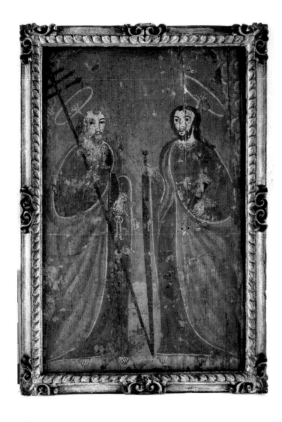

Figure 53
San Pedro y San Pablo, *18th century, water-based paints on pine, 28 x 18 in. Museo Franz Mayer, Mexico City.*

Figure 54
Heavenly and Earthly Trinities, *Church of San Xavier del Bac, 1790s, water-based paints on wall surface, Tohono O'Odham Nation, San Xavier District, Arizona.*

by lines, with a minimal of shading. The backgrounds are equally minimal with perfunctory concern for perspective. Trees and other landscape elements become emblematic. In both cases water-based paints are used. The work of the Laguna Santero and some of the painters at San Xavier share a refreshing lightness, without there being any thought of their having worked together. Rather they both represent a minimalist use of baroque conventions that must have had some currency on the northern Mexican frontier.

Clearly the Laguna Santero was already an accomplished artist when he arrived in New Mexico. He did not need training or inspiration from the work of Miera either in iconography or in style, and thus it is highly unlikely that he worked under or was influenced by Miera. Unlike Miera he worked in water-based paints, not oils. Perhaps the most striking feature of his altar screens is his use of twisted Solomonic columns which first became popular in Europe and the Americas in the seventeenth century and came back into use in the late eighteenth century as part of the transition from baroque to neo-classical.[17] These columns immediately separate his work from the earlier estípite columns used by Miera in the Castrense and Zuni altars.

No work by the Laguna Santero can be definitely dated later than 1808, but he had established a workshop producing not only altar screens in water-

based pigments but also smaller devotional paintings, gesso reliefs, and sculptures. Apprentices who took part in his workshop continued to work long after the Laguna Santero himself had stopped. They constitute one important strand in the web of religious art in nineteenth-century New Mexico, the most prominent being the santero known as Molleno. Other artists in the first half of the nineteenth century with their own distinctive styles include Pedro Fresquís, José Aragón and his brother José Rafael Aragón, José Manuel Benavides (formerly known as the Santo Niño Santero), and the A. J. Santero. None of the work of these artists shows any significant stylistic influence from Bernardo Miera y Pacheco.

While these later santeros often included baroque traits in their work, there is little evidence to suggest that such traits derive from Miera's work. Baroque motifs, available from many other sources, were incorporated by the santeros as decorative devices; they were transformed by simplification, abstraction, size, placement, and in other ways. The profusion and complexity of decoration in baroque churches in Mexico, also seen in paintings and sculpture, had the purpose of awing the viewer by creating a paradisiac ambiance within the church. It was both an aspect of the Catholic triumphalism of the period and a reflection of the material wealth of many communities in eighteenth-century Mexico, wealth fueled in many regions by silver mining. One could say the main purpose of baroque decoration was the glorification of the Church; in many cases the profusion of decoration on altar screens eclipses the holy images which are ostensibly the purpose of the altar.

The transformation of baroque decorative elements by the New Mexican santeros had the opposite effect: it focused attention on the holy figures. Simplified motifs such as curvilinear leaves, flowers and other vegetal elements, rope motifs (drawn from the knotted Franciscan cord), shell motifs as lunettes, curtains, abstracted S and C curves, and geometric shapes were often used as borders around figures, providing a respectful and protective framework that amplified the qualities of the holy personage.

In a similar manner the figures themselves were subject to varying degrees of abstraction and flatness of form. Some artists such as the Laguna Santero, followed by Molleno, often gave the figures of saints unnaturally long bodies, a technique emphasizing holiness which harks back to medieval manuscript paintings and Gothic sculpture. Figures were often depicted as floating in a monochromatic background which emphasized their unworldly qualities, for instance the small devotional paintings of José Manuel Benavides (fig. 55).

The painted pillars of some earlier altar screens by José Rafael Aragón and by Pedro Fresquís are often decorated with motifs that may have been derived from baroque sources. At least two of them appear to be painted renditions of estípite columns in which the highly abstracted triangular motif is narrow at the bottom and top and wide in the center. The carved stone pilasters of the Cast-

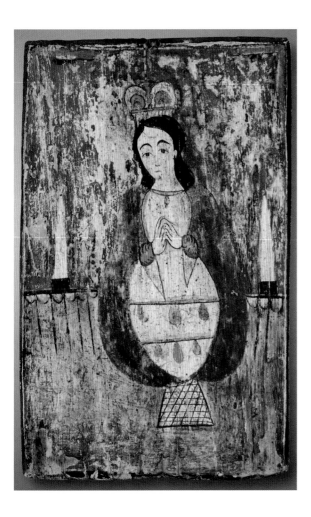

rense altar screen could be a possible source but not the only one, since prints and paintings from Mexico were also available. See, for instance, Aragón's altar screen for the Nuestra Señora de Talpa Chapel (ca. 1838) with its truncated estípite motifs (see fig. 44), and Fresquís's altar screen at Truchas, ca. 1818 –1821 (see fig. 49) Other altar screens by Aragón have abstracted circular motifs painted on the vertical members, probably derived from three-dimensional Solomonic columns, such as those carved by the Laguna Santero.[18]

Neoclassical Influences in Nineteenth-Century Santos

In addition to the baroque, the santeros also incorporated neoclassical motifs in their work. In some ways the art of the santero can be seen as a popular expression of the neoclassical aesthetic which had begun in Europe by the mid-eighteenth century as a reaction against baroque and rococo effusiveness.

Neoclassical thinkers and artists revived what they saw as the aesthetic virtues of the art of the Greek and Roman worlds, as well as that of the Renaissance; they particularly stressed simplicity and order as the crucial qualities of works of art. By the early 1800s neoclassicism came to dominate the arts of Europe and the New World, including architecture, sculpture, painting, and printmaking. Like all reactive movements, neoclassicism went to the opposite extreme in its negation of the baroque, often emphasizing a rigid geometrical ordering of compositional and architectural elements and a simplification that easily fell into sterility. This is especially noticeable in the neoclassical altars in Europe and the Americas which unfortunately in the late 1700s and through the 1800s replaced many elaborate baroque altar screens. Neoclassical changes in the other arts were often more subtle and did not as frequently result in the wholesale destruction of the previous baroque works.

The spread of neoclassical art forms to Mexico owed a great deal to the engraver and die-cutter Geronímo Antonio Gil (1731–1798), who came from Spain to Mexico City to be head of the Real Casa de Moneda (the Mint) in 1778, and there founded the Academía de San Carlos in 1781. The Academía under Gil and other instructors in the fine arts quickly became the arbiter of artistic style and taste in Mexico, and neoclassical elements slowly infused all the art forms and even fashions, spreading throughout the provinces.

Given the santeros' reliance on prints, it is not surprising that neoclassical traits would appear in the santos of the nineteenth century. Although prints were the most common source for the santeros, they varied widely in their adherence to the printed image which served as their inspiration. José Aragón, for instance, often worked closely from prints, carefully copying them and in some cases even copying the inscription or prayer on the print. Other artists such as José Rafael Aragón and Pedro Fresquís, worked more freely, choosing what elements to include. In addition to prints, neoclassical provincial paintings on canvas, board, copper, and later, tinplate found their way to New Mexico and may be counted as another source for the santeros. Some neoclassical architectural elements were introduced in New Mexico churches in the nineteenth century, such as the wooden baldachin erected in the Santa Cruz de la Cañada Church, probably in the 1860s (fig. 56), but they were few in comparison to the California missions where by the 1840s nearly every church was adorned with neoclassical facades, altar screens, and wall decorations, among other decorative elements. [19]

The artistic style of the New Mexican santeros gradually absorbed both general and some specific neoclassical elements. In general terms it is possible to see a reflection of the simple style of the neoclassical aesthetic in some nineteenth-century santos, for instance, the rigorous frontality and static quality of some figures, both painted and sculpted, in contrast to the dynamic and often frenetic emotional qualities of Mexican baroque art. This sculpture

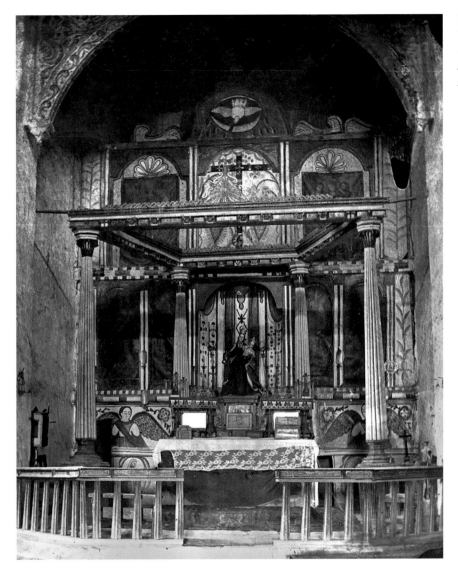

Figure 56
Wooden baldachin, ca. 1860s. Santa Cruz de la Cañada Church, New Mexico. Palace of the Governors Photo Archives, Santa Fe, New Mexico.

of San Ramón Nonato (fig. 57) by José Rafael Aragón (ca. 1838) includes specific traits carried over from neoclassical engravings and lithographs; the saint is presented in a strictly frontal pose, bordered by a simple, almost severe frame lightened by the serrated border in yellow, red, and green at the top, and by two highly stylized plants, also found in images of the Crucifixion (fig. 58). Balanced plant motifs reflect the neoclassical idea of order that was often expressed as bilateral symmetry.

Many santos also include neoclassical pilasters and oval borders framing the central figure, often with simple line or geometric decoration, prob-

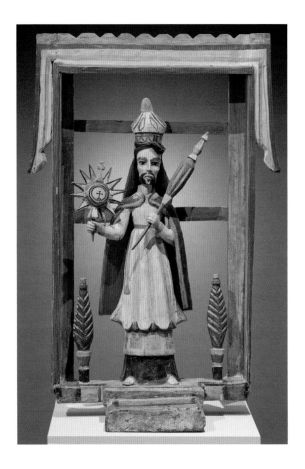

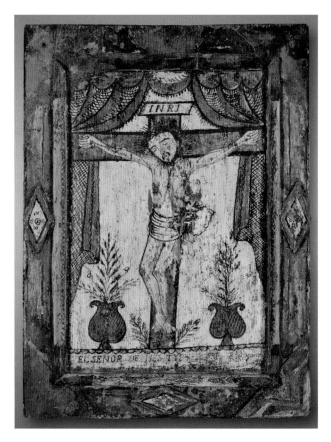

ably inspired by neoclassical prints. The vertical members of two altar screens by José Rafael Aragón (one from Vadito and the other from the Santa Cruz area) are painted with abstracted Doric columns (figs. 48, 59). One remarkable Aragón retablo of San Fernando Rey in the Barton Collection of the Lowe Museum depicts the saint within a neoclassical arched architectural frame which includes abstracted columns and Pueblo stepped motifs, a most creative transformation and localization of the neoclassical. [20]

Even the neoclassical design of silver coins could have had an influence on nineteenth-century santos. On the reverse of this 1786 Charles III silver *real de ocho* (fig. 60) the Spanish crest is framed on each side by simple Doric columns which replaced the more elaborate baroque-influenced design of earlier eighteenth-century silver *reales.* This neoclassical design was used from 1771 until 1821. Although hard coinage was scarce in late eighteenth- and early nineteenth-century New Mexico, some silver coins were in circulation in the province and could have been the inspiration for the Doric column motifs on these altar screens.

In Europe and the New World, the rise of neoclassicism went hand-in-hand with the gradual democratization of societies. It was a turning away from

Figure 59

José Rafael Aragón, Altar screen, ca. 1850s, water-based paints on pine, 132 x 93 in. Santa Cruz Valley, New Mexico.

Inscribed: "Este corateral se pinto por mano de m(ae)stro Rafel Arag(on)...."

Figure 60

Carlos III real de ocho *(piece of eight, or Spanish peso), 1786, silver coin, 1½ in. New Mexico History Museum, Santa Fe.*

the strictly hierarchic social orders still prevailing in the eighteenth century, resulting in some cases, such as the French Revolution, in the overthrow of the established regime. Neoclassical art forms reflected this tendency toward social leveling and democracy.

Baron Alexander von Humboldt, in his important account of New Spain in the early 1800s, noticed the beneficial democratizing effects of the art education provided by the Academía de San Carlos:

"In this assemblage (and this is very remarkable in the midst of a country where the prejudices of the nobility against the castes are so inveterate) rank, colour and race are confounded: we see the Indian and the Mestizo sitting beside the White, and the son of a poor artisan entering into competition with the children of the great lords of the country. It is a consolation to observe, that under every zone the cultivation of science and art establishes a certain equality among men, and obliterates, for a time at least, all those petty passions of which the effects are so prejudicial to social happiness."[21]

The democratizing policies of the Academía both reflected and inspired similar tendencies in the social order throughout New Spain. New Mexico, although distant from Mexico City, could not be immune to these tendencies. Whether consciously or not, the incorporation of neoclassical motifs by santeros on the remote frontier paralleled and perhaps reflected the democratizing effects of this movement. The increasing populations of Hispanic settlers and Genízaros after circa 1780 resulted in new and enlarged communities far from Santa Fe whose residents demanded and cherished their independence and began to oppose, as discussed below, the heavy hand of authority.

Native American Influences

In addition to patterns and designs derived from baroque and from neoclassical sources, we can see quite explicit incorporation of Native American motifs, particularly Pueblo Indian, in the work of nineteenth-century santeros, for instance, stepped pyramidal designs, rain clouds, and lightning bolts. These motifs often coexist, easily or uneasily, with the baroque and neoclassical referents discussed above. This painting by José Rafael Aragón combines the widespread Pueblo stepped pyramidal cloud motif with a seven-petal lunette at the top (fig. 61). The lunette derives quite directly from baroque sources, but this one has a subtly added Native American touch of feather designs within each petal. The lunette and stepped rain symbol effectively combine European and Puebloan motifs to enshrine an iconographically accurate rendition of Nuestra Señora de los Dolores.

Bernardo Miera y Pacheco included some Native American referents in his work, for instance, the depictions of Native Americans in his maps (see Carrillo, this volume) and in at least one of his religious works, the relief depiction of

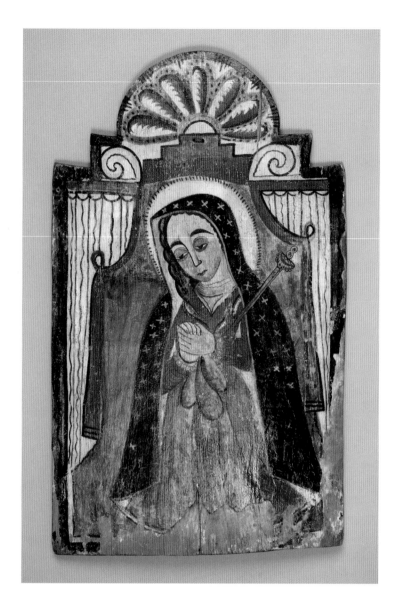

Figure 61
José Rafael Aragón, Nuestra Señora
de los Dolores, *ca. 1830 – 1862,
water-based paints on pine, 12 x 8 in.
Arizona State Museum, University of
Arizona, Tucson.*

San Francisco Solano on the Castrense altar screen. Most of them, however, are
literal, not symbolic, referents.[22] San Francisco Solano, in the typical attributes of
this saint found in prints and paintings, is depicted blessing (with a concha) the
Indians to whom he ministered in Peru. The saint's presence here was most likely
intended to provide an inspiration for the missionary work to be done among the
Indians of New Mexico. This underlines one of the major differences between
the work of Miera and that of the later santeros: The significance of baroque,
neoclassical, and Native American referents in nineteenth-century New Mexico
santos is to be found in the manner in which they have been transformed by the
santeros rather than in any didactic message or direct reference to their sources.
In the hands of the santeros these motifs become part of a local aesthetic.

Although Miera was one of only a few artists working in the third quarter of the eighteenth century in New Mexico, his influence upon the style of later artists was negligible. How do we account for this dramatic change in artistic style within only a few decades? The most likely explanation comes from a comparison of the patronage of Miera with that of the santeros. Who were the patrons, and what were the needs of the market for each?

Miera's patrons for the most part were members of the wealthier urban classes and the clergy, for whom he made both altar screens and individual pieces. While we tend to think of colonial New Mexico as a rough and distant frontier province whose citizens barely eked out a living, such was not the case for members of the ruling class of españoles and criollos who had both wealth and sophistication comparable to that found in urban centers of Mexico and Spain. Miera did not have the wealth of these people, but he was a member of their class and respected by them for his skill and industry.[23]

Arriving in Mexico sometime in the 1730s, Miera soon moved with his wife to the city of Chihuahua (San Felipe de Real de Chihuahua), where their first son, Anacleto, was baptized in April 1742. In August of that year Bernardo was still in Chihuahua, where he was confirmed by the Bishop. He and his wife and son then moved to El Paso del Norte, where his second son Manuel was born in 1743. In about 1754, Miera and his family moved to Santa Fe, and in 1756 Governor Francisco Antonio Marín del Valle appointed him alcalde mayor of Pecos and Galisteo. The following year, Marín del Valle hired Miera to make a map of New Mexico. Miera dedicated a hand-painted version of this map to "Señor don Francisco Antonio Marín del Valle, governor and captain general of said kingdom, by don Bernardo de Miera y Pacheco"[24]

Marín del Valle, appointed governor of New Mexico in 1755, was born in Lumbreras in the Rioja region of northern Spain, not far from Miera's birthplace. Soon after arriving in Mexico, in 1754 he married María Ignacia Martínez de Ugarte, the daughter of Jacinto Martínez y Aguirre, one of the wealthiest merchants of Mexico City. Marín del Valle and his new wife, like many *ricos* of the period, arrived in New Mexico with the finest clothing, jewelry, and furnishings they could bring with them, as is evident from the extensive and valuable (10,000 pesos) dowry María Ignacia brought to the marriage, which included "various pieces of gold, pearl, and diamond jewelry; [and] a four-seater coach."[25]

In 1760 Marín del Valle purchased land on the Santa Fe Plaza and built the Castrense church dedicated to Nuestra Señora de la Luz (Our Lady of Light) in which was constructed the stone-carved altar screen now attributed to Miera. At the same time Marín del Valle founded in Santa Fe a confraternity dedicated to Nuestra Señora de la Luz, whose establishment and constitu-

tion were approved in person by Bishop Pedro Tamarón y Romeral on June 3, 1760, during his ecclesiastical visitation. Marín del Valle served as *hermano mayor* of the confraternity and Miera as secretary.[26]

Both Miera and Marín del Valle would have seen the baroque estípite altar screens in the region of their upbringing in northern Spain, such as that in the cathedral of Burgos, and these may have been the inspiration for Miera's design for the Castrense altar screen.[27] Another possible source closer to home is the altar screen now dedicated to Nuestra Señora de la Luz in the church of San Francisco in the city of Chihuahua (fig. 62). Its estípite columns incorporate heads of cherubs such as are also found on the Castrense altar screen. In comparison with the more complex decoration of the Burgos pieces, both the

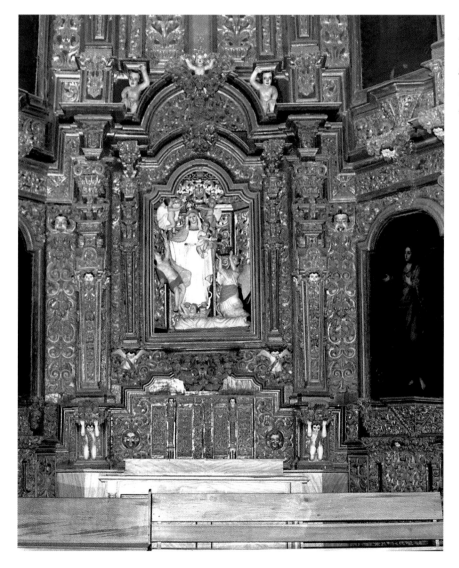

Figure 62
Altar screen of Nuestra Señora de la Luz *(lower portion), ca. 1720 – 1750, paints and gilt on wood.*

Church of San Francisco, Chihuahua, Mexico.

Chihuahua and Castrense altar screens are quite restrained: in both, the estípite columns are demarcated by clearly outlined descending truncated triangles. The relief curvilinear floral motifs on the vertical panels of the Castrense altar screen are remarkably similar to those on the Chihuahua piece, as are the inverted pyramidal pedestals placed in the Castrense under the low reliefs and in the Chihuahua altar screen under the paintings. [28]

The Chihuahua altar screen was originally in the chapel of the Colegio de Nuestra Señora de Loreto founded by the Jesuits in 1717, where apparently it was dedicated to Nuestra Señora de los Dolores and La Crucifixión. In 1767, with the expulsion of the Jesuits, it and a comparable altar screen dedicated to Jesús Nazareno were moved into the transept of the church of San Francisco. [29] Miera had lived in Chihuahua in the 1740s and spent time there in the 1750s when he tried his hand at being a merchant, buying goods in Chihuahua and carrying them north to El Paso. He most likely would have been familiar with this altar screen when it was in the Colegio de Nuestra Señora de Loreto. It may have also been known to Governor Marín del Valle and to some of the other officers of the confraternity of Nuestra Señora de la Luz who had mercantile and family connections in Chihuahua.

Governor Marín del Valle served as *hermano mayor* of the confraternity. The other officers, as listed in the *Constituciones*, were leading citizens and military officers of Santa Fe:

• El Sr. Vicario y Juez Eclesiastico Br. [Bachiller] D. Santiago Roybal (the leading church authority in New Mexico)

• El Theniente general D. Juan Joseph Moreno (also alcalde mayor of Taos and Picuris, whose wife was Juana Roybal, sister of the vicar, Santiago Roybal)

• El Theniente de capitán de real presidio D. Carlos Fernandez (alcalde mayor of Santa Cruz, 1762–63)

• El Alferez Bartolomé Fernández de la Pedrera (alcalde mayor of the Queres Nation)

• El Alcalde mayor de esta Villa [Santa Fe] D. Francisco Guerrero (and former alcalde mayor of Taos and Picuris)

• El Capitán a Guerra Reformado [Retired] D. Bernardo Miera y Pacheco

• El Alferez Reformado D. Juan Phelipe de Ribera

• El Ayudante Reformado D. Miguel de Aliri [Alire]

• D. Clemente Gutierrez (owner of Rancho de las Padillas, 1768)

• D. Juan Francisco de Arroniz

• El Sargento Reformado D. Toribio Hortiz

• El Notario Publico D. Phelipe Tafoya (notary in the ecclesiastical court and later alcalde mayor of Santa Fe)

• D. Diego Antonio Baca (later *hermano mayor* of La Conquistadora confraternity)

• D. Manuel Bernardo Sanz [Sáenz] de Garvizu (lieutenant governor under Governor Joaquín Codallos y Rabal)

These individuals—all of Español status and some of them, like Miera, natives of Spain—represented the closely knit ruling class of mid-eighteenth-century New Mexico. As alcaldes mayores and *capitanes de guerra,* many of them had both extraordinary legal and physical power over the lives of ordinary citizens. In addition, they had great economic power through their business dealings and connections with merchants in Chihuahua and elsewhere in Mexico. Several of them held large land grants, and their names come up in many documents of the period concerning land issues and other commercial enterprises.

At least some of them were closely associated with Bernardo Miera y Pacheco. By 1758 Miera had purchased land near Santa Fe from the vicar Santiago Roybal, abutting the lands belonging to the alcalde Felipe Tafoya. The Tafoya and Miera families were later united in May 1768 by the marriage of Miera's son Anacleto to Felipe's daughter, María Felipa Tafoya, their marriage ceremony performed by Santiago Roybal. Three of the confraternity council members had previously served, as had Miera, as alcaldes mayores of Pecos and Galisteo: Manuel Bernardo Sáenz de Garvizu (1739–1743), Juan José Moreno (1744–1748), and Miguel de Alire (1746).

Governor Marín del Valle may have been Miera's most important patron in Santa Fe but not his only one. In addition to making maps and constructing altar screens, Miera was commissioned by several leading citizens of northern New Mexico to make religious images. In the mid-1750s Manuel Bernardo Sáenz de Garvizu, later to be his colleague on the confraternity council, commissioned him to paint a large painting of San Miguel which Sáenz donated to the San Miguel Church in Santa Fe, still to be seen on the altar screen today (fig. 63). It is inscribed *"A Debocion del Teniente de el Presidio de Santa Fee Dn Manuel Sanz de Garviso"* (fig. 64). At least three other paintings attributed to Miera have inscriptions identifying the patron who commissioned them:

El Sueño de San Antonio. Inscribed: *"A Debol zion de Sel ñora Rosal lia Baldez/ Año de/1754."* Rosalia Valdez was born in Santa Fe in 1700, daughter of María Medina de Cabrera and José Luis Valdez, who was born in Oviedo, northern Spain in 1664. José Luis Valdez was killed by Zunis at Zuni Pueblo in 1703. Rosalia and her siblings were heirs to the land grant owned by their father in the Abiquiu area. The date of 1754 makes it likely that Miera had moved from El Paso to Santa Fe that year (fig. 65).

Figure 63

Miera y Pacheco, San Miguel Arcángel, *1750s, oil paints on canvas, 48 x 32 in. San Miguel Church, Santa Fe, New Mexico.*

Figure 64

Miera y Pacheco, Inscription on painting of San Miguel Arcángel, *1750s. San Miguel Church, Santa Fe, New Mexico.*

ADEBOCION
DEL TENIENTE Đ EL
PRESIDIO Đ SANTAFEE
Dⁿ MANVEL SANZ Đ GAR
VISO

San Rafael. Inscribed: *"Sn Raphael/Medezina de Dios/ Ruego por nosotros/amen/ A devoción de Do/ña Polonia de Sando/bal/ Ano de 1780"* (see fig. 28). Apolonia Sandoval was born in Santa Fe in 1736. On November 29, 1760, in Santa Fe she married José Salvador García de Noriega, who commissioned the painting of San José at right. One of the witnesses of their marriage was Felipe Tafoya, Santa

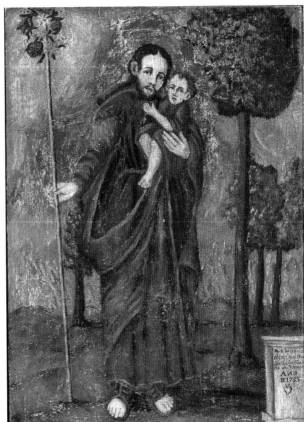

Figure 65
Miera y Pacheco, El Sueño de San
Antonio , *1754, 31 ½ x 22 ¼ in. Taylor
Museum of the Colorado Springs Fine
Arts Center.*

Figure 66
Miera y Pacheco, San José, *1783,
33 7/8 x 25 in. Taylor Museum of the
Colorado Springs Fine Arts Center.*

Fe notary, council member of Nuestra Señora de la Luz confraternity, and
father of Anacleto Miera y Pacheco's wife, María Felipa Tafoya.

San José. Inscribed: *"A Debozion de/ el Capitan Don Salbador Gar/cia de Noriega/
Año/de 1783."* José Salvador García de Noriega was born in 1730, the son
of Captain Juan Esteban García de Noriega. Both father and son served as
alcalde mayor of Santa Cruz de la Cañada, which included much of the Rio
Arriba and the Tewa pueblos. The 1790 census lists them as "Spaniards in the
Jurisdiction of San Juan [Pueblo]," Don Salvador García, farmer age sixty,
and his wife Doña Apolonia Sandoval, age fifty-four. Living with them were
three grandchildren and six servants[30] (fig. 66).

It is clear from the foregoing that Miera's patrons were members of New
Mexico's colonial elite, the richest, most powerful, and most sophisticated fami-
lies in the province. Such people, although living in a frontier province, were
well aware of contemporary artistic styles in Mexico and Spain and would want
and expect that the work commissioned from a local artist would be in confor-
mity with those styles, perhaps understanding that this particular artist, while
not a great master, at least could reasonably replicate the baroque work found
in Mexico.

The marked difference in patronage between Miera and the later santeros is a reflection of the social and economic divide that prevailed between the elites and the rest of New Mexico society. The ruling elite, including members of the clergy, generally had a disdainful view of the lower orders of society and in every way possible maintained their social difference from them. This difference, which of course was universal in mid-eighteenth-century European and Euro-American society, was expressed in many ways, such as occupations, housing, forms of address, literacy, and speech. Speech, the mastery of language, is one of the clearest forms of social distinction. According to Fray Francisco Atanasio Domínguez, the elites in Santa Fe spoke Spanish with "a courtly polish," while members of the lower orders of settlers spoke it "simply and naturally," and finally the detribalized Genízaros were "not very fluent in speaking and understanding Castilian perfectly...they do not wholly understand it or speak it without twisting it somewhat."[31]

Both ecclesiastic and civic leaders were also concerned with what they saw as the potential for chaos and rebellion. Fray Juan Agustín de Morfí, writing in 1778, is representative of these attitudes: "In all the kingdom there is not one town of Spaniards in good order. As if fleeing from the company of their brothers, they withdraw their habitations from one another, string them out in a line as fast as they can build them.... Since [the settlers] do not live under the scrutiny of the authorities, it is not easy for the latter to keep track of the conduct of these subjects. They enjoy a kind of independence that allows their larger crimes to go unpunished because they are not detected...."[32]

Civic leaders held an equally dim view of the lower order settlers of New Mexico. Governor Fernando de la Concha, in his 1794 instructions to his successor, characterized them in the most negative paternalistic terms:

"Under a simulated appearance of ignorance or rusticity they conceal the most refined malice. He is a rare one in whom the vices of robbing and lying do not occur together.... It is the environment that remains and every day propagates similar vices. These cannot be checked except under a new set of regulations and by means of a complete change in the actual system of control."

But instead of proposing "a complete change in the actual system of control," Concha went on to recommend that the new governor give full support to the alcaldes who govern each part of the province:

"Vigilance regarding the conduct of the alcaldes mayores, their lieutenants, and the commissaries of the troops nearly always assures the administration of justice and good order. Upholding these employees in all that they do that is just and maintaining them always in their offices when their management corresponds to the indicated purposes must be the first attention of the Governor.... The people have made repeated unfounded accusations against them....

Seeking the source of these I have discovered easily that they do not spring from anything but the lack of obedience, willfulness, and desire to live without subjection and in a complete liberty, in imitation of the wild tribes which they see nearby." [33]

The settlers and the Genízaros had good reasons to avoid the authorities—such as the powerful and rich alcaldes, unscrupulous merchants, and overbearing priests—who systemically exploited them and the Pueblo Indians in a variety of ways, including economic ill-treatment and religious suppression. There were periodic reactions against this exploitation through the eighteenth and the first half of the nineteenth centuries. To mention a few here: the witchcraft trials in Abiquiu in the 1750s and 1760s; the disturbances in 1805 at San Miguel and San José del Bado over trade with the nomadic tribes, which spread to Santa Cruz de la Cañada and Rio Arriba; the 1837 Rebellion which resulted in the death of the governor Albino Pérez and other members of the governing elite; and finally the 1847 Taos Rebellion against the newly arrived American government. All of these indicate a legitimate "desire to live without subjugation."

By the time of Miera's death in 1785, changes were under way which led to a markedly different situation for the later santeros. With the lessening of the threat from nomadic tribes such as the Comanches, increasing populations of settlers and Genízaros began to establish new communities or revive abandoned ones in more isolated valleys throughout northern New Mexico, creating a new demand for religious images. The urban churches and wealthier homes continued in the late eighteenth and early nineteenth centuries to be furnished with imported academic art, for example the church of Nuestra Señora de Guadalupe in Santa Fe, with its painted altar screen by José de Alcíbar dated 1783. [34] In contrast, the lower-order settlers in rural communities were more likely to commission the local santeros to make santos for their churches and homes.

The desire to live without subjugation also affected the religious life of these settlers at exactly the same time that the art of the santero was flowering in northern New Mexico. On July 21, 1833, the Bishop of Durango, Don José Antonio Laureano de Zubiría, while visiting Santa Cruz de la Cañada, issued a "Special Letter" in which he condemned and forbade the practices of the penitential brotherhoods in the towns and villages of New Mexico. The people of northern New Mexico most directly impacted by this prohibition were the same ones who were commissioning the santeros to make pieces for their churches and homes—and for use in the brotherhood chapels and their Holy Week ceremonies. By this time the art of the santero was far removed from that of the urban artists, just as some of the spiritual practices of the santeros' patrons were now quite distant from the practices of urban Catholics. Through the seventeenth and much of the eighteenth centuries these penitential practices were taken part in by all classes of society in colonial Mexico, but by the 1830s they

were to be found only in more remote areas such as northern New Mexico. Bishop Zubiría's condemnation resulted in the brotherhoods gradually making secret what was once practiced in public by all.[35]

In 1838 or soon after, José Rafael Aragón completed the altar screen and statuary of the chapel of Nuestra Señora de Talpa near Taos and inscribed on the ceiling boards the name of his patron, Nicolás Sandoval, and his own name as artist:

"In the name of God all powerful and the ever Virgin Mary of Talpa since the year 1838 it is built—Jesus Mary and Joseph—by devotion of the slave Nicolás Sandoval [and] by the hand of the sculptor Rafael Aragón."

Members of the penitential brotherhoods and other confraternities used the term slave (*esclavo*) to refer to themselves: "*esclavos de la Sangre de Cristo*" or "*esclavos de Nuestro Padre Jesús Nazareno*," thus identifying themselves as members. Here the patron (*el esclavo*), a brotherhood leader in the area, and the santero (*el escultor*) are separately credited in the completion of the chapel and its furnishings.[36]

It should be noted that many of the nineteenth-century santeros were part of an artisan class of people who were quite distinct from both the elites and the lower order settlers. While not having the formality of craft guilds in Mexico and Spain, they had their own informal traditions, working together in extended families and usually passing the craft vocation down through many generations. As José Esquibel has demonstrated, a number of families of artisans came to New Mexico from Mexico City in 1693–94 with the reconquest. He notes: "Among these families were carpenters, painters, weavers, tailors, blacksmiths, brickmasons, stonemasons, a cabinetmaker, a filigree maker, a shoemaker, and a coppersmith. Their artisan skills were valuable in the re-establishment of New Mexico's frontier society and were essential for renovating and constructing buildings, as well as practical for producing the utensils and clothing for daily living."[37] Esquibel suggests that the santeros José Aragón and his brother Rafael Aragón were probably descended from Ignacio de Aragón, a weaver who came up with the reconquest. Rafael Aragón's wife was descended from the weaver Miguel García de la Riva, a native of Mexico City who was one of the leaders of the artisan families.[38]

The distinct social position of the artisans in relation to the elites is well illustrated in the founding of the Castrense church and the confraternity of Nuestra Señora de la Luz in 1760. The *Constituciones* of the confraternity called for the hiring of a *criado* (employee) to take care of the church and prepare it for different functions. The criado employed in 1760 was Lucas Moya, the son of the mason (*albañil*) Antonio de Moya, one of the artisans who came to Santa Fe from Mexico City in 1694. Lucas Moya quite likely carried on the family trade and may have been in charge of the construction of the church, and he may have helped Miera in the construction of the altar screen. According to the

Constituciones, the criado was required to report to the secretary for his duties to be performed. Thus as the church and altar screen were being built the criado Lucas Moya was reporting to the secretary Bernardo Miera y Pacheco.[39]

The marked differences in style between Miera and the later artists is in large part a reflection of differences in patronage. Thinking in purely economic terms, suppliers must respond to the demands of their market; in the nineteenth century, the market was the rural settlers, the Genízaros, and the Pueblo Indians of northern New Mexico, and the suppliers were the santeros, who made their living, or part of it, from making images. Santeros like other artists and artisans of the day had to make art that would please their patrons. The santeros would have been perfectly capable of producing, with greater or lesser skill, provincial versions of baroque and neoclassical works, but such art was not demanded by their patrons.

Conclusion

While we may never fully understand the remarkable flowering of the art of the santeros in the first half of the nineteenth century, it clearly depended to a great extent upon the wishes of their patrons. The aesthetic of the santos derived directly from the ethos of the people. Catholic images in Hispanic, Genízaro, and Native American contexts played a direct and immediate role in the lives of the people who commissioned and used them. Such images reflected a spirituality that was both personal and communal, based upon a devotional attitude, expressed not only through images but also through all the other aspects of daily life that were imbued with a sense of the sacred: birth; marriage; death; seasonal rounds, including planting and harvesting; healing methods; pilgrimages; and ceremonial occasions, such as saints' days, Lent, and Holy Week.

Thus, influences from academic art, which the art of Bernardo Miera y Pacheco had tried to replicate, were transformed by the santeros into decorative motifs that enhanced the spiritual qualities of the saintly figure. The images are emblematic; they eschew figural naturalism, three-dimensional perspective, complex elaboration of decoration, and narrative sequences, all of which can be seen as distractions from a direct relationship with the saintly figure and its significance. The incorporation of Native American motifs acknowledged the close relations that prevailed over the centuries with the Pueblos and other Native American groups. In both Hispanic and Native American communities, the emphasis is upon the spiritual content of the image: abstraction and simplification allow the spiritual significance to have the primary role. This shared abstraction of form most likely represents a confluence of cultural norms and beliefs concerning the nature of reality, a sympathetic confluence of worldviews. For the urbane elites in the time of Bernardo Miera y Pacheco, such a

sympathetic confluence did not exist; they looked to Mexico and Spain for their aesthetic and cultural sustenance, not to the villages and pueblos of northern New Mexico.[40]

Notes

1. Manuel Toussaint, *Arte Colonial en México*, México, UNAM, 1948, 399: "Dentro de este género, multitud de obras se ofrecen al estudioso, pero el ojo tiene que ser muy cauto para distinguir estos matices, y el crítico de un espíritu muy amplio para no restar méritos ni exagerar cualidades. Debe conducirnos con timón hábil y certero por los complicados y a veces borrascosos mares de nuestras artes plásticas populares."

2. Felipe Mirabal and Donna Pierce, "The Mystery of the Cristo Rey Altar Screen and Don Bernardo de Miera y Pacheco," 60–67.

3. See Manuel Orozco y Berra, *Memoria para el plano de la ciudad de México* (Mexico: Imprenta de S. White, 1867), 138. González Dávila noted the establishment of Nuestra Señora de Valvanera in Mexico City before 1649, with the help of King Philip IV: "Ayudò con su limosna, para edificar en Mexico el Templo, y Convento de Nuestra Señora de Valvanera" (Gil González Dávila. *Teatro eclesiástico de la primitiva iglesia de las Indias Occidentales* (Madrid: Diego Diaz de la Carrera, 1649), tomo 1, 60. Another chapel dedicated to Valvanera was established in Mexico City by Spaniards from La Rioja in 1766: "La capilla de Nuestra Señora de Valvanera en el atrio y contigua a la iglesia del convento de San Francisco, costeada por los Europeos originarios de la Provincia de la Rioja, se dedicó el domingo 7 de Setiembre del año de 1766" (*Noticias de México, Recogidas por D. Francisco Sedano desde el Año de 1756....* Mexico 1880, Tomo I, 198–199). Further research may show connections between the Rioja founders of this chapel and New Mexico governor Don Francisco Antonio Marín del Valle, who was also from the Rioja region.

4. On Aduana see Bernard L. Fontana, "Nuestra Señora de Valvanera in the Southwest," 78–92.

5. Benito Rubio, *Historia del venerable, y antiquissimo Santuario de Nuestra Señora de Valvanera, en la provincia de la Rioja*, (Logroño: Imprenta de Francisco Delgado, 1761), 41.

6. See the discussion by E. Boyd, *Popular Arts of Spanish New Mexico*, 78–95, and Cristina Cruz González, "The Circulation of Flemish Prints in Mexican Missions and the Creation of a New Visual Narrative, 1630–1800," in *Journal of the California Missions Studies Association*, 25, no. 1 (2008), 5–34, among other studies. Felipe Mirabal has written about the print sources for the images on the Castrense altar screen: "Don Bernardo de Miera y Pacheco and the First Twenty-five Years of the Capilla Castrense of Santa Fe" (unpublished

manuscript, University of New Mexico Art and Art History Department, January 1997. My thanks to Charles Carrillo for this reference).

7. See William Wroth, "Our Lady of Valvanera/ Nuestra Señora de Valvanera," *Christian Images in Hispanic New Mexico*, 145 (Plate 119), and Fontana, "Nuestra Señora de Valvanera in the Southwest," 78 – 92.

8. See Wroth, "God the Father/Dios Padre," *Christian Images in Hispanic New Mexico*, 144 (Plate 118). A third depiction of Dios Padre by Aragón is at the top of the altar screen in the San Buenaventura Chapel in Chimayó. There are at least three other Aragón images of God the Father as a member of the Holy Trinity. Two in the Taylor Museum (TM 1218 and TM 3906) and the third at the top of the altar screen in the south transept of the Santa Cruz de la Cañada Church.

9. A similar painting of Dios Padre was also at the top of the Santa Clara Pueblo altar screen. As Robin Gavin and Donna Pierce suggest in their article herein, this altar screen may have been painted by Miera.

10. It would be tempting to say that a gesso relief of Nuestra Señora de la Luz by the Laguna Santero was inspired by Miera's stone relief of the same subject in the Castrense church, but there were certainly prints available of this popular advocation of Mary (including one published in the *Constituciones* of the confraternity dedicated to her in Santa Fe), and the Laguna piece varies in some details from that of Miera. The Laguna relief is illustrated in Wroth, *Christian Images in Hispanic New Mexico*, 85 (Plate 43).

11. E. Boyd, *Popular Arts of Spanish New Mexico*, 329, translated from Archives of the Archdiocese of Santa Fe, Patentes, Book LXX, Box 4, Official Acts of Vicar Rascón, 1829–33.

12. William S. Stallings Jr. Untitled manuscript study of New Mexican retablos, ca. 1951, in Taylor Museum archives, 88–90. See also Wroth, "The Eighteenth-Century Novice" in *Christian Images in Hispanic New Mexico*, 55 – 59. It is worth noting here that one of the Eighteenth-century Novice's paintings is of Nuestra Señora de la Luz (Taylor Museum — TM 877). It may have been inspired by the image in the Castrense church.

13. Donna Pierce, "Saints in New Mexico," 33. Kessell notes that Manuel Miera y Pacheco was born in El Paso del Norte in 1743, his full name Salvador Manuel Miera y Pacheco (Kessell, *Miera y Pacheco*, 17, 74). With thanks to Dr. Kessell for making his study available to me prior to publication. See also Chávez, *Origins of New Mexico Families*, 229–30.

14. E. Boyd, *Popular Arts of Spanish New Mexico*, 110.

15. On the Laguna Santero, see Marsha Bol, "The Anonymous Artist of Laguna and the New Mexican Colonial Altar Screen"; and Wroth, "The Laguna Santero and his School" in *Christian Images in Hispanic New Mexico*, 69–103. Recent research has been conducted by Aaron Fry of the University of New Mexico Art and Art History Department (lecture "The Laguna Santero," Tesoros de Devoción Symposium, New Mexico History Museum, May 15, 2010).

16. On Mexican popular painting prior to the nineteenth century, see Abelardo Carrillo y Gariel, *Imagineria Popular Novoespañola* (Mexico, D. F., 1950). Two popular paintings are illustrated in Manuel Toussaint, *Colonial Art in Mexico*, frontispiece and Plate 353. On the mural paintings of San Xavier del Bac, see Bernard L. Fontana, *A Gift of Angels: The Art of Mission San Xavier del Bac* (Tucson: University of Arizona Press 2011).

17. On the revival of Solomonic columns, see Paula B. Kornegay, "The Altar Screens of an Anonymous Artist in Northern New Spain: The Laguna Santero," *Journal of the Southwest*, 38, no. 1 (Spring 1996), 63–79.

18. The Talpa altar screen is illustrated in William Wroth, *The Chapel of Our Lady of Talpa* (Colorado Springs: Taylor Museum, Colorado Springs Fine Arts Center, 1979), pls. 1, 32. The Fresquís altar screen is illustrated in David Wakely and Thomas A. Drain, *A Sense of Mission: Historic Churches of the Southwest* (San Francisco: Chronicle Books, 1994), 62 and 64, and in Marie Cash, *Santos: Enduring Images of Northern New Mexican Village Churches*, 73. See Pierce, "The Life of an Artist: The Case of Captain Bernardo Miera y Pacheco," in Farrago and Pierce, eds., *Transforming Images*, 134–37.

19. For a survey and many illustrations of neoclassical altar screens and decoration in California, see Norman Neuerburg, *The Decoration of the California Missions*, Santa Barbara: Bellerophon Books, 1987.

20. The Santa Cruz valley altar screen was probably made after 1850; it is constructed of milled, rather than hand-adzed, lumber and put together with nails, not pegs. Milled lumber and nails were not readily available prior to the coming of American sovereignty in 1846. The retablo of San Fernando is illustrated in E. Boyd, *The Alfred I. Barton Collection of Retablos* (Miami Beach: Franklin Press, 1951), fig. 3 and is inscribed "San Fernandes/ La Bondad es la verdade romerito" (St. Ferdinand/ Goodness is the true cure). For further discussion of Aragón's images of San Fernando Rey, see Wroth, "Saint Ferdinand the King/San Fernando Rey" in *Christian Images*, 148, 207; and Donna Pierce, "Possible Political Allusions in Some New Mexican Santos" in Farrago and Pierce, *Transforming Images*, 58–61.

21. Alexander von Humboldt, *Selections from the works of the Baron de Humboldt, relating to the climate, inhabitants, productions, and mines of Mexico: with notes by John*

Taylor (London: Printed for Longman, Hurst, Rees, Orme, Brown, and Green, 1824), 33.

22. An exception is the sculpted face with Indian headdress at the center of the Castrense altar screen, just below Nuestra Señora de Valvanera.

23. Biographical information about Miera is found in, among other sources, John L. Kessell's *Miera y Pacheco*. See also Fray Angélico Chávez, *Origins of New Mexican Families*, 229–30, and Donna Pierce, "The Life of an Artist: The Case of Captain Bernardo Miera y Pacheco" in Farrago and Pierce, *Transforming Images*, 134–37.

24. Illustrated in color in Kessell, *Kiva, Cross, and Crown*, following 166.

25. For the inventory of María Ignacia's dowry, see Rick Hendricks, "Governor Francisco Antonio Marín del Valle in México City" (http://www.newmexicohistory.org/filedetails.php?fileID=24919). For other colonial inventories of what today would be luxury goods, see Donna Pierce and Cordelia Thomas Snow, "Hybrid Households: A Cross Section of New Mexican Material Culture," in Farrago and Pierce, *Transforming Images*, 101–13, and their "'A Harp for Playing,'" in Gabrielle G. Palmer and Stephen L. Fosberg, eds, *El Camino Real de Tierra Adentro* (Santa Fe: BLM, 1999), 71–86. Also in the same volume, Rick Hendricks, "El Paso del Norte" (215–18) lists the inventories of the sumptuous estates of Manuel Antonio San Juan and Francisca Micaela García de Noriega upon their marriage in 1759. See also Richard Ahlborn, "The Will of a New Mexican Woman in 1762," *New Mexico Historical Review* 65 (July 1990), 319–55.

26. The regulations for this confraternity were published in Mexico City in 1766, at Marín del Valle's expense: *Constituciones de la Congregacion de Nuestra Señora de la Luz, Erigida en la Villa de Santa Feé, Capital de la Provincia de la Nueva Mexico, y aprobada del Ilmó. Señor D. Pedro Tamarón Obispo de Durango. A sus expensas las dà al publico D. Francisco Antonio Marin del Valle, Gobernador, Capitan general que fue de dicha Provinicia, Hermano mayor de su Congregacion.* Impresas en Mexico, con licencias necesarias, por Phelipe de Zuñiga, y Ontiveros, en la calle de la Palma, año de 1766.

27. Pierce, "The Life of an Artist," in Farrago and Pierce, *Transforming Images*, 135–36.

28. Another possible connection with Chihuahua is the eighteenth-century stone carved façade of the church of San Francisco, portions of which are still present. Above the west doorway the simple rounded and edged cornice which supports the finials and the three Franciscan seals (two of the Five Wounds and one of the crossed arms of Jesus and St. Francis) is strikingly similar to that on the Castrense altar screen, especially the one across the top course just below

Nuestra Señora de Valvanera. The construction of the Castrense altar screen was clearly done by an accomplished stonemason, who may have been Miera himself, having learned in Spain or Chihuahua, or may have had been someone else with that training, possibly Lucas Moya, as discussed below. On church builders and their crafts in northern New Spain see Gloria Fraser Giffords, *Sanctuaries of Earth, Stone, and Light*, 73–75.

29. Clara Bargellini, *Marcos de Veneración: Los Retablos Virreinales de Chihuahua* (Chihuahua: Pitahaya Editores, 2011), 91–93. Bargellini cites a 1794 inventory of the former property of the church of Nuestra Señora de Loreto which states this altar screen was originally dedicated to La Crucifixión and Nuestra Señora de los Dolores, not to Nuestra Señora de la Luz. Her image was apparently added later, after the altar screen was moved to the church of San Francisco. See also Zacarías Márquez Terrazas, *Chihuahua: Apuntes Para Su Historia* (Chihuahua: Grupo Cementos de Chihuahua, 2010), 77–80, and Emilia Díaz Arreola, "Templo de San Francisco" http://sitioshistoricosdechihuahua. blogspot.com/2011/04/templo-de-san-francisco.html.

30. Virginia Langham Olmstead, *Spanish and Mexican Colonial Censuses of New Mexico: 1790, 1823, 1845* (Albuquerque: New Mexico Genealogical Society, 1975), 107. See also the database of the Hispanic Genealogical Research Center of New Mexico: http://www.hgrc-nm.org/surnames/GNMPD.html/d0054/ g0005414.html#I6671 and http://www.hgrc-nm.org/surnames/GNMPD.html/ d0139/g0013994.html.

31. Adams and Chávez, *The Missions of New Mexico*, 42. Domínguez's account is full of disparaging comment about the lower order settlers and the Genízaros. For instance, in Las Trampas he noted with regard to the settlers: "For the most part they are a ragged lot….They are as festive as they are poor, and very merry. Accordingly, most of them are low class, and there are very few of good, or even moderately good, blood. Almost all are their own masters and servants, and in general they speak the Spanish I have described in other cases" (99).

32. *Father Juan Agustín de Morfi's Account of Disorders in New Mexico 1778*, Marc Simmons, trans. and ed., (Santa Fe: Historical Society of New Mexico, 1977), 12.

33. Fernando de la Concha, "Advice on Governing New Mexico, 1794," trans. by Donald E. Worcester, *New Mexico Historical Review:* 24 (1949), 236–54.

34. José de Alcíbar (ca. 1730–1803) was a prominent and prolific artist in Mexico, trained in academic baroque painting. He later became a professor of painting at the Academía de San Carlos.

35. For further information on the history of penitential practices in New Mexico, see Marta Weigle, *Brothers of Light, Brothers of Blood: The Penitentes of the*

Southwest (Albuquerque: University of New Mexico Press, 1976), and William Wroth, *Images of Penance, Images of Mercy, Southwestern Santos in the Late Nineteenth Century* (Norman: University of Oklahoma Press, 1991). Bishop Zubiría's Special Letter of July 21, 1833, and his Pastoral Letter of October 19, 1833, are transcribed by Weigle, 195–97. Related documents are transcribed by Wroth, 172–74.

36. Wroth, *The Chapel of Our Lady of Talpa*, 57. The inscription goes on to note: "Approved by the most illustrious Don José Antonio de Zubiria. Hail Jesus, Mary and Joseph." Such approval most likely was obtained by Father Antonio José Martínez, who was a supporter of the penitential brotherhoods in the Taos area. Another roof board inscription dated July 2, 1851, states that the chapel was "for the use of the priest Don Antonio José Martínez." Martínez was later accused by Father Damaso Taladrid in 1856 of performing masses without permission in the unlicensed chapel of Nuestra Señora de Talpa. See *The Chapel of Our Lady of Talpa*, 33–37.

37. José Antonio Esquibel, "The Artisan Families of Mexico City that Settled New Mexico in 1694" in *Tradicion Revista* 8, no. 1 (Spring 2003). See also his "Mexico City to Santa Fe: Spanish Pioneers on the Camino Real, 1693–1694," in Gabrielle G. Palmer and Stephen L. Fosberg, eds., *El Camino Real de Tierra Adentro* (Santa Fe, BLM, 1999), 55–69.

38. Esquibel, "The Artisan Families." For the family connections between santeros and other artisans in early nineteenth-century Santa Fe, see Charles Carrillo and José Antonio Esquibel, *Tapestry of Kinship: The Web of Influence Among the Escultores and Carpinteros of the Parish of Santa Fe, 1790–1860* (Albuquerque: Rio Grande Press, 2004).

39. The duties of the criado are outlined in Chapter 14 of the *Constituciones*: "…[el criado] acudirá a la casa del Secretario el primero Domingo de cada mes, por si se ofreciere alguna cosa…. estará a cargo de la Congregacion el salario, que pareciere correspondiente a su trabajo." Lucas Moya's appointment as criado is noted on a later page: "Criado de la Congregacion Lucas Moya." Alexander von Wuthenau, "The Spanish Military Chapels in Santa Fe and the Reredos of Our Lady of Light" (*New Mexico Historical Review*, 10, no. 3, 175–194) and Chávez, *Origins of New Mexico Families*, 240, both mistakenly call Lucas Moya an officer of the confraternity. On Antonio de Moya see Esquibel, "The Artisan Families," and Esquibel and John Colligan, *The Spanish Recolonization of New Mexico: An Account of the Families Recruited at Mexico City in 1693* (Albuquerque: Hispanic Genealogy Research Center of New Mexico, 1999), 39, 50, 276 ff. Lucas Moya, born about 1710, was still living in Santa Fe in 1790, with a number of masons and carpenters as neighbors, including furniture maker Nicolás Apodaca. In the 1790 census his occupation is listed as "cantor de

la Yglesa [Iglesia]." See Olmstead, *Spanish and Mexican Colonial Censuses*, 54–55. It is possible that the criado Lucas Moya could have been Lucas de Jesus Moya (1732–), the son of Lucas Miguel de Moya (1710–after 1790). Moya family genealogy is detailed on http://www.hgrcnm.org/surnames/GNMPD.html/d0105/ g0010588.html. See also Waldo Alarid, *Santa Fe Shadows Whisper: A History of the Alarid and Moya Families* (Pueblo, Colo.: El Escritorio, 1997).

40. For further discussion of the shared aesthetic of Hispanic and Native American imagery, see Robin Farwell Gavin, "Creating a New Mexico Style" and William Wroth, "The Meaning and Role of Sacred Images in Indigenous and Hispanic Cultures of Mexico and the Southwest" in William Wroth and Robin Farwell Gavin, eds., *Converging Streams: Art of the Hispanic and Native American Southwest* (Santa Fe: Museum of Spanish Colonial Art, 2010), 37–51, 83–95.

Selected Bibliography

Adams, Eleanor B. and Fray Angélico Chávez, trans. and eds. *The Missions of New Mexico, 1776: A Description by Fray Francisco Atanasio Domínguez.* Albuquerque: University of New Mexico Press, 1956 (reprint 1975).

Bannon, John Francis. *The Spanish Borderlands Frontier, 1513–1821.* New York: Holt, Rinehart and Winston, 1970.

Bargellini, Clara. "Painting in Colonial Latin America." In *The Arts in Latin America, 1492–1820,* organized by Joseph J. Rishel with Suzanne Stratton-Pruitt. Philadelphia: Philadelphia Museum of Art, 2006.

Bargellini, Clara, Elisabeth Fuentes et al., *Los retablos de la ciudad de México, siglos XVI al XX.* Mexico: Coordinación Editorial Armando Ruiz, 2005.

Bol, Marsha Clift. "The Anonymous Artist of Laguna and the New Mexican Colonial Altar Screen." MA thesis, University of New Mexico, Dept. of Art and Art History, 1980.

Bolton, Herbert E., trans. and ed. *Pageant in the Wilderness: The Story of the Escalante Expedition to the Interior Basin, 1776: Including the Diary and Itinerary of Father Escalante.* Salt Lake City: Utah State Historical Society, 1950.

Boyd, E. *Popular Arts of Spanish New Mexico.* Albuquerque: University of New Mexico Press, 1974.

Buisseret, David. "Spanish Military Engineers before 1750." In *Mapping and Empire: Soldier-Engineers on the Southwestern Frontier,* edited by Dennis Reinhartz and Gerald D. Saxon. Austin: University of Texas Press, 2005.

Burke, Marcus. *Treasures of Mexican Colonial Painting: The Davenport Museum of Art Collection*. Santa Fe: Museum of New Mexico Press, 1998.

——. "Painting: The Eighteenth-Century Mexican School." In *Mexico: Splendors of Thirty Centuries*. New York: The Metropolitan Museum of Art, 1990.

Carrillo, Charles, and Thomas J. Steele, SJ. *A Century of Retablos: The Dennis and Janis Lyon Collection of New Mexican Santos, 1780–1880*. Easthampton, MA: Hudson Hills Press, 2007.

Cash, Marie Romero. *Santos: Enduring Images of Northern New Mexican Village Churches*. Boulder: University Press of Colorado, 2003.

Chávez, Fray Angélico. *Origins of New Mexico Families: A Genealogy of the Spanish Colonial Period*. Santa Fe: Museum of New Mexico Press, 1992.

Chávez, Fray Angélico, and Ted J. Warner, trans. and eds. *The Domínquez and Escalante Journal: Their Expedition Through Colorado, Utah, Arizona, and New Mexico in 1776*. Salt Lake City: University of Utah Press, 1995.

Chávez, Thomas E., ed. *A Moment in Time: The Odyssey of New Mexico's Segesser Hide Paintings*. Albuquerque: Rio Grande Press, 2012.

Ebright, Malcolm, and Rick Hendricks. *The Witches of Abiquiu: The Governor, the Priest, the Genízaro Indians, and the Devil*. Albuquerque: University of New Mexico Press, 2006.

Farago, Claire, and Donna Pierce, eds. *Transforming Images: New Mexican Santos In-Between Worlds*. University Park: Pennsylvania State University Press, 2006.

Fireman, Janet K. *The Spanish Royal Corps of Engineers in the Western Borderlands: Instrument of Bourbon Reform, 1764–1815*. Glendale, CA: Arthur H. Clark, 1977.

Fontana, Bernard L. "Nuestra Señora de Valvanera in the Southwest." In *Hispanic Arts and Ethnohistory in the Southwest: New Papers Inspired by the Work of E. Boyd*, edited by Marta Weigle with Claudia and Samuel Larcombe. Santa Fe: Ancient City Press and the Spanish Colonial Arts Society, 1983.

Gavin, Robin Farwell. "New Mexico's Indo-Hispano Altar Screens." *El Palacio* 116, no. 4 (Winter 2011).

——. "Creating a New Mexico Style." In *Converging Streams: Art of the Hispanic and Native American Southwest*, edited by William Wroth and Robin Farwell Gavin. Santa Fe: Museum of Spanish Colonial Art, 2010.

Giffords, Gloria Fraser. *Sanctuaries of Earth, Stone, and Light: The Churches of Northern New Spain, 1530–1821*. Tucson: University of Arizona Press, 2007.

Hodge, Frederick Webb, George P. Hammond, and Agapito Rey. *Fray Alonso de Benavides' Revised Memorial of 1634*. Albuquerque: University of New Mexico Press, 1945.

Huseman, Ben W. *Revisualizing Westward Expansion: A Century of Conflict in Maps, 1800–1900*. Arlington: The University of Texas at Arlington, 2008.

Ivey, Jake. 'El Ultimo Poblado del Mundo' (The Last Place On Earth): Evidence for Imported Retablos in the Churches of Seventeenth-Century New Mexico." In *El Camino Real de Tierra Adentro*, vol. 2, edited by June-el Piper. BLM Cultural Resources Series No. 13. Santa Fe: Bureau of Land Management, 1999.

Kelemen, Pál. "The Significance of the Stone Retable of Cristo Rey." *El Palacio* 61, no. 8 (August 1954).

Kessell, John L. *Kiva, Cross, and Crown: The Pecos Indians and New Mexico, 1540–1840*. Washington, DC: The National Park Service, U.S. Department of the Interior, 1979.

——. *Miera y Pacheco: A Renaissance Spaniard in Eighteenth-Century New Mexico*. Norman: University of Oklahoma Press, 2013.

——. *The Missions of New Mexico Since 1776*. Albuquerque: University of New Mexico Press, 1980.

Kubler, George. *The Religious Architecture of New Mexico in the Colonial Period and Since the American Occupation*. Colorado Springs: The Taylor Museum, 1940; reprint by The Rio Grande Press, 1962.

Mac Gregor, Greg, and Siegfried Halus. *In Search of Domínguez and Escalante: Photographing the 1776 Spanish Expedition through the Southwest*. Santa Fe: Museum of New Mexico Press, 2011.

McAndrew, John. *Open-Air Churches of Sixteenth-Century Mexico: Atrios, Posas, Open Chapels, and Other Studies*. Cambridge: Harvard University Press, 1965.

Mirabal, Felipe, and Donna Pierce. "The Mystery of the Cristo Rey Altar Screen and Don Bernardo de Miera y Pacheco." In *Spanish Market Magazine* 12, no. 1 (1999).

Morfí, Fray Juan Agustín. "Geographical Description of New Mexico written by the Reverend Preacher Fray Juan Agustín de Morfí, Reader Jubilado and son of this province of Santo Evangelio of Mexico. Year of 1782." In Alfred Barnaby Thomas, *Forgotten Frontiers: A Study of the Spanish Indian Policy of Don Juan Bautista de Anza Governor of New Mexico 1777–1787*. Norman: University of Oklahoma Press, 1969, reprint 1932.

Pierce, Donna. "From New Spain to New Mexico: Art and Culture on the Northern Frontier." In *Converging Cultures: Art and Identity in Spanish America*. New York: The Brooklyn Museum and Harry N. Abrams, 1996.

——. "Heaven on Earth: Church Furnishings in Seventeenth-Century New Mexico." In *El Camino Real de Tierra Adentro*, vol. 2.

——. "Historical Introduction," "Saints in the Hispanic World," and "Saints in New Mexico," in *Spanish New Mexico: The Spanish Colonial Arts Society Collection*, edited by Donna Pierce and Marta Weigle. Santa Fe: Museum of New Mexico Press, 1996.

Reinhartz, Dennis. "Spanish Military Mapping of the Northern Borderlands after 1750." In *Mapping and Empire: Soldier-Engineers on the Southwestern Frontier*. Ed. by Dennis Reinhartz and Gerald D. Saxon. Austin: University of Texas Press, 2005.

Rivero Borrell M., Héctor, et al. *The Grandeur of Viceregal Mexico: Treasures from the Museo Franz Mayer*. Houston: Museo Franz Mayer and the Houston Museum of Fine Arts, 2002.

Scholes, France V. "Documents for the History of the New Mexico Missions in the Seventeenth Century." *New Mexico Historical Review* 4, no. 2 (1929).

Scholes, France V., and Eleanor B. Adams. "Inventories of Church Furnishings in Some of the New Mexico Missions, 1672." In *Dargan Historical Essays*, edited by William M. Dabney and Josiah C. Russell. University of New Mexico Publications in History, No. 4 (1952).

Sobré, Judith Berg. *Behind the Altar Table: The Development of the Painted Retable in Spain, 1350–1500*. Columbia: University of Missouri Press, 1989.

Stratton-Pruitt, Suzanne. *The Virgin, Saints and Angels: South American Paintings 1600–1825 from the Thoma Collection*. Milan: Skira, 2006.

Taylor, William B. *Shrines and Miraculous Images: Religious Life in Mexico Before the Reforma*. Albuquerque: University of New Mexico Press, 2010.

Tovar de Teresa, Guillermo. *Miguel Cabrera: Drawing Room Painter of the Heavenly Queen*. Mexico: InverMexico, 1995.

Weber, David J. *The Spanish Frontier in North America*. New Haven and London: Yale University Press, 1992.

Wheat, Carl I. *Mapping the Transmississippi West*. San Francisco, CA: Institute of Historical Cartography, 1957. 5 vols.

Wroth, William. *Christian Images in Hispanic New Mexico: Taylor Museum Collection of Santos*. Colorado Springs: The Taylor Museum of the Colorado Springs Fine Arts Center, 1982.

——. "The Santero José Rafael Aragón." In *The Chapel of Our Lady of Talpa*. Colorado Springs: Taylor Museum of the Colorado Springs Fine Arts Center, 1979.

von Wuthenau, Alexander. "The Spanish Military Chapels in Santa Fe and the Reredos of Our Lady of Light." In *New Mexico Historical Review* 10, no. 3 (1935).

Credits

Fig. 14

History Collection NMHM DCA 9599/45, Santa Fe, NM. Photo by Blair Clark.

Fig. 15

Cristo Rey Church, Archdiocese of Santa Fe. Photo by Blair Clark.

Fig. 16

Courtesy of the Dirección General de Geografín y Meteorolgía, Tacubaya, D. F., Mexico (Colleción de Orozco y Berra, no. 1148).

Fig. 17

Courtesy of the Dirección General de Geografín y Meteorolgía, Tacubaya, D. F., Mexico (Colleción de Orozco y Berra, no. 1148).

Fig. 18

Courtesy of the Dirección General de Geografín y Meteorolgía, Tacubaya, D. F., Mexico, (Colleción de Orozco y Berra, no. 1148).

Fig. 19

The University of Arizona Libraries, Tucson. E98.T35 J2 1974.

Fig. 20

Fray Angélico Chávez Library, New Mexico History Museum, Santa Fe, MSS 826 BC.

Fig. 21

New York Public Library, NY. G92F120.030ZF.

Fig. 22

The U.S. National Archives and Records Administration, Washington, DC, ARC ID #517731.

Fig. 23

Cristo Rey Church, Archdiocese of Santa Fe. Photo by Blair Clark.

Fig. 24

Zuni Pueblo Visitor's Center, NM. Photo by Blair Clark.

Fig. 25

Photo courtesy of Donna Pierce.

Fig. 26

Photo courtesy of the Brooklyn Museum, NY. Acc. Nos. 04.297.5143-5144.

Fig. 27

Collection of the Archdiocese of Santa Fe. L.1.60.23. Photo by Blair Clark.

Fig. 28

Collection of the Spanish Colonial Arts Society, 1954.77. Photo by Addison Doty.

Fig. 29

Toledo Cathedral, Toledo, Spain. Photo courtesy of Donna Pierce.

Fig. 30

Burgos Cathedral, Burgos, Spain. Photo courtesy of Donna Pierce.

Fig. 31

Our Lady of Loretto Convent, Littleton, CO. Photo by Blair Clark.

Fig. 32

Archdiocese of Santa Fe. Photo by Blair Clark.

Fig 33

Courtesy of the Bancroft Library, University of California, Berkeley. Photo by D. B. Chase.

Fig. 34

Amon Carter Museum, Fort Worth, TX,1975.16.14.

Fig. 35

Photograph by Timothy O'Sullivan, 1873. Courtesy of the Bancroft Library, University of California, Berkeley 10044977A.

Fig. 36

Photograph by I.W. Tabor, ca. 1880. Palace of the Governors Photo Archives 89946.

Fig. 37

National Museum of American History, Smithsonian Institution. Photo courtesy of Donna Pierce.

Fig. 38

Photo by A. C. Vroman, 1899. Palace of the Governors Photo Archives 012438.

Fig. 39

Museum of International Folk Art, Santa Fe. A. 66.30-1/4. Photo by Blair Clark.

Fig. 40

Private collection.

Fig. 41

Collection of the Spanish Colonial Arts Society, 2000.49. Photo by Addison Doty.

Fig. 42

Archdiocese of Santa Fe, 8.2.A18/19. Photo by Jack Parsons.

Fig. 43

Archdiocese of Santa Fe. Photo by Blair Clark.

Fig. 44

Taylor Museum of the Colorado Springs Fine Arts Center, Colorado Springs. Photo by Blair Clark.

Fig. 45

Cristo Rey Church, Archdiocese of Santa Fe. Photo by Blair Clark.

Fig. 46

Museo de Traje. Centro de Investigación del Patrimonio Etnológico, Madrid, Spain 79889.

Fig. 47

Taylor Museum of the Colorado Springs Fine Arts Center, TM 3847. Photo by Blair Clark.

Fig. 48

Museum of International Folk Art, Santa Fe, NM. Photo by Blair Clark.

Fig. 49

Nuestra Señora del Rosario de Truchas, NM. Photo by Jack Parsons.

Fig. 50

Museum of International Folk Art, Santa Fe, NM. Photo by Blair Clark.

Fig. 51

Santa Cruz de la Cañada Church, NM. Photo by Blair Clark.

Fig. 52

Museum of International Folk Art, Santa Fe, NM. A713126. Photo by Blair Clark.

Fig. 53

Museo Franz Mayer, Mexico City.

Fig. 54

Tohono O'Odham Nation, San Xavier District, AZ, Photo by Edward McCain.

Fig. 55

Taylor Museum of the Colorado Springs Fine Arts Center, TM 886.

Fig. 56

Photo by Henry T. Hiester, ca. 1860s. Palace of the Governors Photo Archives 038006.

Fig. 57

Taylor Museum of the Colorado Springs Fine Arts Center, TM 1400. Photo by Blair Clark.

Fig. 58

Taylor Museum of the Colorado Springs Fine Arts Center, TM 949. Photo by Blair Clark.

Fig. 59

Taylor Museum of the Colorado Springs Fine Arts Center, TM 2783.

Fig. 60

History Collection NMHM DCA 01845.45, Santa Fe, NM. Photo by Blair Clark.

Fig. 61

Arizona State Museum, University of Arizona, Tucson. Photo by Jannelle Weekly.

Fig. 62

Church of San Francisco, Chihuahua, Mexico. Photo courtesy of Gloria F. Giffords.

Fig. 63

San Miguel Church, Santa Fe. Photo by Blair Clark.

Fig. 64

San Miguel Church, Santa Fe. Photo by Blair Clark.

Fig. 65

Taylor Museum of the Colorado Springs Fine Arts Center, TM 523. Photo by Blair Clark.

Fig. 66

Taylor Museum of the Colorado Springs Fine Arts Center, TM 1560. Photo by Blair Clark.

Index

Project editor: Mary Wachs
Design and production: David Skolkin
Composition: Set in Cochin
Manufactured in China
10 9 8 7 6 5 4 3 2 1

Library of Congress Cataloging-in-Publication Data
The art and legacy of Bernardo Miera y Pacheco : New Spain's explorer, cartographer, and artist / edited by Josef Diaz. — First [edition].
pages cm
Includes bibliographical references and index.
ISBN 978-0-89013-585-3 (clothbound : alk. paper)
1. Miera y Pacheco, Bernardo de--Themes, motives. I. Diaz, Josef, editor of compilation.
F799.A78 2013
709.2 — dc23
2013023045

Museum of New Mexico Press
PO Box 2087
Santa Fe, New Mexico 87504
mnmpress.org